Generations in Black and White

FOAL

Generations

in Black and White

Photographs by CARL VAN VECHTEN

from the JAMES WELDON JOHNSON Memorial Collection

EDITED BY RUDOLPH P. BYRD

THE UNIVERSITY OF GEORGIA PRESS ATHENS AND LONDON

© 1993 by the University of Georgia Press
Athens, Georgia 30602

Photographs are from the James Weldon Johnson Memorial Collection of
Negro Arts and Letters, Beinecke Rare Book and Manuscript Library,
Yale University, New Haven, Connecticut. © Estate of Carl Van Vechten.

"Corrected Review" and "Song: I Want a Witness"
© Michael S. Harper.

Designed by Sandra S. Hudson
Set in 11 on 17 Gill Sans Book by Tseng Information Systems, Inc.
Printed and bound by Maple-Vail
The paper in this book meets the guidelines for permanence
and durability of the Committee on Production Guidelines
for Book Longevity of the Council on Library Resources.

Printed in the United States of America
97 96 95 94 93 C 5 4 3 2 1

Library of Congress Cataloging in Publication Data

Van Vechten, Carl, 1880–1964.
Generations in Black and white : photographs / by Carl Van Vechten
from the James Weldon Johnson Memorial Collection ;
edited by Rudolph P. Byrd.
p. cm.
ISBN 0-8203-1558-3 (alk. paper)
1. Afro-Americans—Portraits. 2. Afro-Americans—Biography.
3. Van Vechten, Carl, 1880–1964—Photograph collections.
4. Photograph collections—Connecticut—New Haven. I. Byrd, Rudolph P.
II. Title. III. Title : James Weldon Johnson Memorial Collection.
E185.96.V36 1993
973'.0496073'00922—dc20
93-2684

British Library Cataloging in Publication Data available

To the Next Generation

Contents

Portraits

x

Acknowledgments

Generations in Black and White is a project I undertook with enthusiasm and trepidation. Such volatile poles of feeling very often produce paralysis, and paralysis does not produce books. I was fortunate, however, in that from conception to completion I stood on the shoulders of many, and as a consequence of this unwavering support I have produced a better and more satisfying book than I had first imagined.

I was introduced to Yale University's James Weldon Johnson Memorial Collection of Negro Arts and Letters by Michael S. Harper, the Israel J. Kapstein Professor of English at Brown University and Poet Laureate of Rhode Island. I wish to thank Professor Harper for that timely introduction, which in retrospect was nothing less than an initiation into the valiant tradition of thought, service, and excellence this volume seeks to honor, to celebrate, and to make more widely known. I also wish to thank Professor Harper for granting permission to reprint two of his finest poems.

I owe special debts of gratitude to Professor Vera M. Kutzinski of Yale University, Professor Herman A. Beavers of the University of Pennsylvania, and Professor Bruce Kellner of Millersville University, all of whom recognized the value of this project even in its earliest stages and whose generosity of spirit helped bring it to fruition.

I wish to thank Patricia M. Willis and Steve Jones of Yale University's Beinecke Rare Book and Manuscript Library for their cooperation in all stages of this project. I also wish to thank Joseph Solomon, executor of the Carl Van Vechten Estate, for granting permission to reprint Van Vechten's photographs in book form.

I have read that strong and imaginative leadership in the publishing industry is rapidly disappearing, but that tradition of leadership can still be found at the University of Georgia Press. Once again I am under an obligation to Karen K. Orchard, Executive Editor of the University of Georgia Press, for her editorial judgment and faith in this project. I also wish to express my admiration for the professionalism of Madelaine Cooke and Sandra Hudson. Committed to producing a perfect book, Ms. Cooke maintained the very highest standards during all stages of copyediting. Once again, Ms. Hudson has designed a book that beautifully complements both language and imagery.

As a member of the faculty at Emory University, it is my privilege to test and to explore ideas with exceptional students. Among those students is Jeffrey B. Leak, who was by turns research assistant and colleague in the final stages of this project.

I wish to acknowledge the forbearance and advice of Henry A. Leonard during the various stages of this project. I also wish to acknowledge the encouragement of Meardis Cannon and other members of my family who refrained from attaching uncharitable

constructions upon my absences and forgetfulness as I sought to meet real and imagined deadlines. Finally, I wish to acknowledge the aid and good will of friends, most especially Richard A. Benson, Tyrone Cannon, Robert Carwell, Brenda Files, Craig Fort, Earl Gordon, Kemp Harris, Cecelia Corbin Hunter, Ingrid Saunders Jones, James D. Manning, Walter L. Miller, Barry Nelson, Phillip Robinson, Garth Tate, Deborah G. Thomas, William A. Tibbs, Jr., and Jerome Wright. Finally, thanks and praise to the Spirit, who makes all things possible.

Introduction

"In the early days of the Negro literary and artistic movement," wrote James Weldon Johnson of his friend Carl Van Vechten, "no one in the country did more to forward it than he accomplished in frequent magazine articles and by his many personal efforts in behalf of individual Negro writers and artists."[1] When Johnson published this tribute to Van Vechten in *Along This Way* in 1933, Van Vechten had just begun his important work in photography, a medium through which he would enlarge his contributions as a patron of African American culture. Indeed, most of the portraits published in this volume were decades away from conception and completion. Moreover, when Johnson published this tribute to Van Vechten very few members of the African American intelligentsia held such a high opinion of what Johnson regarded as Van Vechten's unselfish commitment to the artists and writers of the New Negro movement, or Harlem Renaissance.[2] The event that made African American intellectuals suspicious of Van Vechten's undisguised enthusiasm for African American culture, an enthusiasm Van Vechten shared with other American intellectuals of European descent, was the publication of *Nigger Heaven* (1926), his controversial novel of Harlem life.

Although keenly aware of Van Vechten's efforts to promote African American culture, many African American intellectuals felt almost betrayed following the publication of *Nigger Heaven,* the first novel of Harlem life by a white author. It was the opinion of some of the most astute critics of African American culture that the novel celebrated only the most unsavory and unseemly aspects of African American life and, its flattering portrait of the black middle class notwithstanding, failed to suggest the diversity of African American life as it emerged with all its force and beauty in Harlem. In the pages of the *Crisis,* W. E. B. Du Bois expressed the opinion of many astonished readers in his review of *Nigger Heaven:* "I cannot for the life of me see in this work either sincerity or art, deep thought, or truthful industry. It seems to me that Mr. Van Vechten tried to do something bizarre and he certainly succeeded."[3] Some years later, in his landmark study *The Negro in American Fiction* (1937), Sterling A. Brown offered an assessment that echoes the criticism of Du Bois and emphasizes what Brown terms Van Vechten's predisposition for "exotic singularities": "Modern Negro life is not in *Nigger Heaven*; certain selected scenes to prove Negro primitivism are."[4]

Johnson's opinion of Van Vechten's achievement as a novelist was not altered by the furor ignited by *Nigger Heaven:* seven years after its publication, Johnson still regarded Van Vechten as "the most sophisticated of American novelists." In comparing *Nigger Heaven* with Claude McKay's *Home to Harlem,* also a novel Brown criticized for

its emphasis upon "Negro primitivism," Johnson argued that Van Vechten's portrayal of Harlem life was more balanced than that of McKay: "[*Home to Harlem*] dealt with low levels of life, a lustier life, it is true, than the dissolute modes depicted by Mr. Van Vechten, but entirely unrelieved of any brighter lights; furthermore, McKay made no attempt to hold in check or disguise his abiding contempt for the Negro bourgeoisie. . . . From the first, my belief has held that *Nigger Heaven* is a fine novel." Johnson also argued that the severest critics of *Nigger Heaven* had never read the novel, since most "were estopped by the title."[5] It is clear that such critics as Du Bois and Brown were offended not only by the portrayal of African American life but also by the racial slur that was part of the novel's title. These objections are certainly valid: as a white author writing about black life Van Vechten should have exhibited more tact. Van Vechten's regrettable choice of titles has endowed his only novel of African American life with a prominence born of scandal. This unfortunate fact further distinguishes *Nigger Heaven* from other contemporaneous explorations of African American life by such authors as Eugene O'Neill, e. e. cummings, Waldo Frank, and Sherwood Anderson. If Van Vechten had chosen a less sensational title, *Nigger Heaven* would have passed into the obscurity of his other novels, and his patronage of African American culture would be more widely known and appreciated.

Van Vechten's interest in African American culture started in the home of his parents, Amanda Fitch and Charles Duane Van Vechten, in Cedar Rapids, Iowa. His father was the cofounder of the Piney Woods School, a primary and secondary school for African American children located in rural Mississippi. The father's example of philanthropy had a lasting impact upon the son. As a member of a privileged and homogenous community in Cedar Rapids, Van Vechten developed an early awareness of African American life that, in the words of Van Vechten's biographer, Bruce Kellner, "helped inoculate [Van Vechten] against [race] prejudice."[6] After his father's death, Van Vechten continued to represent the family interest in the Piney Woods School. In a letter to Countee Cullen, Van Vechten invited Cullen to make a contribution to a ten-thousand-dollar capital campaign to build a library for the Piney Woods School.[7] Like his father before him, Van Vechten recognized the value of establishing institutions that would support and advance African American culture, and he would devote significant amounts of his own time and resources to establish several himself.

From 1899 to 1903, while Van Vechten was a student at the University of Chicago, his interest in African American culture acquired a certain weight and solidity. In the clubs and cabarets of Chicago, Van Vechten first encountered ragtime as it was embodied in the dancing and singing genius of such artists as Bert Williams, Carita Day, and George Walker. When the young Van Vechten left Chicago for New York City in 1906, he took with him a burgeoning interest in African American culture that would

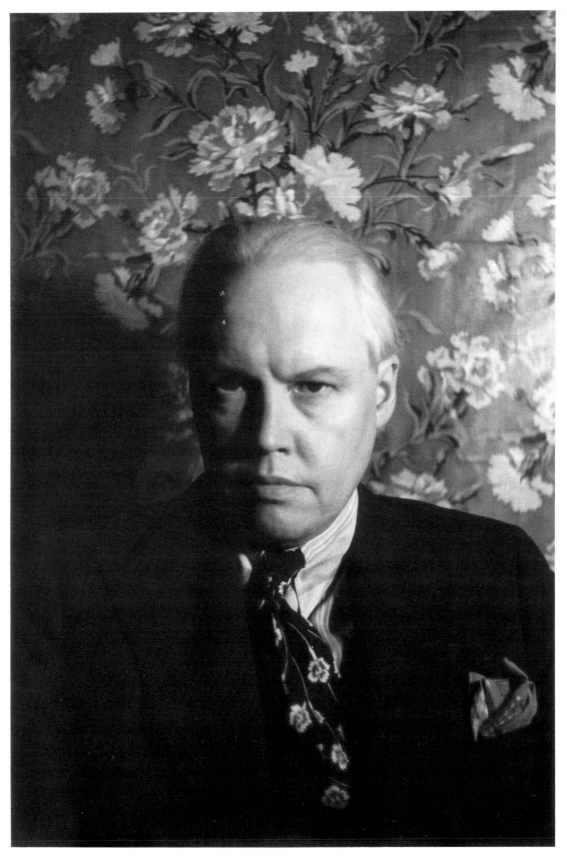

Carl Van Vechten

be shaped and refined by study, as well as by his friendships with prominent African American intellectuals.

Although he had written sympathetic and prophetic reviews of African American theater, dance, and music as drama critic for the *New York Press* and later as music critic for the *New York Times,* Van Vechten's formal introduction to African American culture in New York City actually began in 1924, with his introduction to Walter White. Having read White's *Fire in the Flint* (1924), a fictionalized account of the Atlanta riots of 1902 and 1906, Van Vechten arranged a meeting with White through Alfred Knopf, their mutual publisher. In his biography of Van Vechten, Kellner writes that this "meeting was, for both men, propitious." As assistant secretary for the National Association for the Advancement of Colored People (NAACP), White was "anxious to strengthen contact with a society that shunned his race," and Van Vechten, "already impressed with Negro music and theater, [was] anxious to move beyond the confines to the periphery." Van Vechten and White, in Van Vechten's words, "got on like a house afire."[8] According to Kellner, it was White who introduced Van Vechten to James Weldon Johnson, an introduction that moved Van Vechten from the periphery to the center of African American life and culture in New York City. These pivotal introductions between Van Vechten and White, and then between Van Vechten and Johnson, took place in 1924, one year after the publication of Jean Toomer's *Cane* and one year before the publication of Alain Locke's *New Negro.* Van Vechten's timing could not have been better, for he was present at the flowering of the New Negro movement: an arts movement that inspired the writers of the Negritude movement, the writers of the Black Arts movement, and the present renaissance in the writings of African American women.

As a lawyer, educator, composer, author, diplomat, and, at the time of their meeting, executive secretary of the NAACP, Johnson was in a unique position to introduce Van Vechten to some of the most distinguished and talented African Americans of his generation. According to Kellner, Johnson and White escorted Van Vechten to his first NAACP cabaret party, at the Happy Rhone Club, where he met the young Countee Cullen and Langston Hughes. Congenial and gregarious, Van Vechten was soon attending awards dinners hosted by the NAACP and the Urban League, occasions that provided him with an opportunity to cultivate what would be lifelong friendships with such writers as Hughes, Cullen, and the talented and redoubtable Zora Neale Hurston. Van Vechten moved gracefully from the formal banquets of the NAACP and the Urban League to such fashionable Harlem cabarets as Small's and the Nest, where one could gaze upon the brightest stars in the ever-expanding Harlem galaxy. The erudite conversations begun among the satin and crystal of NAACP dinners or among the jazz and gin of Small's very often achieved their denouement in the elegant *fin de siècle* rooms of Van Vechten and

Fania Marinoff's West Fifty-fifth Street apartment that Walter White roguishly dubbed the midtown branch of the NAACP.[9]

It was through Johnson that Van Vechten met such luminaries as W. E. B. Du Bois, Rudolph Fisher, and Arna Bontemps. In these early years of the New Negro movement, Van Vechten understood he was in the presence of greatness, and he understood that he was living in an age of greatness. As early as 1925 in his many articles published in *Vanity Fair,* the *Crisis, Theatre,* and the *New York Herald Tribune,* Van Vechten wrote with passion and insight of the ground-breaking work of Langston Hughes, Countee Cullen, Bessie Smith, Clara Smith, and Ethel Waters. Impressed by the talent of these and other artists, Van Vechten sought to shatter the parochialism of the American public and to increase the awareness of and appreciation of the dynamic cultural traditions of African Americans.

In an age of rising nativism, Van Vechten was one of a small group of European American intellectuals who recognized the uniqueness, depth, and far-reaching significance of African American culture. Van Vechten rejected the insular, false, and Eurocentric arguments of white supremacists such as Harvard's Lothrap Stoddard, whose *Rise of the Colored Nations* (1920) was in part a systematic refutation of the existence of African American culture. Like Du Bois, Johnson, and Locke, Van Vechten not only believed in the legitimacy and the transformational value of African American culture, he also believed that African American art forms—the spirituals, the blues, jazz—constituted the most advanced and profound expression of a national art. In *Keep A-Inchin' Along* (1979), a collection of selected essays and reviews, Van Vechten emerged as a critic and cultural historian ahead of his own generation. He was sometimes guilty of condescension and the lapses of judgment in phrasing that curiously foreshadow the controversy of *Nigger Heaven;* nevertheless his assessments of African American music, dance, and theater reveal a deep appreciation for what is abiding, authentic, and unique to American art.

As a patron, Van Vechten's interest in African American culture was never purely abstract. In contributing to the fund to support the literary prizes awarded by the Urban League and by making private contributions to support many insolvent artists, Van Vechten took a personal interest in the lives of individuals whose work he promoted faithfully and about whom he wrote with much enthusiasm and insight. Van Vechten read and commented upon many of Hughes's poems in manuscript and campaigned for their publication at Alfred A. Knopf. Hughes remembered Van Vechten's generosity in *Fine Clothes to the Jew* (1927), a volume of poems he dedicated to Van Vechten. There were also instances when Van Vechten turned to Hughes for guidance and support. When the lawyers for the American Society of Composers, Authors and Publishers challenged Van Vechten concerning the authorship of certain blues lyrics published in *Nigger Heaven,*

Hughes, in collaboration with Van Vechten, composed new and original blues lyrics that appeared in the seventh and subsequent printings of the novel. Although Van Vechten had to pay twenty-five hundred dollars to settle the ASCAP claim, he was nonetheless deeply grateful for Hughes's timely contribution.[10]

Hughes was not the only writer of the New Negro movement with whom Van Vechten enjoyed an enduring friendship. Zora Neale Hurston expressed her gratitude for the interest Van Vechten had shown in her work as a folklorist and anthropologist by dedicating *Tell My Horse* (1938), one of her three volumes of African American folklore, to Van Vechten. Countee Cullen also benefited from the largess of Van Vechten. It was through the influence of Van Vechten that *Vanity Fair* first published the early poems of Cullen. Perhaps by way of thanks, there is a flattering portrait of Van Vechten as Walter Dervent in Cullen's novel *One Way to Heaven* (1932). Van Vechten supported the work of what we know as the "younger generation of writers" (Hughes, Hurston, and Cullen) and collaborated with their literary ancestors, the "older generation of writers" (Du Bois, Johnson, and Locke). At Van Vechten's insistence Alfred Knopf published a new edition of Johnson's *Autobiography of an Ex-Coloured Man* (1912) in 1927, and Van Vechten, with Johnson's approval, wrote an introduction that helped dispel the many myths regarding authorship of the novel.

During the New Negro movement, Van Vechten's commitment to African American culture was shared by other patrons. The wealthy Charlotte Mason supported for many years both Zora Neale Hurston and Langston Hughes, but her unfortunate need to dominate ultimately poisoned the relationships between artists and patron.[11] Caspar Holstein, a dashing Virgin Islander who presided over the numbers and liquor business that flourished in Harlem during prohibition, made large financial gifts that supported literary prizes and scholarships awarded by the Urban League.[12] Joel E. Spingarn, who was a writer, a humanitarian, and for many years the president of the NAACP, contributed to the literary prizes sponsored by the *Crisis* and *Opportunity* and in 1914 established the Spingarn Medal, an annual award in recognition of the "highest and noblest achievement of an American Negro during the preceding year or years." Recipients of the Spingarn Medal during the New Negro movement include William S. Braithwaite, W. E. B. Du Bois, Charles Gilpin, James Weldon Johnson, and Roland Hayes.[13] During the New Negro movement, many African American writers and artists competed for prizes and fellowships awarded by the Harmon Foundation and the Julius Rosenwald Fund. If their research did not require them to leave New York City, many writers began at the Arthur Schomburg Center for Research in Black Culture of the New York Public Library. Established in 1926 by the cultural historian and bibliophile Arthur Schomburg, the Schomburg Collection is perhaps the oldest, and by now one of the largest, collections of African, Caribbean, and African American culture in the United States. Schomburg's scholarly

commitment as a bibliophile and connoisseur of black culture served as an important example for Van Vechten.

> The dinner then is to commemorate the birth of a great responsibility, the responsibility of preserving the Negro present and the Negro past, historically and artistically, for the future when the united races will seek to learn what each has contributed towards the building of the nation.
>
> Carl Van Vechten, November 1942, at a dinner in recognition of his founding of the James Weldon Johnson Memorial Collection of Negro Arts and Letters

When James Weldon Johnson was killed in an automobile accident on June 26, 1938, Van Vechten's work as patron moved to a new level of difficulty and commitment. Shortly after Johnson's funeral, the James Weldon Johnson Memorial Committee was formed to determine how best to memorialize Johnson's outstanding contributions in the arts, literature, civil rights, education, and public service. The membership of this committee reflected the range of Johnson's intellectual interests and professional appointments: Theodore Roosevelt, Jr., a soldier, businessman, and son of President Theodore Roosevelt, was chairman; Fiorello H. La Guardia, then mayor of New York, served as honorary chairman; Gene Buck, a lyricist and president of ASCAP, was treasurer and chairman of the executive committee; and Walter White, Johnson's successor as executive secretary of the NAACP, served as secretary. Other members included Sterling A. Brown, the critic, poet, and professor of English at Howard University; Harry T. Burleigh, a singer, composer, and founding member of ASCAP; Elmer A. Carter, editor of *Opportunity*; W. C. Handy, a master musician, composer, and arranger of the blues; J. Rosamond Johnson, the musician, composer, and younger brother of James Weldon Johnson; E. George Payne, dean of the School of Education at New York University; and Arthur B. Spingarn, a lawyer and bibliophile of African American culture. Carl Van Vechten served as the committee's vice-chairmen.[14]

After reviewing the several proposals for a Johnson memorial that had emerged from a national competition, the committee voted to commission a work in bronze that would commemorate Johnson's efforts to preserve and promote the spirituals. In a publicity statement he wrote for the *Crisis* and *Opportunity* issues of February 1940, Van Vechten described the memorial, explained its rationale, and identified its site in Manhattan.

> The idea which finally crystallized . . . was a monument in bronze, not *of* James Weldon Johnson, but *to* his Black and Unknown Bards, the creators of the Spirituals which Mr. Johnson so much admired, their arms and faces uplifted to heaven, an inspiration to his race, a challenge to the defamers of that race. On the marble base of this memorial would appear on one side a bas-relief of Mr. Johnson's head, while on the other would be carved a stanza from the verses of the poet

which had inspired the monument. . . . The particular site which the committee would prefer is the island in the center of Seventh Avenue, immediately above One hundred and tenth Street, the monument facing the entrance to Central Park, so that anyone who emerged from the park at that point . . . would meet the statue face to face. On the other hand, schoolchildren and their elders on their way to the park from Harlem would pass it by from the other direction.[15]

Richmond Barthé, an African American sculptor who was trained at the Art Institute of Chicago and whose splendid works in bronze had garnered him an international reputation, was chosen by the James Weldon Johnson Memorial Committee to execute this commission. There was some disagreement among committee members concerning whether the figures in this singing group of bronze should be nude or clothed, but the unavailability of bronze during World War II made these discussions moot.[16] By 1945 the project was abandoned, and members of the James Weldon Johnson Memorial Committee voted to donate the funds raised for the memorial, with allowances made for Barthé's design, to the James Weldon Johnson Memorial Collection of Negro Arts and Letters at Yale University, which Van Vechten had established in 1941.[17]

From 1941 until his death in 1964 Van Vechten established several important collections, including the George Gershwin Memorial Collection of Music and Musical Literature at Fisk University, which officially opened in 1947. He established these collections at both black and white universities because he believed that research by scholars interested in American and African American culture would lead to an erosion of segregation and thus to an improvement in race relations.[18] Van Vechten's belief that cultural exchange and research could function as a bridge between the races reflects the thinking of such cultural theoreticians as Du Bois, Locke, and Johnson, who, as products of classical educations, were influenced by their study of Matthew Arnold, who similarly attached great importance to the role of culture in advancing human understanding.

Van Vechten's work as a patron of African American culture achieved its fullest expression in the establishment of the James Weldon Johnson Memorial Collection of Negro Arts and Letters, which opened officially on January 7, 1950, at Yale University. Yale was chosen as the repository for the collection because of the interest exhibited by Bernhard Knollenberg, then the librarian of Yale University, in Van Vechten's personal papers and library. At the time, Yale did not have, in the words of Knollenberg, "any Negro books at all." [19] Committed to building a collection in African American culture worthy of the memory of an esteemed friend and colleague, Van Vechten, guided by Knollenberg, began the difficult and time-consuming work of amassing and cataloging the rich materials of the Johnson Collection.

Initially, Van Vechten's personal library formed the nucleus of the collection, which, in the years since 1941, has been augmented by the contributions of performing and

visual artists, musicians, playwrights, novelists, poets, and critics whose works have been inspired by African American life and history. Not surprisingly, the writers of the New Negro movement enjoy a prominent place. The collection includes a substantial number of works in sociology and history, as well as the correspondence of many of the most distinguished scholars and artists of this century. In recent years, Professor Charles T. Davis, founder of the graduate program of African American Studies at Yale, was successful in adding some of the papers of Richard Wright and Jean Toomer. Abundantly rich in works celebrating African American life and history from all periods, the Johnson Collection is also rich in artifacts of various kinds, including sculpture, painting, furniture, and, most especially, photography. The photographs that compose this volume are cultural artifacts that epitomize the wide current of creative expression the Johnson Collection seeks to honor and to preserve.

> Felt negatives work the pores
> coal black in darkness
> double negatives;
> now in the light
> the emulsive side down
> on top of brown-gray paper
> human images rise.
>
> Michael S. Harper,
> from "Photographs"

"One of the most brilliant episodes in the [James Weldon Johnson Memorial] collection," wrote Van Vechten to his friend Langston Hughes, "is my mounted photographs of Negroes prominent in the arts and sciences."[20] Van Vechten's black and white photographs of distinguished African Americans in the arts, literature, sciences, education, civil rights, and athletics are in some ways the cynosure of the Johnson Collection. It is an extreme pleasure to pore over the manuscripts and letters of Hughes and then to turn one's attention to the many well-known black and white photographs of Hughes. In other words, it is a pleasure to join a face with language, to join an image with a reputation; in fine, it is a pleasure to ponder what some would term a different *text*. Van Vechten's arresting photographs of Hughes convey, among so many things, not only the changing beauty of an American poet but also Van Vechten's growing mastery as a photographer.

Like his interest in philanthropy, Van Vechten's interest in photography began at home in Cedar Rapids, where as a boy he was introduced to the art of photography through the rather crude medium of the box camera. After high school, ever in search of improving technology, Van Vechten graduated from the box camera to more sophisti-

cated Kodak cameras. As a staff member of the *Chicago American,* his chief responsibility was to collect photographs for the paper; it seems that he was never charged with the responsibility of *taking* photographs. Some years later, when Miguel Covarrubias (the Mexican artist who satirized Van Vechten's interest in African American culture in his drawing "A Prediction") taught Van Vechten to use a Leica, his boyhood pastime became the waking preoccupation of an adult. Van Vechten's enthusiasm for photography was so great that it completely supplanted his vocation as a writer. A darkroom was soon installed in Van Vechten's West Fifty-fifth Street apartment, where his subjects "came—still by invitation only—to sit before his camera eye." [21]

In one of several carefully documented sections of his biography of Van Vechten, Kellner skillfully conveys something of the mood, rhythm, and setting of a typical photographic session with Van Vechten in the later years of his long and full life.

> Carl always puttered a little; an assistant set up the lights. Carl adjusted his camera on a wooden easel; the assistant supplied stools, chairs—indeed, chaise lounges or beds—against the draped or otherwise decorated fourth wall. Then the subject sat. The lights were excruciatingly hot, and the room was stuffy. Carl stood behind his camera, . . . waiting for the "exact moment," in which he always believed. Then the shutter began to snap, sometimes quickly, sometimes with syncopated hesitations, always with Carl's embalmed stare above. Occasionally, there were stops while the composition was improved or complicated with props: robes, costumes, banshee hats, Easter eggs, masks, feathers, cats, marionettes.

These photographic sessions produced memorable results: a striking seminude Pearl Bailey, a prayerful Mahalia Jackson, a contemplative Richard Wright, a courtly Ralph Bunche. As an amateur photographer, Van Vechten did not limit himself to African American subjects. On the contrary, Van Vechten's subjects included everyone from the actress Anna May Wong to the novelist William Faulkner, from the dancer Martha Graham to the architect Philip Johnson. Van Vechten's experiments in photography garnered him high praise from art critics, and his photographs were exhibited along with those of such masters as Cecil Beaton, Edward Steichen, and Man Ray. Although Van Vechten's subjects were often famous and distinguished, his photographs were neither sold nor exploited for personal profit. They were "primarily gifts to his subjects and for the pleasure of their maker." [22]

Although gifts to an inspiring subject, Van Vechten's photographs were also an extension of his work as a patron committed to promoting and preserving the vitality of African American culture. Like the collections established at Fisk and Yale, Van Vechten's photographs of prominent African Americans were testimony to the diverse contributions of African Americans to American culture.

I am certain that my first interest in making photographs was documentary and probably my latest interest in making them is documentary too. . . . I wanted to show young people of all races how many distinguished Negroes there are in the world. . . . The subjects are representative, I think, although several fields of endeavor are scarcely covered at all. They are certainly more representative of the artistic fields than of the others. This is probably due to the fact that my own interests lie more in this direction. . . . To many, I suppose, this collection will come as a revelation of the great number of Negroes who have achieved fame in America. If this be the case, it is sufficient justification for making the photographs and exhibiting them.[23]

From 1932 until his death, Van Vechten sought to document through photography the changing face of African American culture, and in the process he established collections of photography not only at Fisk and Yale but also at Howard University, the Detroit Public Library, Atlanta University, the New York Public Library, the Museum of the City of New York, the Museum of Modern Art, the Hammond Museum of New York, the Philadelphia Museum of Art, Princeton University, Brandeis University, the University of Iowa, and the University of New Mexico.[24] That these collections are located at both private and public educational institutions reflects Van Vechten's broad and abiding commitment to fostering racial harmony through the contemplation of cultural artifacts within the framework of research and writing on African American culture.

Although Van Vechten was committed to documenting the extraordinary impact of African Americans upon American culture and politics, his photographs are not merely *evidence* of the race's range of talent and influence. On the contrary, these photographs are distinguished by their beauty and by Van Vechten's ability to capture and convey something of the truth of the life of the subject. Van Vechten's appreciation for the dramatic possibilities of shadow and light, his calculated exploitation of positive forms and negative space, his sensitivity to the value of creating and preserving a mood are discrete factors that together yield a nuanced statement. In a Van Vechten photograph, this statement is often registered through the pose, the attitude and position of the subject before the camera. The pose is perhaps the primary locus of meaning. It is in the pose that one encounters the mystery, the personality, and the force of the subject. Van Vechten appreciated and understood this fact of composition. Whether the pose is accidental or determined in part by the requirements of the subject's art, Van Vechten's skillful positioning of his subjects produced startling, dramatic, and memorable effects.

"Photography," asserts Van Vechten, "is a . . . magical act."[25] Van Vechten's photographs of prominent African Americans manifest something of the magic of the artistic imagination (his own and that of his subjects), something of the daring, the force, and the mystery of the men and women captured and preserved forever by the magic of Van Vechten's "camera eye."

The photographs selected for this book from the James Weldon Johnson Memorial Collection are not arranged in the order in which Van Vechten took them, but are instead presented in the order in which the subject emerged as a vital presence in the African American tradition of dissent and protest, of transcendence and grace. As a record of black achievement and black excellence, this compilation is like a family album of the race on this North American continent in the first six decades of the twentieth century. As a record of a patron's abiding commitment to an evolving tradition, these photographs are proof that the shifting and complex relationship between patron and artist need not always be tainted by condescension, racial superstition, and calculated displays of power. The photographs, in all their beauty and range, contain images that constitute a powerful legacy that draws its enlarging significance from the engaged imagination of the viewer.

Through the depth and power of Van Vechten's image-making, our cultural and historical legacy is greatly enlarged. In these images we confront the broad outline of the Middle Passage, the psychic demands of artistic production, and American history recaptured. In these transforming images we discover images of kin: generations in black and white.

NOTES

1. James Weldon Johnson, *Along This Way* (1933; reprint, New York: Viking Press, 1973), 382.

2. I prefer to use the term *New Negro movement* rather than *Harlem Renaissance* because, as I heard Sterling A. Brown assert more than once, *New Negro movement* does not limit the significance of this movement to Harlem. In further contrast to *Harlem Renaissance*, *New Negro movement* enlarges the scope of the movement to include not only an emphasis upon the arts and letters but also an emphasis upon cultural anthropology, politics, and social reform. Equally as important, Sterling A. Brown, Zora Neale Hurston, Alain Locke, and their contemporaries employed the term *New Negro* to describe themselves and the movement they shaped, a movement that also shaped them. Though it is certainly acceptable to use the term *Harlem Renaissance*, it is important to remember that this term appeared in the literary criticism, histories, and biographies of the era years after the New Negro movement assumed its place as a seminal event in the wide stream of American modernism.

3. Nathan I. Huggins, *Harlem Renaissance* (London: Oxford University Press, 1971), 115.

4. Sterling A. Brown, *The Negro in American Fiction* (1937; reprint, New York: Atheneum Press, 1969), 132.

5. Johnson, 379, 381–82, 382.

6. Bruce Kellner, *Carl Van Vechten and the Irreverent Decades* (Norman: University of Oklahoma Press, 1968), 195.

7. Bruce Kellner, ed., *Letters of Carl Van Vechten* (New Haven: Yale University Press, 1987), 206.

8. Kellner, *Carl Van Vechten and the Irreverent Decades*, 197.

9. Ibid., 198, 162.

10. Ibid., 212–13.

11. For additional information on Charlotte Mason (Mrs. Rufus Osgood), consult Langston Hughes, *The Big Sea*; Zora Neale Hurston, *Dust Tracks on a Road*; Robert Hemenway, *Zora Neale Hurston*; and Arnold Rampersad, *The Life of Langston Hughes*, vol. 1: *1902–1941*.

12. Bruce Kellner, ed., *The Harlem Renaissance: A Historical Dictionary for the Era* (New York: Methuen, 1984), 171–72.

13. Kellner, *The Harlem Renaissance*, 337–39.

14. Bruce Kellner, ed., *Keep A-Inchin' Along:*

Selected Writings of Carl Van Vechten about Black Art and Letters (Westport, Conn.: Greenwood Press, 1979), 123.

15. Ibid., 121.

16. Ibid., 266–67.

17. Ibid., 275–76.

18. Kellner, *The Letters of Carl Van Vechten,* 199.

19. Ibid., 124.

20. Ibid., 283.

21. Kellner, *Carl Van Vechten and the Irreverent Decades,* 258, 28–29, 271.

22. Ibid., 271–72, 261, 272. It was never Van Vechten's intention to sell for profit or personal gain any of his portraits. Indeed, the terms of Van Vechten's will specify that any money realized from his photography and books after his death be donated to the James Weldon Johnson Memorial Collection.

23. Kellner, *Keep A-Inchin' Along,* 241.

24. The photography collections at the Hammond Museum, the Philadelphia Museum of Art, and Brandeis University were established by Saul Mauriber, Mark Lutz, and Fania Marinoff, respectively, after Van Vechten's death.

25. Kellner, *Carl Van Vechten and the Irreverent Decades,* 261.

The Portraits

Corrected Review

*"The tree is unique, qualitatively speaking, and cannot be subject to purely
quantitative comparison; it is impossible to reduce the world of sense-perceptions
to quantitative categories. Qualitative things do not belong to matter,
which is merely mirror for it, so it can be seen, but not so that it can be
altogether limited to the material plane."*

*"Man is created for the purpose of active participation in Divine Intellect,
of which he is the central reflection."*

From the *source* comes the imagery and language,
compassion and complexity in the *one*
achieved in the imagination conjured,
admired in surrender and transcendence:
where is the *perfect* man?

Words beyond words to conjure this malaise
to infamy and death in effort
immanence forsaken:
to blow the music
maelstrom-tempered.

Our mode is our jam session
of tradition,
past in this present moment
articulated, blown through
with endurance,
an unreaching extended
improvised love of past masters,
instruments technically down:
structured renderings of reality
our final war with self;
rhetoric/parlance arena-word-consciousness:
morality: man to man
man to god
in a tree
more ancient than eden.

Michael S. Harper,
Images of Kin

William Edward Burghardt Du Bois

July 18, 1946

Sociologist, historian, journalist, novelist,
educator, poet, and humanitarian

A native of Great Barrington, Massachusetts, W. E. B. Du Bois (1868–1963) was educated at Fisk University (1885–88). In 1888 he entered Harvard University, where he received his second baccalaureate and later was the first African American to earn the degree of doctor of philosophy from Harvard. As a graduate student, Du Bois studied with the philosopher William James and with the historian Albert Bushnell Hart. Before completing the degree requirements for his doctorate in history, Du Bois studied for two years at the University of Berlin. *The Suppression of the African Slave-Trade to the United States of America, 1638–1870,* Du Bois's doctoral thesis, was published in 1896 as the first volume of the Harvard Historical Studies. In 1894 Du Bois accepted a faculty appointment at Wilberforce University. In subsequent years, he held faculty appointments at the University of Pennsylvania, where he completed *The Philadelphia Negro* (1899), and at Atlanta University. During his twenty-three years of service and teaching at Atlanta University, Du Bois coordinated the annual Atlanta University Studies conferences and established *Phylon,* a journal of race and culture. He wrote or edited thirty-four books, including the classic *The Souls of Black Folk* (1903), which contains his far-reaching theory of African American psychology known as "double consciousness." In the life of Du Bois, scholarship and activism merged in a single stream. From 1905 to 1910, he was cofounder and general secretary of the Niagara Movement, the parent organization of the National Association for the Advancement of Colored People. As a senior staff member of the NAACP, Du Bois was director of publicity and research as well as founder and editor of *Crisis: A Record of the Darker Races,* the organization's weekly publication. As editor of the *Crisis,* he denounced all forms of racial inequality, supported the New Negro movement, and promoted Pan-Africanism. Du Bois's brief membership in the Socialist Party, his travels in the former Soviet Union, and his uncompromising call for full civil rights for African Americans made him the subject of investigations by the federal government. In 1951 he was indicted by a federal grand jury as an "unregistered foreign agent." He was subsequently arrested, tried, and acquitted. In 1961 Du Bois joined the United States Communist party and accepted the invitation of President Kwame Nkrumah of Ghana to supervise the research for the *Encyclopedia Africana.* In the final year of his life, Du Bois became a citizen of Ghana, where he died on the eve of the historic march on Washington.

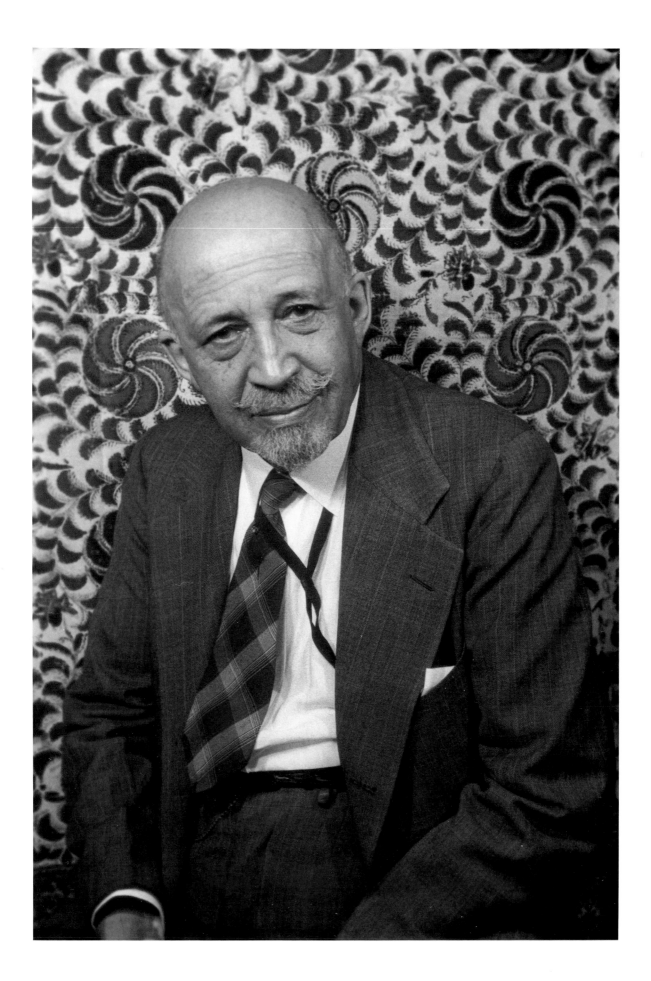

Mary McLeod Bethune

April 6, 1949

Educator and humanitarian

The daughter of former slaves, Mary McLeod Bethune (1875–1955) was born near Mayesville, South Carolina. She began her education at Trinity Presbyterian Mission School, attended Scotia Seminary in Concord, North Carolina, from 1888 to 1894, and spent one year in Chicago studying at Dwight Moody's Institute for Home and Foreign Missions. Bethune began her teaching career at Haines Institute in Augusta, Georgia, where she taught from 1896 to 1897. In 1904 she established the Daytona Educational and Industrial Institute in Daytona Beach, Florida. A school for young African American women, the Daytona Institute offered instruction in reading and mathematics and prepared its students to be teachers. In 1923 the Daytona Institute merged with Cookman Institute of Jacksonville, Florida. This merger produced Bethune-Cookman College, a coeducational school for which Bethune served as president until 1942. Bethune provided national leadership as president of Bethune-Cookman and as president of the National Association of Colored Women from 1924 to 1928. In 1935 she established the National Council of Negro Women. During her fourteen years as president of the NCNW, Bethune championed such causes as equity in federal employment, voter registration, antilynching activities, and involvement in global affairs. The NCNW's emphasis upon global affairs led to Bethune's appointment in 1945 as an adviser to the United States delegation at the founding conference of the United Nations, where she helped create the United Nation's Charter for the Declaration of Human Rights. From 1936 to 1943 Bethune was the director of the Negro Division at the National Youth Administration under President Franklin D. Roosevelt. She was a formidable advocate for equality for her gender and for her race. In September 1920, in the presence of the Ku Klux Klan, Bethune, exercising her rights guaranteed by the Nineteenth Amendment to the Constitution, registered to vote in Daytona Beach. She joined A. Philip Randolph in an unrealized march on Washington, D.C., in 1941, the very threat of which led to Roosevelt's Executive Order 8802, which resulted in the creation of the Fair Employment Practices Commission. Bethune's zeal for equality for African Americans made her the target of federal investigations. In the 1940s she was labeled a "communist" by the House Un-American Activities Committee but was later vindicated of this charge. Bethune's many honors include the Spingarn Award, the highest award of the National Association for the Advancement of Colored People.

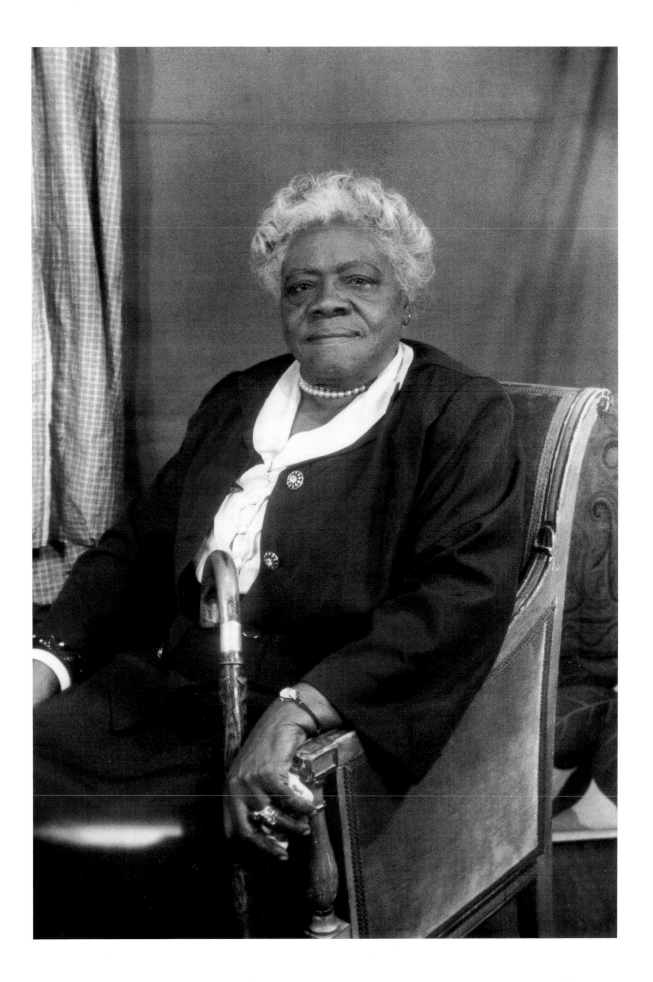

Harry Thacker Burleigh

October 23, 1941

Singer and composer

Harry Thacker Burleigh (1866–1949) attended the National Conservatory of Music in New York City, where he studied voice on a scholarship and met Antonín Dvořák, the director of the conservatory. Burleigh's original and powerful renditions of spirituals greatly impressed Dvořák, who incorporated elements of these sacred songs into his *Symphony no. 9 in E Minor (From the New World).* A renowned baritone, Burleigh was a soloist at St. George's Episcopal Church and a member of the choir of Temple Emanu-El in New York City. The author of *Old Songs Hymnal,* he was a charter member of the American Society of Composers, Authors and Publishers and was the first African American to serve on its board of directors.

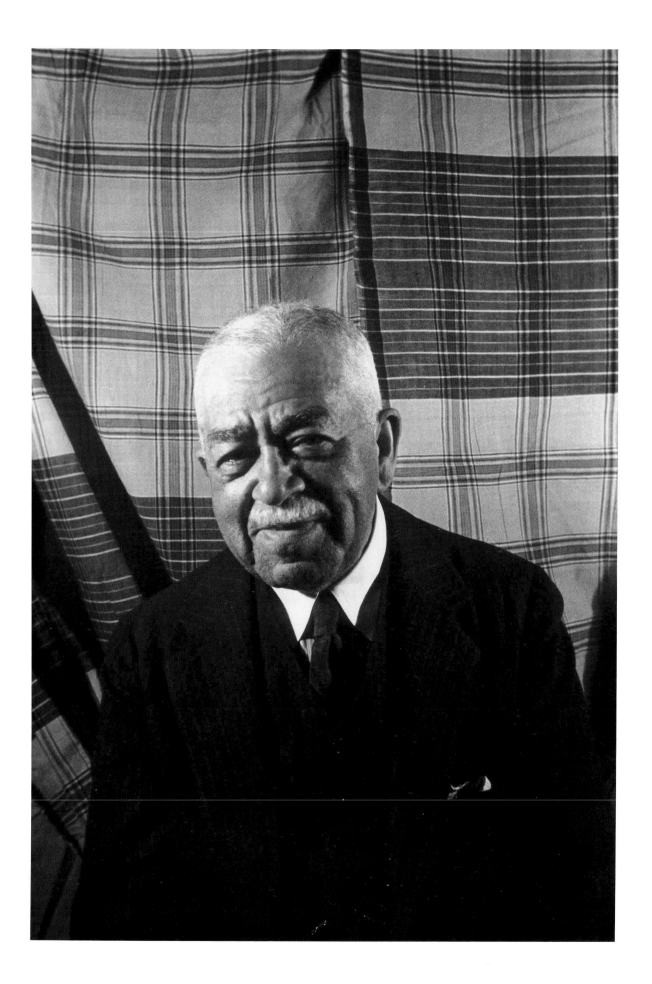

James Weldon Johnson

December 3, 1932

Educator, lawyer, composer, diplomat,
novelist, poet, and humanitarian

James Weldon Johnson (1871–1938) was an alumnus of Atlanta University. While principal of Stanton Elementary School, his alma mater, in Jacksonville, Florida, he studied law and was the first African American admitted to the Florida bar. Deeply interested in international affairs, Johnson served as the United States consul to Venezuela and Nicaragua from 1906 to 1912. In 1916 Johnson joined the National Association for the Advancement of Colored People as its field secretary. In this position, Johnson quadrupled the number of NAACP branches, organized the historic 1917 Silent Protest March in New York City, investigated lynchings, and sought to persuade President Woodrow Wilson to grant clemency to African American soldiers who had been dishonorably discharged for their alleged participation in the Houston Riot of 1917. In 1920 Johnson became the first African American to serve as secretary of the NAACP. Providing national leadership in this position for ten years, Johnson accelerated his campaign against lynching. He was the force behind the Dyer Anti-Lynching Bill of 1921, which was adopted by the United States House of Representatives but because of insufficient votes failed in the Senate. An individual of considerable talents, Johnson was an accomplished composer. In a memorable collaboration with his brother, J. Rosamond Johnson, he wrote "Lift Every Voice and Sing," a song often called the "Negro national anthem." A man of letters, Johnson was the author of several books, including his experimental novel *The Autobiography of an Ex-Coloured Man* (1912); *God's Trombones* (1927), a collection of verse inspired by black folk sermons; *Black Manhattan* (1930), a history of African American life and culture in New York; and *Along This Way* (1933), an autobiography. Johnson was the editor of *The Book of American Negro Poetry* (1921), whose prefaces contain his now famous assessment of dialect poetry, and with his brother, he was the coeditor of *The Book of American Negro Spirituals* (1925) and *The Second Book of Spirituals* (1926). Before his death in a car accident, Johnson was a member of the faculty at Fisk University.

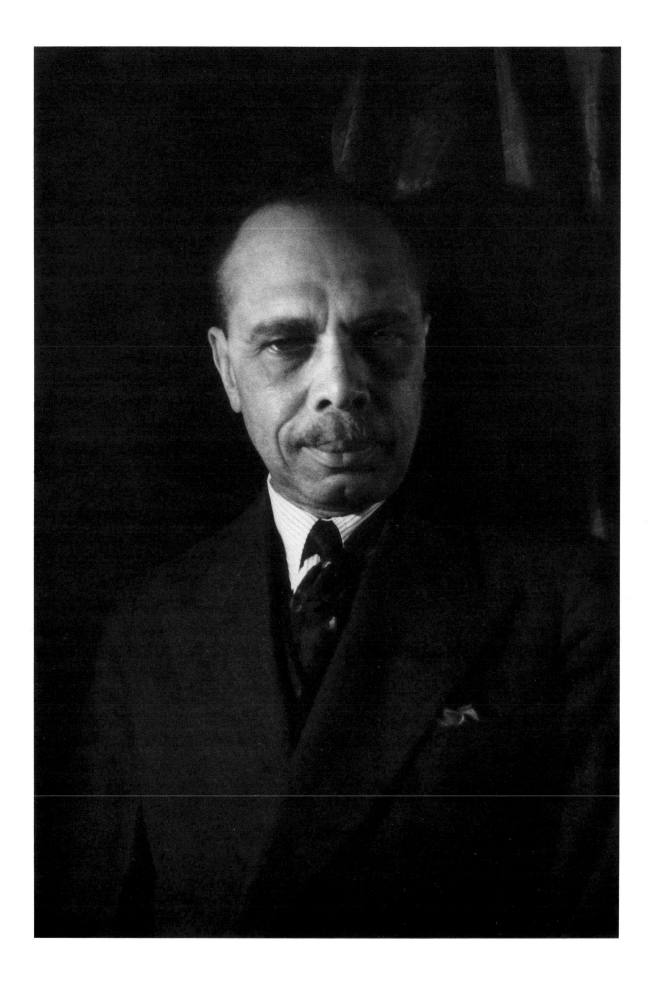

John Rosamond Johnson

April 22, 1932

Musician and composer

John Rosamund Johnson (1873–1954) was trained at the New England Conservatory of Music in Boston, Massachusetts. He collaborated with his elder brother, James Weldon Johnson, to write, among other compositions, "Lift Every Voice and Sing," a song regarded as the "Negro national anthem." The Johnsons composed several musicals with the composer Bob Cole, including *Shoo-Fly Regiment* (1906) and *The Red Moon* (1908). The younger Johnson and Cole composed the music for *Mr. Lode of Kole* (1909), which showcased the dancing and singing genius of the entertainer Bert Williams. Johnson created the role of Frazier in George Gershwin's opera *Porgy and Bess* (1935). He was also choirmaster for and played the part of Brother Green in the film *Cabin in the Sky* (1941). Johnson was the author of two song collections, including *Roll Along in Song* (1937), and, with James Weldon Johnson, was the coeditor of *The Book of American Negro Spirituals* (1925) and *The Second Book of Spirituals* (1926).

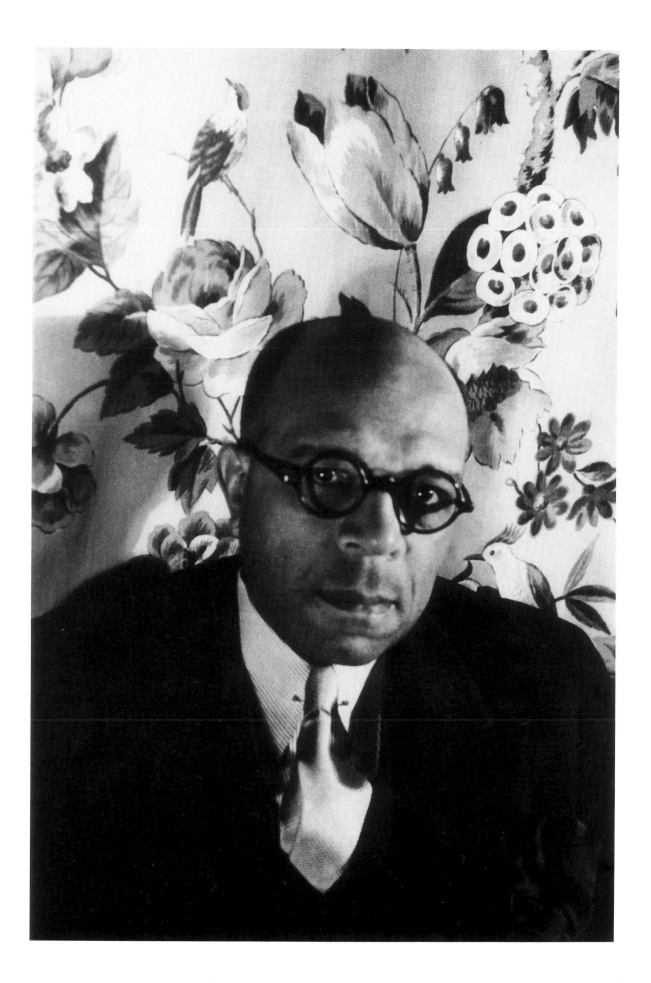

William Christopher Handy

May 24, 1932

Musician and composer

W. C. Handy (1873–1958) is regarded as the "father of the blues," not because he created the blues but because he standardized the blues into the twelve-bar and three-line structure. He studied voice and organ at the Florence District School for Negroes in Florence, Alabama, and received private cornet lessons. After completing his secondary education, Handy toured the South as a cornet soloist and as a singer with the Bessemer Brass Band and Mahara's Minstrels. He taught for a short period at the Teacher's Agricultural and Mechanical College for Negroes in Huntsville, Alabama. The author of such blues classics as "Memphis Blues," "St. Louis Blues," and "Jo Turner Blues," Handy also wrote several books, including *Blues: An Anthology* (1926), *Book of Negro Spirituals* (1938), and an autobiography, *Father of the Blues* (1941).

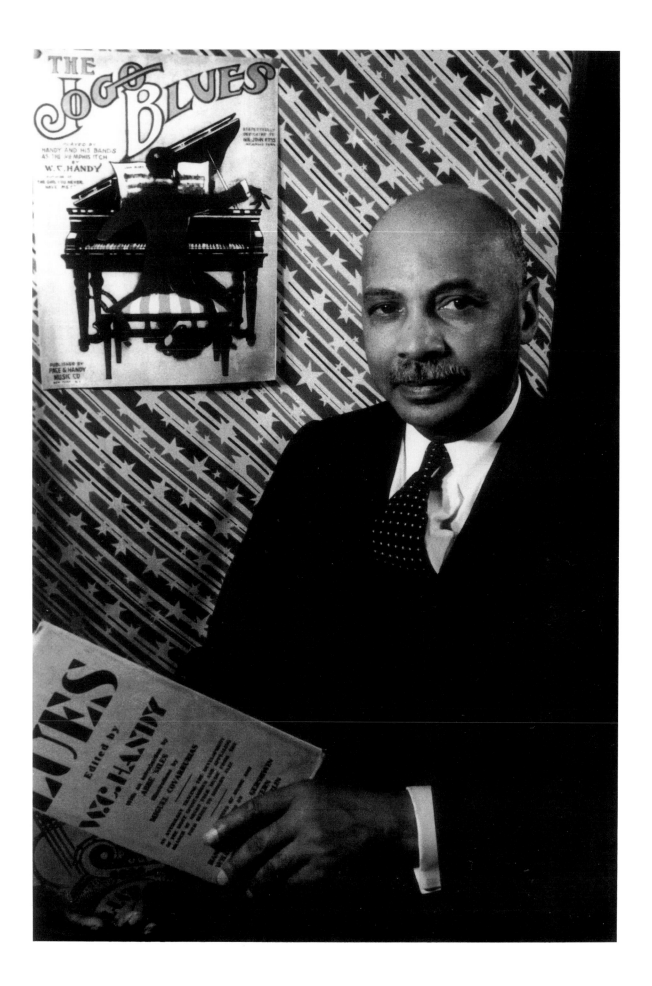

Luther Bill "Bojangles" Robinson

April 18, 1941

Dancer and choreographer

One of America's most popular and beloved dancers of vaudeville, Broadway, and Hollywood, Bill Robinson (1878–1949) learned to dance as a child in the taverns and beer gardens of Washington, D.C. In 1891 he made his New York City debut in *The South Before the War* and established himself as a favorite on the vaudeville circuit. He moved from vaudeville to Broadway to perform in *The Blackbirds of 1928, Brown Buddies* (1930), *Hot from Harlem* (1931), and *The Hot Mikado* (1939). Robinson's three films with Shirley Temple—*The Little Colonel* (1935), *The Littlest Rebel* (1936), and *Rebecca of Sunnybrook Farm* (1938)—established him as a national figure in American dance.

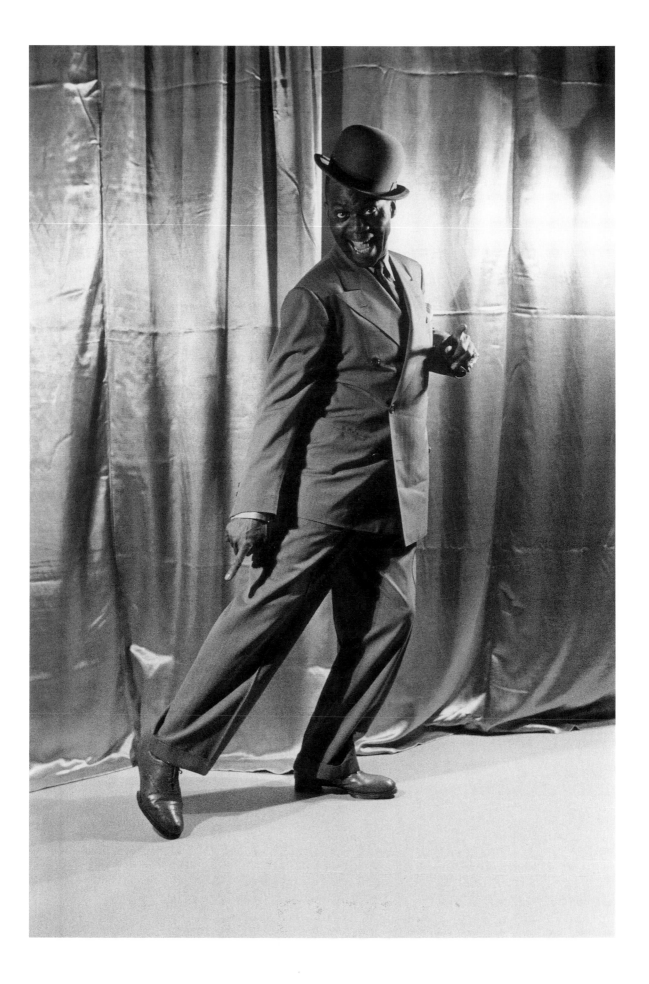

William Stanley Braithwaite

March 27, 1947

Literary critic, poet, and educator

William Stanley Braithwaite (1878–1962) was educated in the public schools of Boston, Massachusetts, and Newport, Rhode Island. From 1934 to 1945, he was a member of the faculty at Atlanta University. He was the author of several books of poetry, including *Lyrics of Life and Love* (1904); the editor of *The Book of Elizabethan Verse* (1906) and other anthologies; and the author of *The House Under Arcturus* (1940), his autobiography. Braithwaite was one of the first established critics of American literature to recognize the artistic achievement and influence of Jean Toomer's *Cane* (1923). Among his many honors are the Spingarn Medal, awarded by the National Association for the Advancement of Colored People, and honorary degrees from Talladega College and Atlanta University.

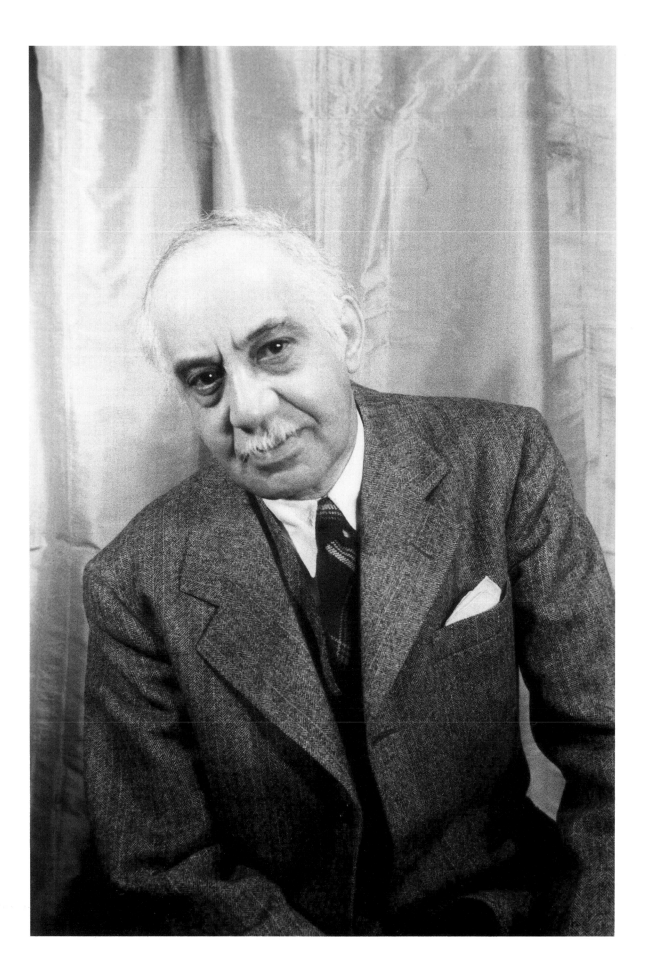

Rose McClendon

November 19, 1935

Actress and director

A pioneer in American theater, Rose McClendon (1884–1936) studied acting on a scholarship at the American Academy of Dramatic Art in New York City. Her first stage appearance was in *Justice* (1919), and she was recognized as an important actress in American theater after her critically acclaimed performance in *Deep River* (1926). An actress of considerable force and range, McClendon was part of the original production of *Porgy and Bess* and appeared in *In Abraham's Bosom* (1926), and in Langston Hughes's *Mulatto* (1935). When not acting, McClendon directed several plays at the Negro Experimental Theater. Firmly committed to a community-based theater that featured the talent of both African American dramatists and actors, McClendon founded, in 1935, with Dick Campbell, a friend and fellow actor, the Negro People's Theater. Ten years after McClendon's death, Carl Van Vechten established the Rose McClendon Memorial Collection at Howard University. This collection of one hundred photographs contains Van Vechten's several portraits of McClendon and other prominent African American artists and writers.

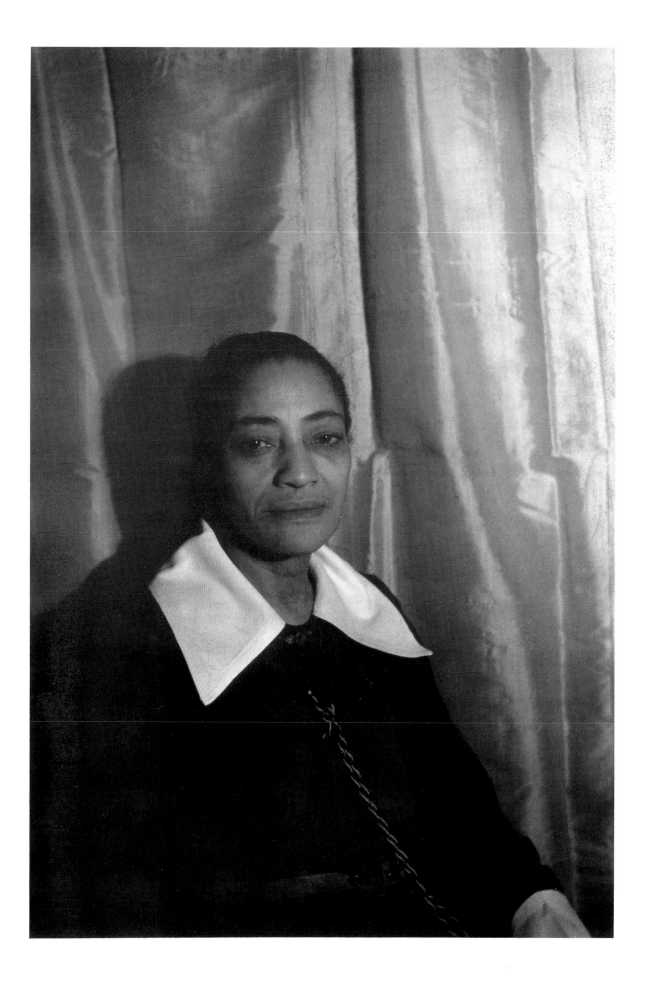

Alain Locke

July 23, 1941

Cultural critic, philosopher, and educator

Alain Locke (1886–1954) attended the public schools of Philadelphia, Pennsylvania, where he graduated from Central High School. He completed his bachelor of arts degree with honors from Harvard College, and in 1907 he was the first African American to receive a Rhodes scholarship. After joining the faculty of Howard University in 1912, Locke returned to Harvard to complete his doctorate in philosophy. Locke is best known for his role as mentor and promoter of the New Negro movement. As the editor of the anthology *The New Negro* (1925), the cultural manifesto of the New Negro movement, he emerged as the principal theorist of an arts movement whose goal was to achieve racial progress by emphasizing the contributions of African Americans to American culture. During his decades of service to Howard University, Locke established the Howard Players, a university theater group, and with Montgomery Gregory, a member of the theater department and director of the Howard Players, edited *Plays of Negro Life* (1927), the first anthology of African American drama. Until his retirement from Howard University in 1952, Locke continued to promote black culture in scores of articles and reviews.

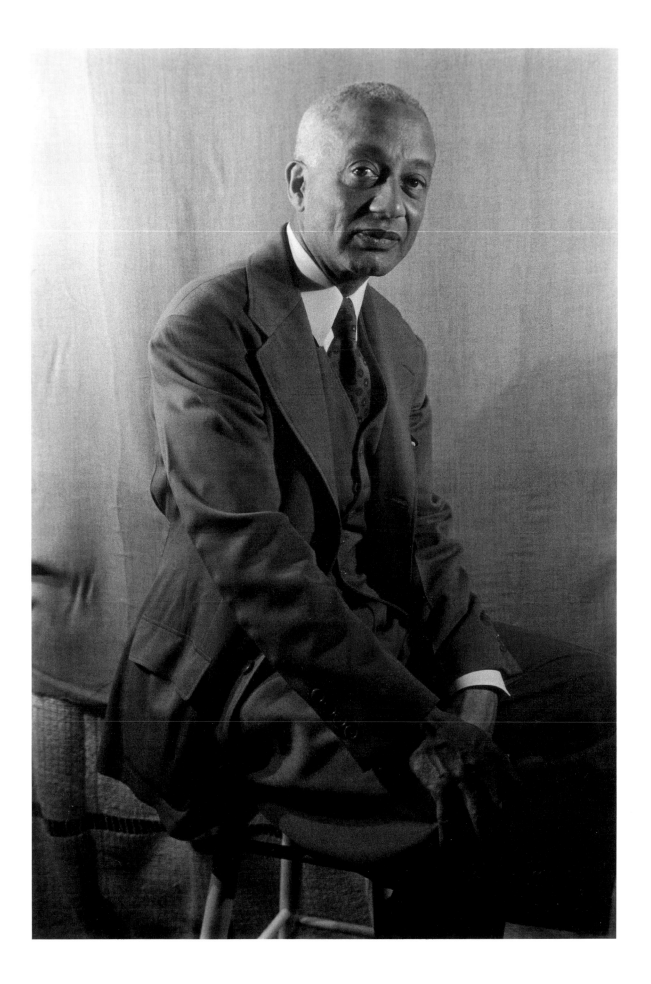

Roland Hayes

January 29, 1954

Opera singer and educator

Roland Hayes (1887–1977), the son of former slaves, was an alumnus of Fisk University. In 1911 he joined the Fisk Jubilee Singers for a series of concerts in Boston, Massachusetts, and remained there to study with Arthur Holland. In 1912 he gave his first recital, at Steinhart Hall in Boston. He later established the Hayes Trio, in which as a tenor he sang with the baritone William Richardson and the pianist William Lawrence, and in 1914 he joined Harry T. Burleigh to perform duets on one of Booker T. Washington's lecture tours. Hayes made his New York City debut at Aeolian Hall in 1917, just months after a sold-out performance at Boston's Symphony Hall. Ever in search of techniques to enlarge the range of his voice and craft, Hayes studied voice in Europe, and as a performer there he earned the respect and admiration of European audiences. Upon returning to the United States, he gave two critically acclaimed solo recitals, one at New York City's Town Hall in December 1923, the other at Carnegie Hall. Hayes toured widely in the United States and was the first African American singer to perform before integrated audiences at Constitution Hall in Washington, D.C., and in the South. Shortly after editing *My Songs: Aframerican Religious Folksongs* (1948), Hayes joined the faculty of Boston University, where he taught voice. Twelve years later, on his seventy-fifth birthday, he sang his final concert, at Carnegie Hall.

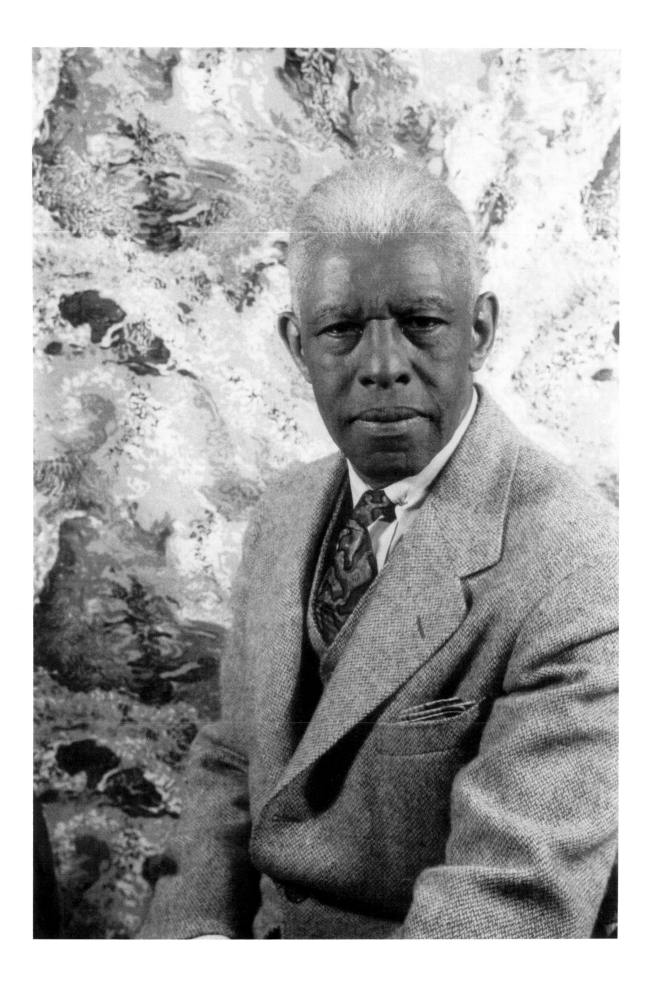

Hall Johnson

May 14, 1947

Choral director and composer

Hall Johnson (1888–1970) began his musical education in Athens, Georgia, as a member of the African Methodist Episcopal church where his father was an elder. Johnson received undergraduate instruction in music at a variety of institutions, including Atlanta University, Allen University, and the Hahn School of Music. He pursued graduate instruction in music at such institutions as the University of Pennsylvania and the University of Southern California. Arriving in New York City in 1914, he played violin with several orchestras and was the violist in the Negro String Quartet, which appeared with Roland Hayes at Carnegie Hall in 1925. Johnson founded the Hall Johnson Choir, which appeared in the film *Cabin in the Sky* (1943), and organized the Negro Festival Chorus of Los Angeles in 1941, as well as the Festival Chorus of New York in 1946. The Hall Johnson Choir represented the United States at the International Festival of Fine Arts in Berlin in 1951. Johnson was a prolific composer, and among his compositions are the cantata *Son of Man,* the operetta *Fiyer,* and many arrangements of spirituals.

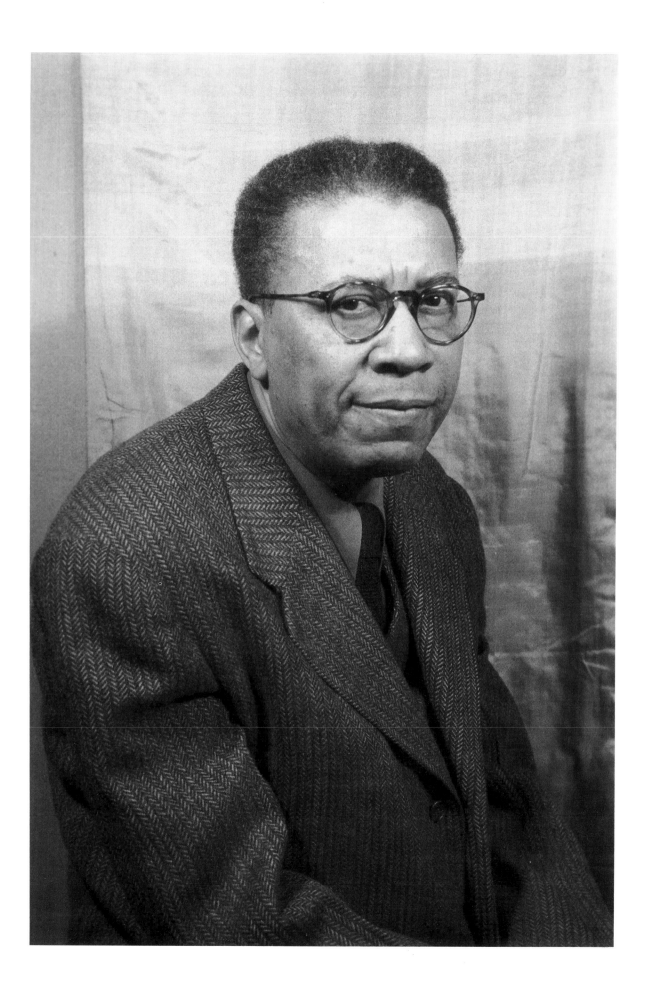

Horace Pippin

February 4, 1940

Painter

A self-taught artist born in West Chester, Pennsylvania, Horace Pippin (1888–1946) achieved a national reputation for his sensitive rendering of war, black domestic life, still lifes, and Biblical scenes. He painted his first oil, *End of the War: Starting Home,* in 1930, and this painting, along with others by him, is now part of the collection in American art at the Philadelphia Museum of Art. Dr. Christian Bernard "discovered" Pippin and arranged for the artist's first exhibition of paintings, at the West Chester Community Center in 1937. In the same year, four of Pippin's oils were included in an exhibition at the Museum of Modern Art in New York. In 1940 Pippin enrolled in art courses at the Barnes Foundation in Merion, Pennsylvania, and shortly thereafter had his first one-man show at the Bignou Gallery in New York City. His work was included in exhibitions at the Carlen Galleries of Philadelphia, the Arts Club of Chicago, and the San Francisco Museum of Art. Along with painting, Pippin experimented with burnt-wood panels.

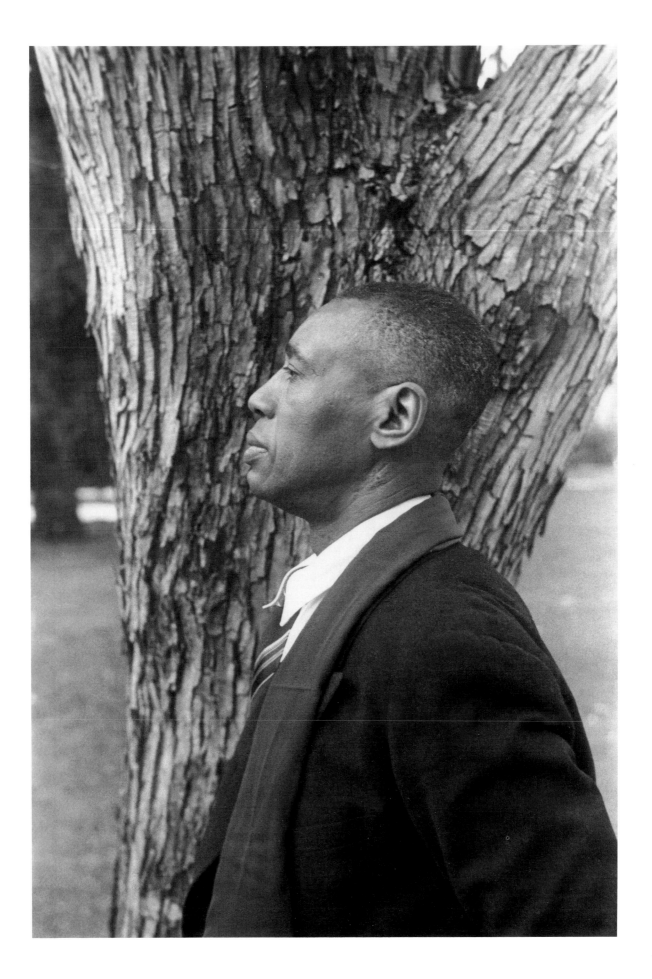

Noble Sissle

November 20, 1951

Actor and composer

Although Noble Sissle (1889–1975) studied for the ministry at Butler University in Indianapolis, Indiana, he is best known as a talented entertainer. After touring with the Thomas Hann Jubilee Singers from 1911 to 1913, Joe Porter's Serenaders until 1915, and, most important, with Eubie Blake from 1915 to 1920 as the Dixie Duo, Sissle applied his considerable talents to composition and performance. In 1921 Sissle and Blake produced their first Broadway musical, *Shuffle Along.* The success of *Shuffle Along,* which featured Josephine Baker, was followed by *Elsie* (1923), *Chocolate Dandies* (1924), which again featured Josephine Baker, and a revival of *Shuffle Along* (1933). Sissle and Blake traveled and performed in Europe as the "American Ambassadors of Syncopation." Of the many songs composed by Sissle, "I'm Just Wild About Harry" is perhaps the most well known. Sissle is credited with having founded the Negro Actor's Guild.

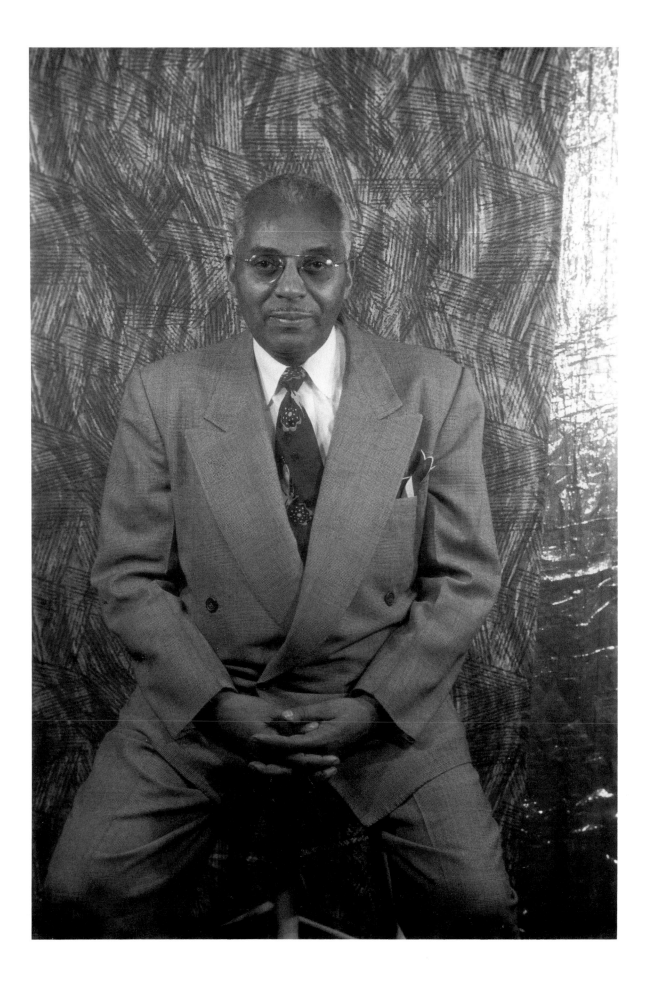

Claude McKay

April 13, 1934

Poet, novelist, and editor

Claude McKay (1890–1948) was born in Jamaica. When he arrived in the United States in 1912 to study agriculture at the Tuskegee Institute and at Kansas State University, he was already the author of two volumes of poetry, *Songs of Jamaica* (1912) and *Constab Ballads* (1912), and had been honored by the Jamaica Institute of Arts and Sciences. He soon discovered that his interest in agriculture did not run as deeply as his interest in writing, and he left Kansas for Harlem in 1914. The publication of his poems in *Seven Arts* brought McKay to the attention of the New York City literati, and his influence among them was enhanced by his position as associate editor for the radical *Liberator*. His reputation as a poet grew with the publication of *Spring in New Hampshire* (1920) and *Harlem Shadows* (1922). He later established himself as an important writer of fiction with the publication of *Home to Harlem* (1928), the first novel by a writer of the Harlem school to achieve the status of a best-seller. In *The New Negro* (1925), Alain Locke identified McKay as an important and promising figure of the "younger generation" of black writers, but McKay was more attracted to the radical politics of the left and was critical of what he regarded as the integrationist and elitist politics of the New Negro movement.

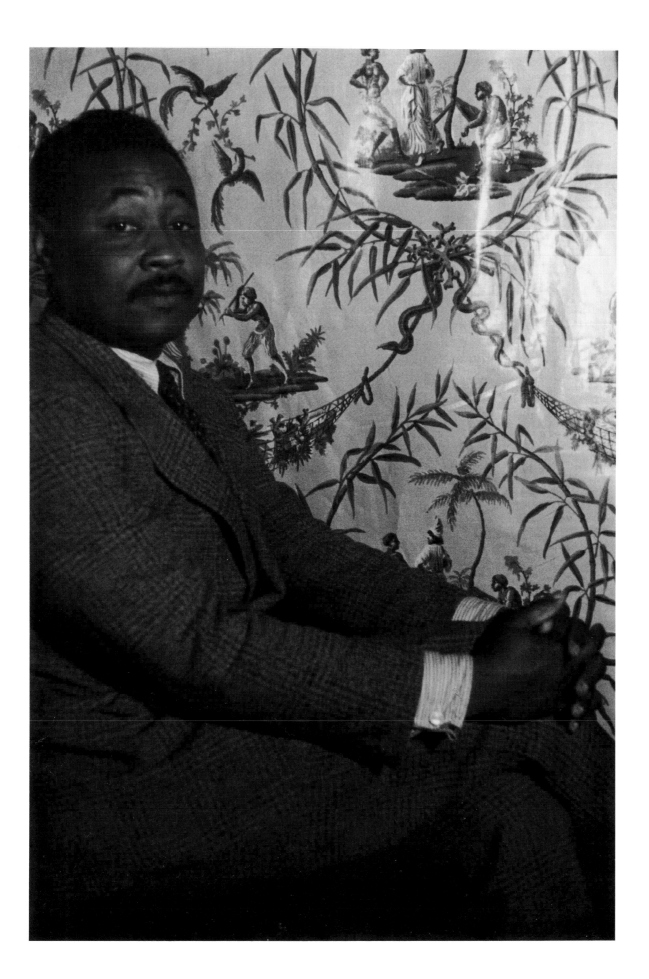

Nora Holt

(Lena Douglas)

August 29, 1937

Music critic and singer

Nora Holt (1890–1974) was an alumna of Western University in her native Kansas and, in 1918, the first African American woman to earn a master of music degree at the Chicago Musical College. She performed in many clubs in Chicago's red-light district while writing reviews as a music critic for the Chicago *Defender*. Later Holt was a music critic for the *Amsterdam News* and the *New York Courier* as well as the host of her own radio program, "The Nora Holt Concert Showcase" on WLIB from 1953 until 1964. She is credited with founding the National Association of Negro Musicians. A glamorous figure during the New Negro movement, Holt was the inspiration for the sultry Lasca Sartoris in Carl Van Vechten's *Nigger Heaven* (1926).

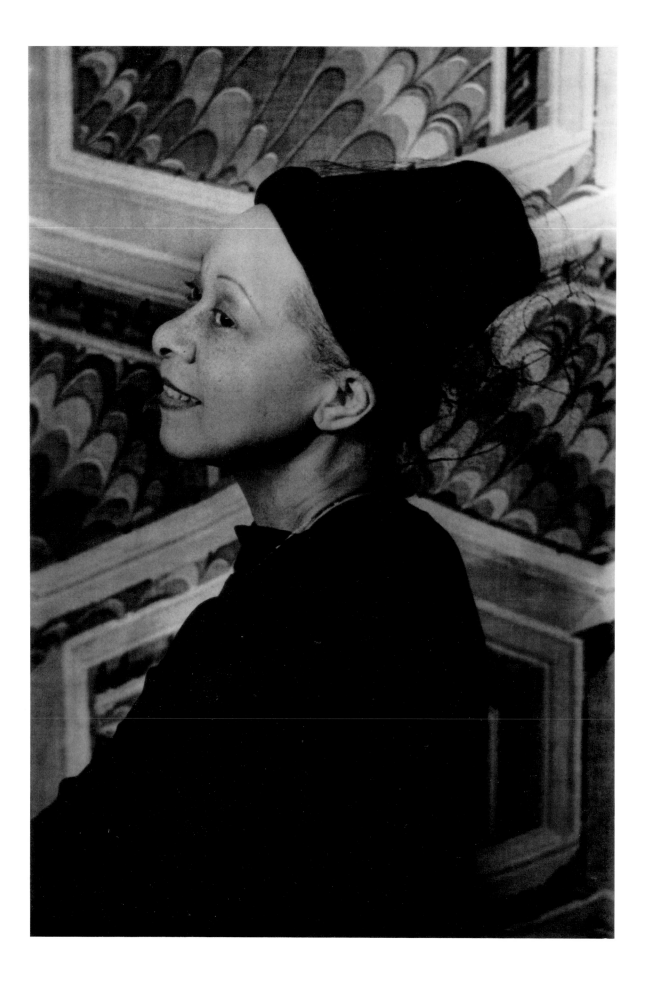

Charles Spurgeon Johnson

January 10, 1948

Sociologist and educator

Along with Alain Locke and the novelist Jessie Fauset, Charles Spurgeon Johnson (1893–1956) is regarded as one of the "midwives" of the New Negro movement. Educated at Wayland Academy in Virginia and at Virginia Union, Johnson completed graduate work at the University of Chicago in 1917. From 1921 until 1928, he was executive director of research and publicity for the National Urban League. During his tenure at the Urban League, Johnson edited the *Urban League Bulletin* and established *Opportunity,* a journal that chronicled the cultural activities of Harlem and featured many of the writers of the New Negro movement. Johnson organized the now legendary Civic Club Dinner of March 1924 to celebrate the publication of Jessie Fauset's novel *There Is Confusion* (1924). In retrospect this particular event marked the ascendancy of the New Negro movement, for the list of guests included Alain Locke, W. E. B. Du Bois, James Weldon Johnson, Countee Cullen, and Langston Hughes. In 1928 Johnson joined the faculty of Fisk University, where for several years he served as its first African American president.

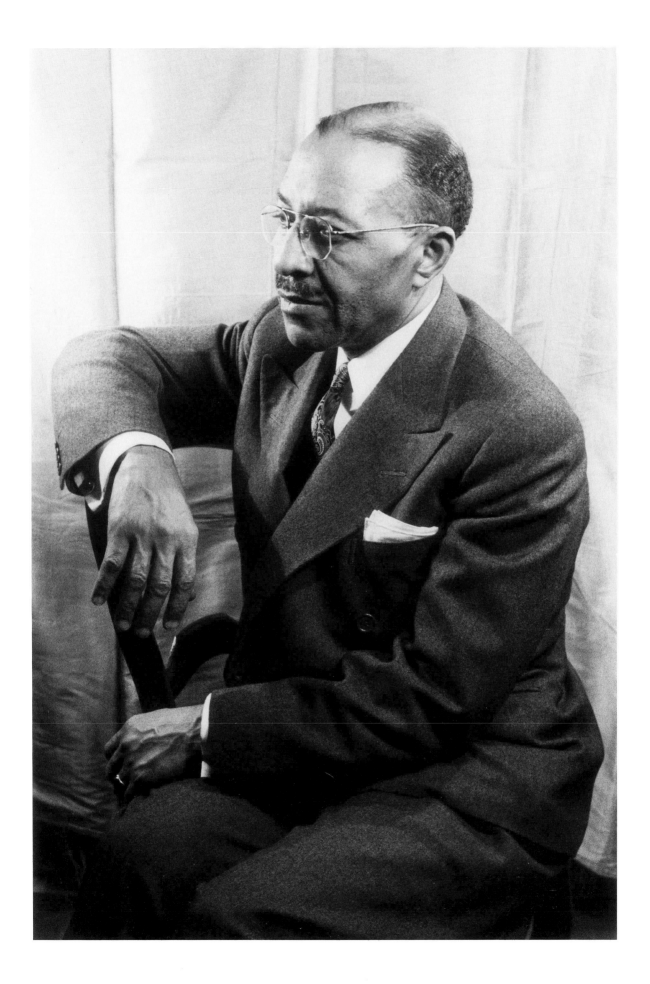

Nella Larsen

November 23, 1934

Novelist, librarian, and nurse

Nella Larsen (1893–1963) studied for one year at Fisk University, completed her training as a nurse at Lincoln Hospital in New York City in 1915, and enrolled in the New York Public Library Training School. During her tenure as the children's librarian at the 135th Street branch of the New York Public Library from 1922 until 1929, she wrote *Quicksand* (1928) and *Passing* (1929). In 1930 Larsen was the first African American woman to receive a Guggenheim Fellowship in creative writing. The award was intended to support the completion of her third novel. Unfortunately this goal was never realized. In 1933 Larsen returned to nursing and was a supervising nurse at Bethel Hospital in Brooklyn, New York, for the remaining years of her life.

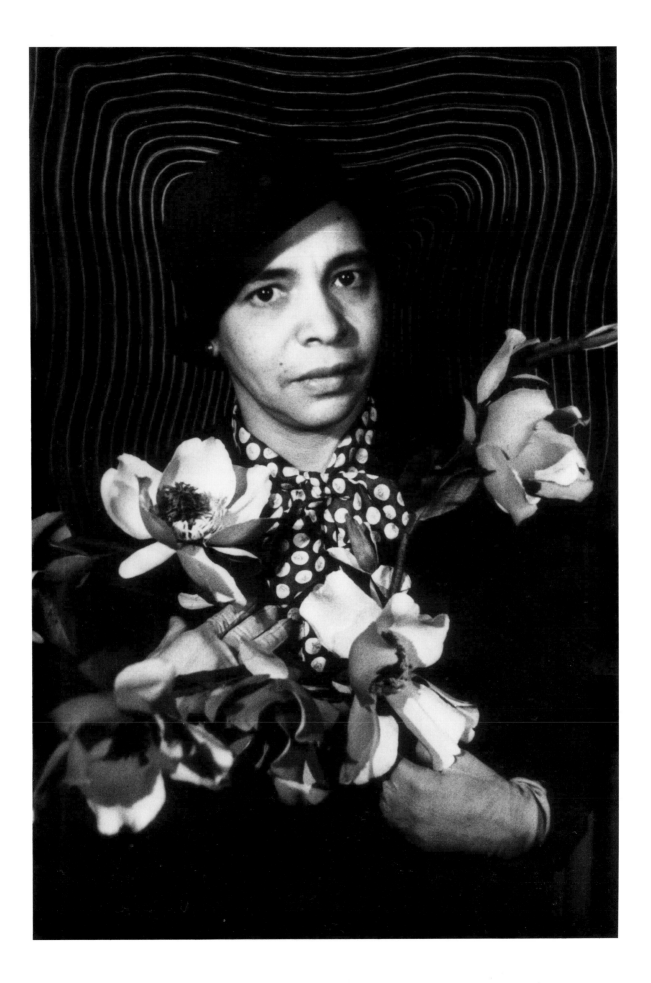

Walter White

August 17, 1932

Humanitarian and novelist

Walter White (1893–1955) graduated from Atlanta University in his native Georgia. Physically white but racially mixed, he identified himself as an African American, and his firsthand knowledge of the effects of segregation in the South made him a tireless proponent of civil rights. Invited by James Weldon Johnson to join the New York staff of the National Association for the Advancement of Colored People, White was appointed assistant executive secretary in 1918. After Johnson's retirement in 1931, White served in the position of executive secretary until his death, when he was succeeded by Roy Wilkins. During White's thirty-seven years of service as a senior staff member of the New York Branch of the NAACP, he was an advocate for civil rights and a supporter of work by African American artists. He promoted the careers of his younger colleagues Thurgood Marshall and Marian Anderson. White was the author of six books, and his *Fire in the Flint* (1924), an impassioned indictment of lynching in the South, made him a celebrity within the Harlem school. After reading *The Fire in the Flint,* Carl Van Vechten arranged to meet White through Alfred Knopf, their publisher. This meeting marked the beginning of many collaborations to advance civil rights and to support the contributions of African Americans to American culture.

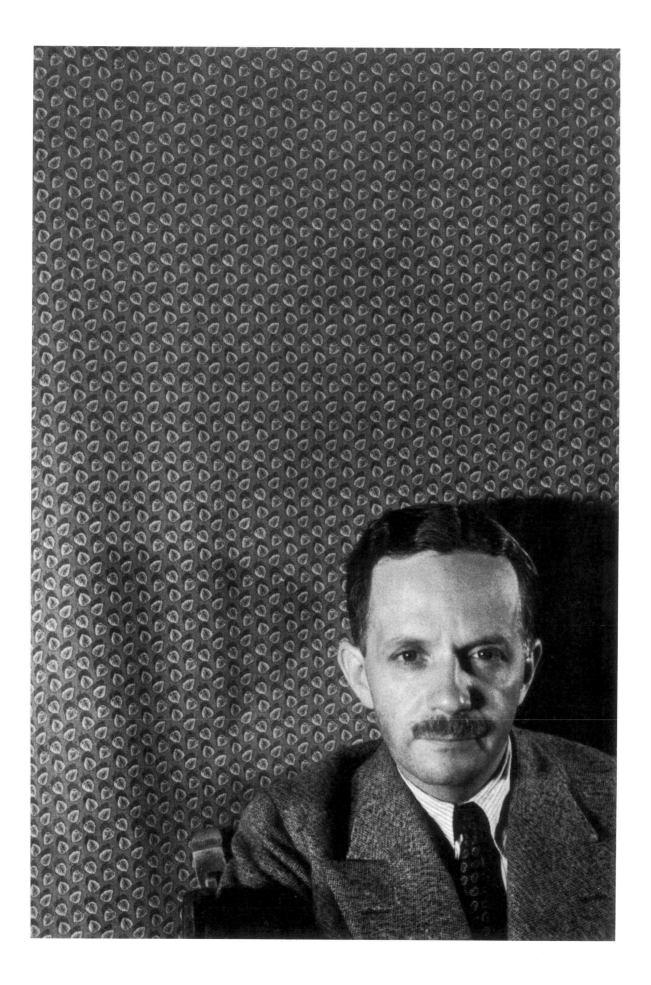

Bessie Smith

February 3, 1936

Blues singer

Remembered as the Empress of the Blues, Bessie Smith (1894–1937) began her career in Moses Stokes's traveling company in 1912. This company included blues giant Ma Rainey, with whom Smith toured again in Fat Chappelle's Rabbit Foot Minstrel Show in 1915. Smith began her recording career at Columbia Records after having been rejected by other recording companies, including the Black Swan Phonograph Corporation, whose board members preferred the voice and singing style of Ethel Waters. Smith's first recording, "Down Hearted Blues/Gulf Coast Blues," was an immediate success and established her as Columbia's most popular and best-selling artist. In the entertainment world, Smith was an impressive and formidable figure. As Empress of the Blues, she ruled members of her troupe with both persuasion and coercion. Absolutely fearless, she once expelled from her camp a group of Ku Klux Klansmen who were determined to destroy her property. Smith appeared in the now famous film *St. Louis Blues* (1929), which featured a choir conducted by J. Rosamond Johnson. In an effort to restore to prominence a career that had suffered a decline, Smith replaced Billie Holiday in *Stars Over Broadway* at Connie's Inn in Harlem in 1936. While touring with *Broadway Rastus* (1937), Smith died in a segregated hospital in Clarksdale, Mississippi, from injuries sustained in a car accident.

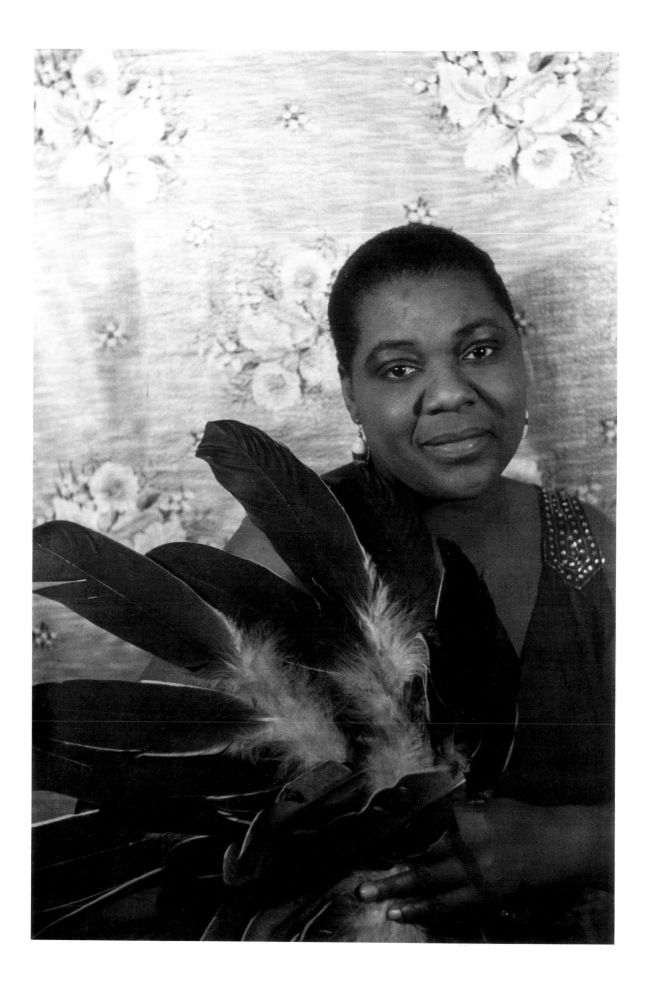

Ada "Bricktop" Smith

June 22, 1934

Jazz singer and nightclub owner

Affectionately called Bricktop because of her freckles and bright red hair, Ada Smith (1894–1984) left her native West Virginia to begin her singing career at Jack Johnson's Chicago Club Du Champ. Later she toured with Florence Mills and Cora Green as the Panama Trio. Like Billie Holiday and Bessie Smith, she was a regular performer at Connie's Inn in Harlem. As a cafe singer in Paris at the nightclub Le Grand Duc, she met Langston Hughes, who was employed there as a dishwasher. Within a year of her first engagement at Le Grand Duc, Smith was managing the club and transformed it into the meeting place for Cole Porter and his International Smart Set. As a nightclub owner, Smith enjoyed considerable success and opened Bricktops in other parts of Paris, in Italy, and in Mexico.

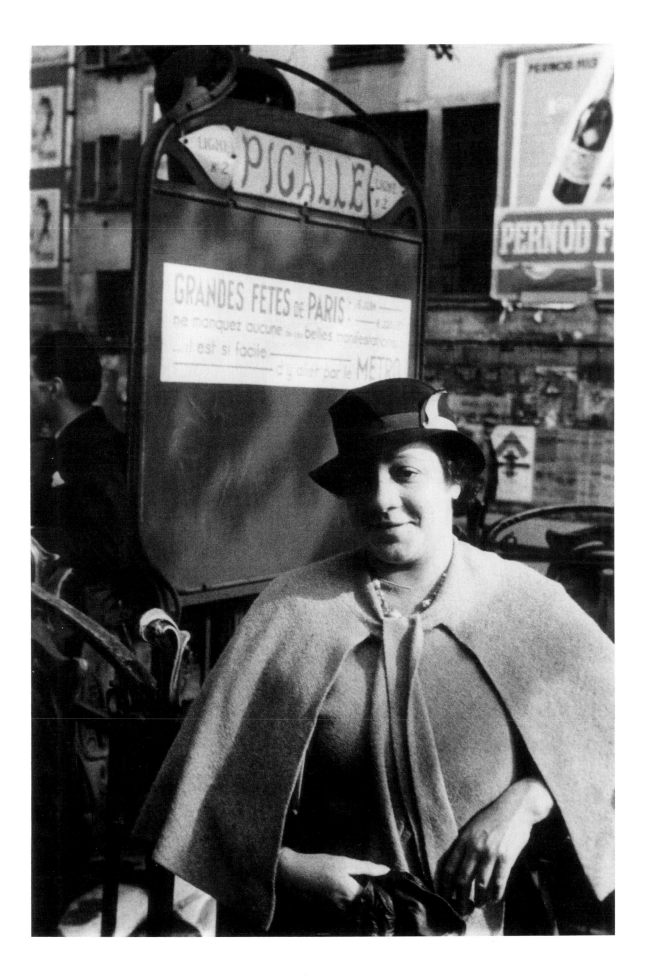

George Schuyler

July 2, 1941

Editor, journalist, and novelist

George Schuyler (1895–1977) attended public schools in Syracuse, New York, but dropped out of high school and enlisted in the army, where he served as a member of the black 25th Infantry Division from 1912 to 1919. He moved to New York City in 1922 and after a period of unemployment joined A. Philip Randolph and Chandler Owens as members of the editorial board of the *Messenger.* Schuyler also wrote columns for the *Pittsburgh Courier* and essays for the *Nation,* the most famous of which is "The Negro-Art Hokum" (1926), in which he dismissed Alain Locke's theories of a distinctive African American art as set forth in *The New Negro* (1925) and argued that an African American was "merely a lampblacked Anglo-Saxon." Proud of his race, Schuyler was suspicious and critical of any movement that would separate African Americans from the mainstream. In "The Negro Artist and the Racial Mountain," which followed Schuyler's essay in the *Nation,* Langston Hughes challenged Schuyler's position and argued that African American artists should develop an art free of the expectations of any audience and ideology. A writer of science fiction, Schuyler was also the author of *Black No More* (1931), the first full-length satire by an African American author. In the final years of his life, Schuyler became a conservative and was an outspoken opponent of both communism and the civil rights movement.

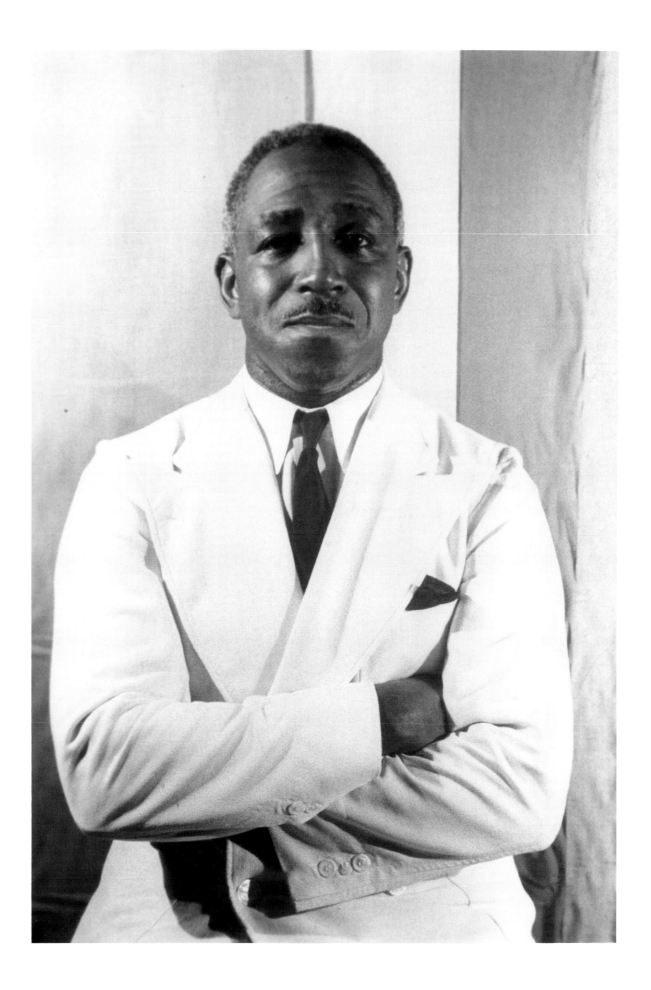

William Grant Still

March 12, 1942

Musician and composer

William Grant Still (1895–1978) studied music at Wilberforce University and Oberlin College and joined W. C. Handy's music publishing firm in New York City as an arranger in 1919 after touring with Handy in Memphis. In 1921 he was appointed musical director of the Black Swan Phonograph Corporation, on whose board of directors sat W. E. B. Du Bois. While in this position, Still played oboe in the orchestra for Eubie Blake and Noble Sissle's *Shuffle Along* (1921) and studied with composers Edgard Varèse and George Chadwick. Of his many compositions, it was *Afro-American Symphony* (1931) that elevated Still to national and international prominence. This symphony was performed by the Rochester Philharmonic Symphony and by the New York Philharmonic at Carnegie Hall and for many years was performed widely in the United States and in Europe. A versatile composer with a wide range of interests, Still composed the film score for *Pennies from Heaven* (1936) and was the musical adviser for *Stormy Weather* (1943). Still's opera *Troubled Island* (1938), to a libretto by Langston Hughes, premiered at the New York City Opera in 1949 and was the first opera by an African American composer to be produced by a major opera company.

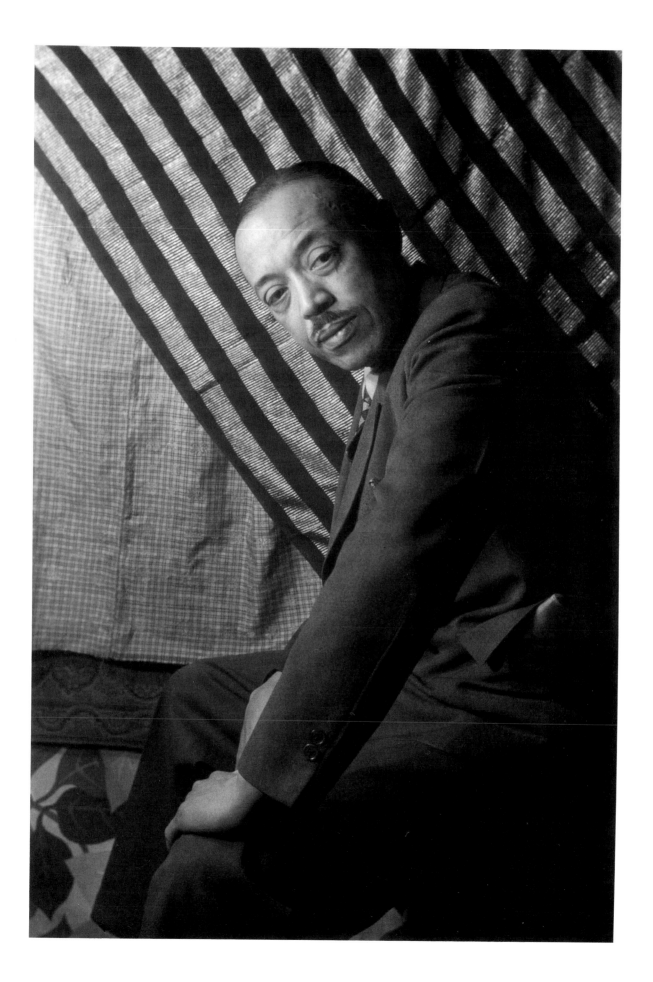

Ethel Waters

August 28, 1938

Singer and actress

Ethel Waters (1896–1977) made her stage debut in 1917 at the Lincoln Theater in Baltimore, Maryland, and later toured in the South playing vaudeville, carnivals, and tent shows. She first performed in New York City at the Lincoln Theater and subsequently at Edmond's Cellar and at the Lafayette Theater in *Hello 1919*. Although Waters's first Broadway musical was *Africana* (1927), her performance in Irving Berlin's *As Thousands Cheer* (1933) firmly established her as a major figure in the American theater. In 1939 Waters made her debut as a dramatic actor as Hagar in DuBose and Dorothy Heyward's *Mamba's Daughters*. As an actress, Waters was a presence in both the theater and the American film industry. Of her several film roles, the most memorable are Petunia in the musical *Cabin in the Sky* (1943) and Berenice in Carson McCullers's *Member of the Wedding* (1950). She began her recording career with Cardinal Records in 1919 and is remembered for such songs as "Dinah," "Am I Blue?" and, most especially, "His Eye Is on the Sparrow."

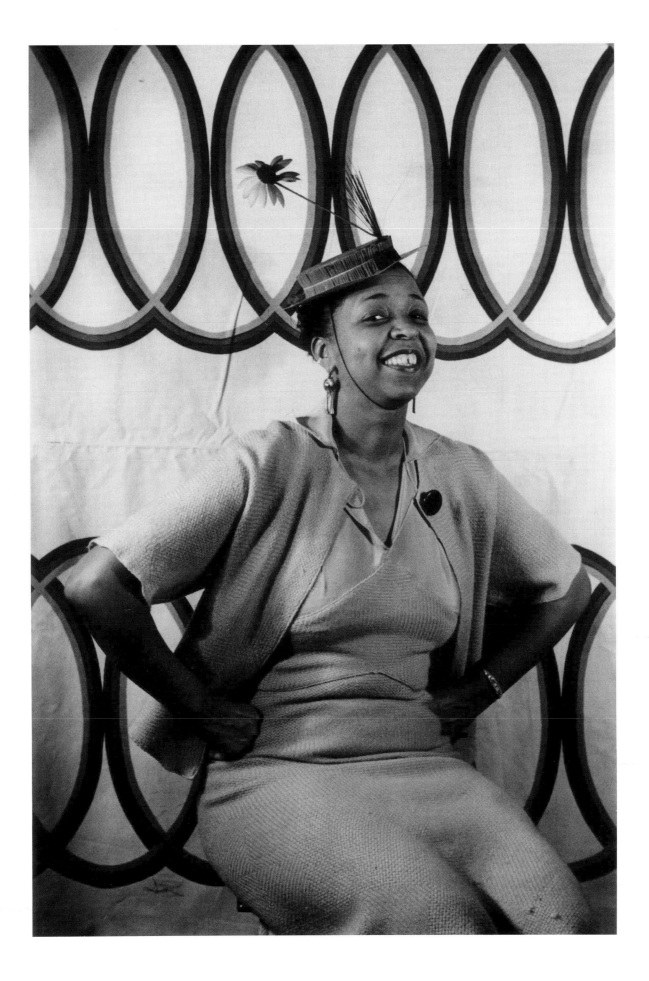

Paul Robeson

June 1, 1933

Actor, athlete, singer, and humanitarian

Paul Robeson (1898–1976) was an alumnus of Rutgers University, where he earned varsity letters in football, baseball, basketball, and track. A member of Phi Beta Kappa, he was twice named to Walter Camp's All-American Football Team. He also attended the Law School of Columbia University. Robeson seemed destined for a career in the law, but his stage debut in Ridgely Torrence's *Simon the Cyrenian* at the 135th Street YMCA in 1921 was the beginning of a long and distinguished career in the theater. Remembered most for his performances in Eugene O'Neill's *Emperor Jones* in 1925 and in *Show Boat* in 1928, Robeson also appeared in *Shuffle Along* (1921) and *Taboo* (1922), where he performed a song by Harry T. Burleigh. Robeson was one of the great interpreters and singers of the spirituals, and his concert of the spirituals with the pianist and arranger Lawrence Brown at the Greenwich Village Theater in 1925 was an enormous success. An actor of impressive range and ability, Robeson appeared as Othello in 1930 at the Savoy Theater in London and six years later as Toussaint in *Toussaint L'Ouverture,* establishing himself as an actor of international importance. Robeson's film debut was in Oscar Micheaux's *Body and Soul* (1924), and one of his last films was *Tales of Manhattan* (1942), which also featured Ethel Waters. Robeson was a powerful advocate for civil rights, and his criticism of the American political and social order and his open admiration of the Soviet Union made him the subject of a government investigation that resulted in the revocation of his passport in 1950. Robeson's last performance in the United States was at Carnegie Hall in 1958.

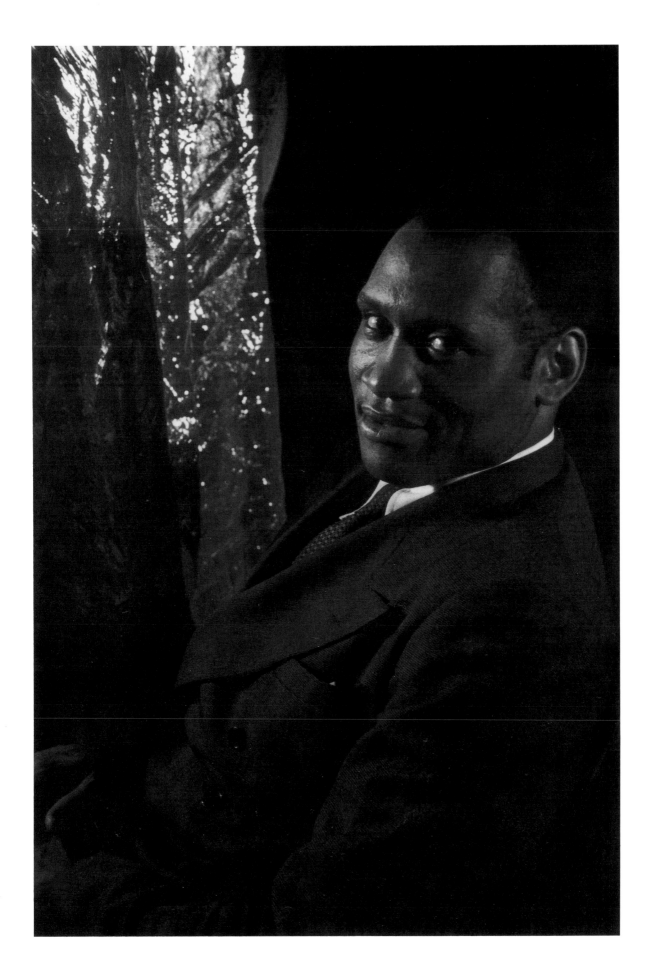

Aaron Douglas

April 10, 1933

Painter, muralist, and educator

A native of Topeka, Kansas, Aaron Douglas (1898–1979) was an alumnus of the University of Nebraska at Lincoln. Soon after his arrival in Harlem in 1924, Douglas met and studied with the German painter Winold Reiss. In 1928 Douglas was awarded a fellowship from the Barnes Foundation, which was established in 1922 by the art collector and philanthropist Albert C. Barnes to promote the study of African art. During his fellowship year he exhibited his works at the Harmon Foundation, a philanthropic trust established in 1922 by William Elmer Harmon, who was persuaded by Alain Locke to support the work of African American artists. Although Douglas, and much later Romare Bearden, was critical of the Harmon Foundation for supporting only African American artists whose works imitated the art produced by mainstream American artists, it was the exhibition sponsored by the Harmon Foundation that brought Douglas's murals and paintings to the attention of a wide audience. Chiefly a muralist and painter, Douglas also designed posters for the Krigwa Players, W. E. B. Du Bois's theater group, and illustrated the books of such authors as Carl Van Vechten, Countee Cullen, James Weldon Johnson, Langston Hughes, and Alain Locke. Douglas's work was also published in various periodicals, including *Vanity Fair,* the *Crisis, Opportunity, Boston Transcript,* and *American Mercury.* Among his public works were murals in the Harlem Branch of the New York Public Library and in the administration building of Fisk University, where he was a member of the faculty from 1937 until his death.

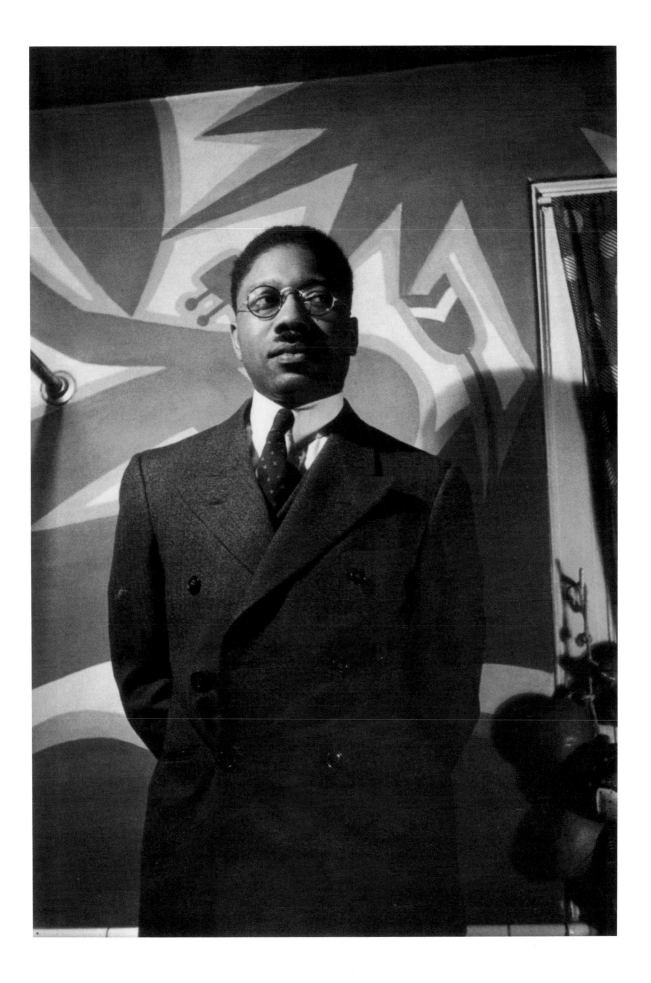

Harold Jackman

September 11, 1932

Educator and philanthropist

Harold Jackman (1900–1960), a middle-school history teacher, was born in London and reared in Harlem. His lifelong friendship with Countee Cullen brought him in regular contact with the major figures of the New Negro movement. Jackman achieved a degree of fame when his portrait by the German artist Winold Reiss was published in the New Negro issue of *Survey Graphic* in March 1925. A presence in the art and literature of the New Negro movement, Jackman was the model for Carl Van Vechten's protagonist in *Nigger Heaven* (1926); he also emerges as a character in Wallace Thurman's *Infants of the Spring* (1932). Jackman was a bibliophile, and his collection of first editions in African American literature and his journals form the nucleus of the Countee Cullen-Harold Jackman Memorial Collection at Atlanta University.

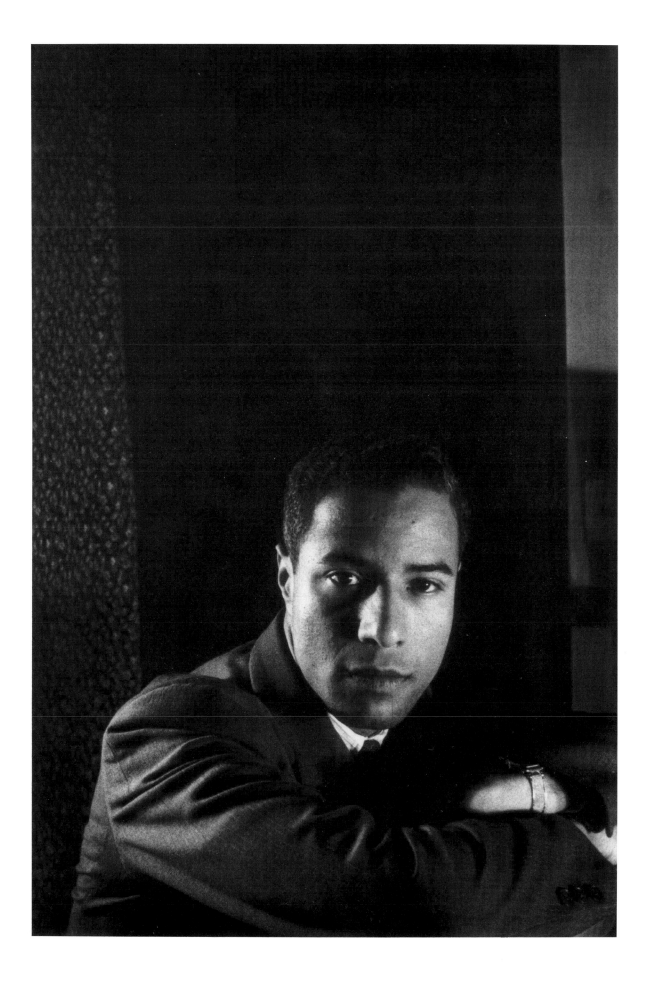

William Henry Johnson

May 4, 1944

Painter and graphic artist

William Henry Johnson (1901–70) left his native Florence, South Carolina, for New York City in 1918. Three years later he was admitted to New York's National Academy of Design, where he studied under Charles L. Hinton. From 1923 to 1926, Johnson studied under Charles Hawthorne at the Cape Cod School of Art in Provincetown, Massachusetts. Maintaining residences in New York City and in Denmark, where he would mature as a painter, Johnson taught at the Harlem Community Art Center and was employed by the Federal Art Project in 1939. A prolific artist whose subject matter ranged from abstract expressionist landscapes and flower studies influenced by Vincent van Gogh to abstract figure studies in the manner of Georges Rouault, Johnson had his first solo exhibition at the Peter White Public Library in Marquette, Michigan, in 1930. Using black subjects, he explored Christian themes, and some of his most important works are *Nativity* (1939), *Lamentation* (1939), and *Mount Calvary* (1939). Through the years Johnson's paintings have been shown at major museums and galleries in such cities as Chicago, Washington, D.C., Paris, and Stockholm.

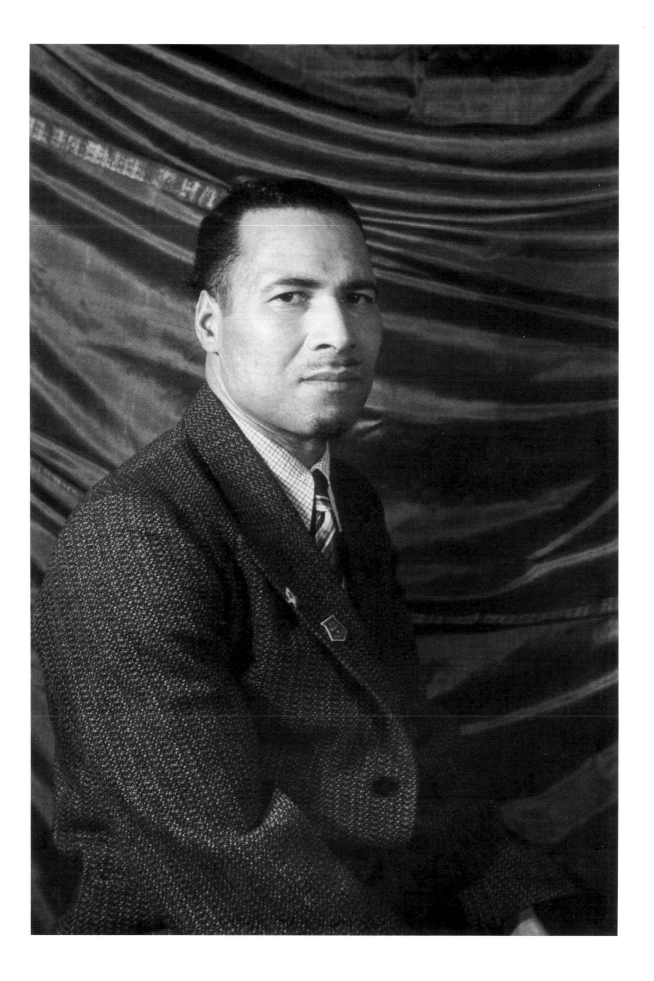

Roy Wilkins

May 27, 1958

Journalist and humanitarian

Roy Wilkins (1901–81) attended public schools in St. Paul, Minnesota. In 1923, with a major in sociology and a minor in journalism, he received his bachelor's degree from the University of Minnesota and began his career as an editor for the *Kansas City* (Mo.) *Call,* an African American weekly. In 1934, after serving as assistant executive secretary of the National Association for the Advancement of Colored People for three years with Walter White, Wilkins succeeded W. E. B. Du Bois as editor of the *Crisis* magazine. Following the death of Walter White in 1955, Wilkins assumed the position of executive secretary of the NAACP and served the nation in this position for twenty-two years. A forceful and judicious advocate for civil rights during the civil rights movement, Wilkins was honored by the NAACP in 1964, when he was awarded the Spingarn Medal, established in 1914 by Joel E. Spingarn, chair of the board, treasurer, and president of the NAACP, to honor the highest and noblest achievement of an African American.

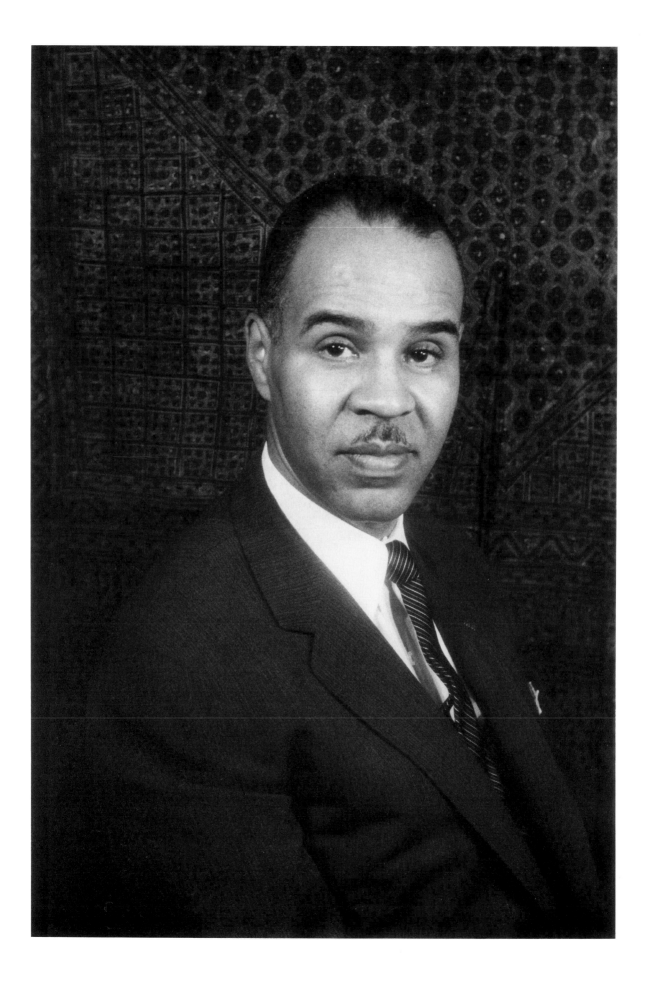

John Wesley Work, Jr.

April 26, 1947

Composer and educator

John Wesley Work, Jr. (1901–67), born in Tennessee, received his undergraduate training in music there at Fisk University in Nashville. He earned graduate degrees in music from Columbia and Yale universities. After a two-year Rosenwald fellowship from the Julius Rosenwald Foundation, Work pursued advanced studies in music at the Juilliard Institute of Musical Art and returned to Fisk University as chair of the music department. Like those of his father, John W. Work, Sr., who studied at Harvard University and was a member of the faculty at Fisk University, Work's musical tastes and compositions resided chiefly within the sacred tradition of African American music. Some of Work's most important compositions are *Yenvalou,* for string orchestra; *Isaac Watts Contemplates the Cross,* a choral cycle; *The Singers,* a cantata; and the hymns "Go Tell It on the Mountain" and "My Lord, What A Morning."

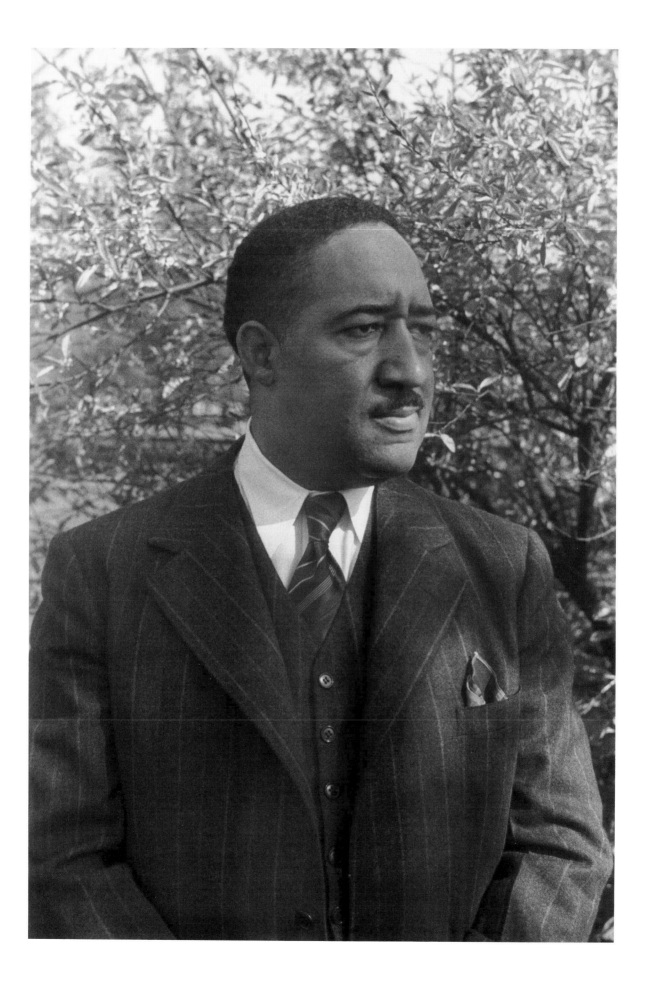

Richmond Barthé

March 1, 1933

Sculptor

A native of Mississippi reared in Louisiana, Richmond Barthé (1901–89) began drawing at the age of six. He was initially interested in drawing and painting, but as a student at the Chicago Art Institute, he was introduced to sculpture, which quickly became a lifelong passion. In 1928 Barthé received a Harmon Award and the first of two Rosenwald fellowships, which provided him with the leisure and the resources to develop and refine his impressive talents as a sculptor. One of his best-known works is the highly stylized *Feral Benga,* a dancing nude male figure in bronze. Among his public works are monuments of Pierre Dominique Toussaint L'Ouverture and Jean Jacques Dessalines commissioned by the government of Haiti. After James Weldon Johnson's death in a car accident in 1938, Barthé was commissioned to execute a memorial to him, but because of the unavailability of bronze during World War II this project was never realized. He was a prolific artist whose work and example influenced the artistic development of the painter Jacob Lawrence, and his works are part of the permanent collection of such libraries and museums as the Schomburg Collection of the New York Public Library, the Metropolitan Museum of Art, the Whitney Museum of American Art, and the Smithsonian Institution.

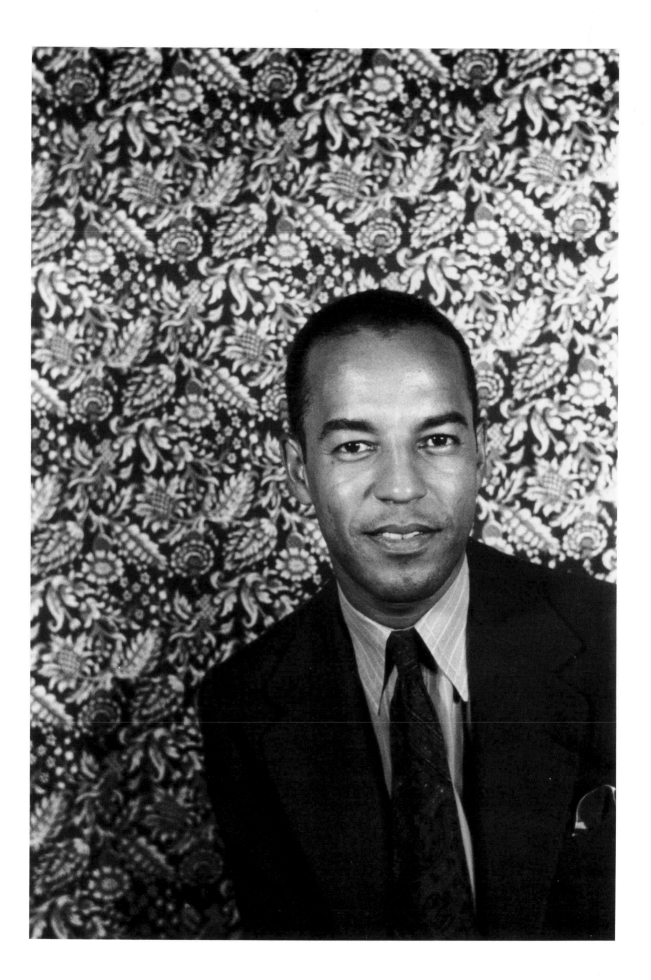

Zora Neale Hurston

April 3, 1935

Anthropologist, folklorist, and novelist

Zora Neale Hurston (1891–60) left her native Florida to study at Morgan State University (then Morgan Academy), Howard University, where she studied with Alain Locke, and Barnard College, where she earned her bachelor's degree. She undertook doctoral study in anthropology and folklore at Columbia University and there met the anthropologist Franz Boas, but she left Columbia before completing the requirements for the doctorate. As a member of the "younger generation" of writers of the New Negro movement, Hurston and her intellectual interests were supported and encouraged not only by Alain Locke but also by Charles S. Johnson, who published Hurston's earliest works of fiction in *Opportunity*. A glamorous and somewhat controversial figure of the New Negro movement, Hurston enjoyed a friendship with Langston Hughes until their disagreement over the authorship of the play *Mule Bone* resulted in charges of plagiarism on both sides. Like many other members of the New Negro movement, Hurston appeared in Wallace Thurman's novel *Infants of the Spring* (1932)—as Sweetie Mae Carr. Evident in her writing is the enormous breadth of Hurston's intellect. *Mules and Men* (1935), containing an introduction by Boas, is a classic work in folklore studies, and *Their Eyes Were Watching God* (1937), although initially dismissed by Richard Wright as a minor work because of Hurston's decision to explore the subjects of love and marriage, is one of the most written about and widely taught novels in American literature.

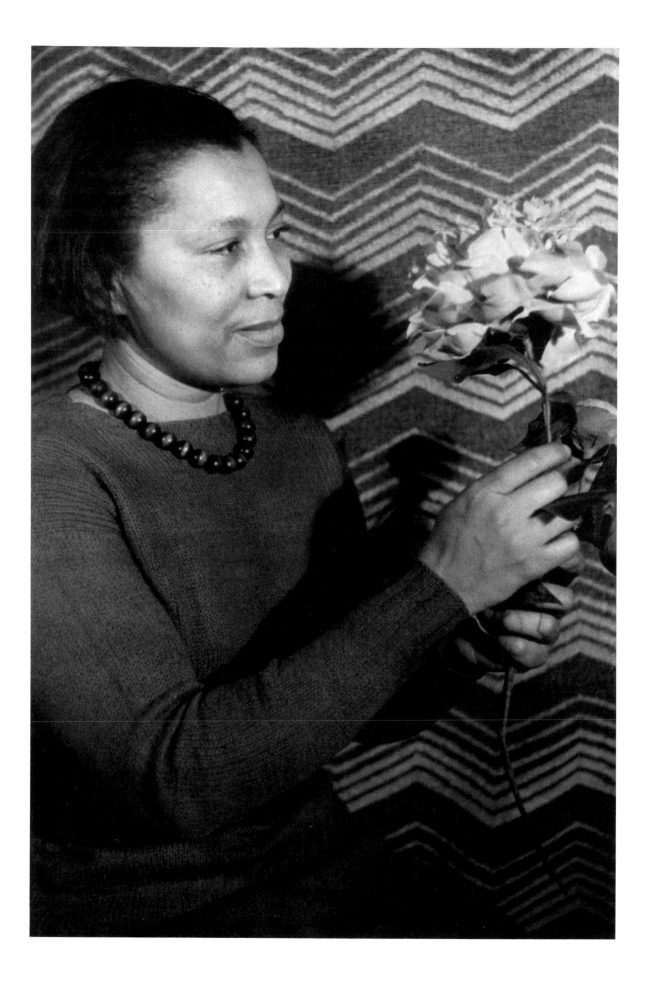

Langston Hughes

(James Langston Hughes)

June 11, 1942

Poet, fiction writer, and dramatist

Langston Hughes (1902–1967), one of the best-known and most widely read poets of this century, attended Central High School in Cleveland, Ohio. He began his higher education at Columbia University in 1922 but was soon swept away by the glamour of nearby Harlem as well as by the excitement of the New Negro movement. In 1929 the young author of "The Negro Speaks of Rivers," a poem Hughes dedicated to W. E. B. Du Bois, received his baccalaureate from Lincoln University. Between the years 1922 and 1929, Hughes's first poems appeared in the *Crisis, Opportunity,* and *Vanity Fair,* and his first books of poetry, *The Weary Blues* (1926) and *Fine Clothes to the Jew* (1927), were published with the assistance of Carl Van Vechten. In his landmark essay "The Negro Artist and the Racial Mountain," which appeared in the *Nation* in 1926, Hughes expressed the yearnings and artistic position of the "younger generation" of writers associated with the New Negro movement. Hughes enjoyed friendships with many writers of the New Negro movement, most notably Arna Bontemps, his collaborator on many projects, and Zora Neale Hurston, with whom he was never able to reconcile after a dispute with her over the authorship of the play *Mule Bone.* A prolific writer who distinguished himself in fiction, opera, drama, translation, gospel song-plays, folklore, history, autobiography, children's literature, and humor Hughes had a long career that cannot be confined to the New Negro movement. During the 1940s and 1950s, he continued to explore with humor and insight the condition of African Americans through the character of Jess B. Simple, who first appeared in the pages of the *Chicago Whip.* Hughes's predisposition for experimentation forcefully expressed in *The Weary Blues* was given fuller expression in *Montage of a Dream Deferred* (1951): in his first volume of poems Hughes masterfully adapted the blues to verse; in the later volume of poems he expertly joined the rhythms of bebop with verse that captured the diversity and vitality of Harlem. For his contributions to the evolving tradition of African American letters, Hughes received many awards and honors, including the Spingarn Medal from the National Association for the Advancement of Colored People, induction into the National Institute of Arts and Letters, and an honorary degree from Howard University.

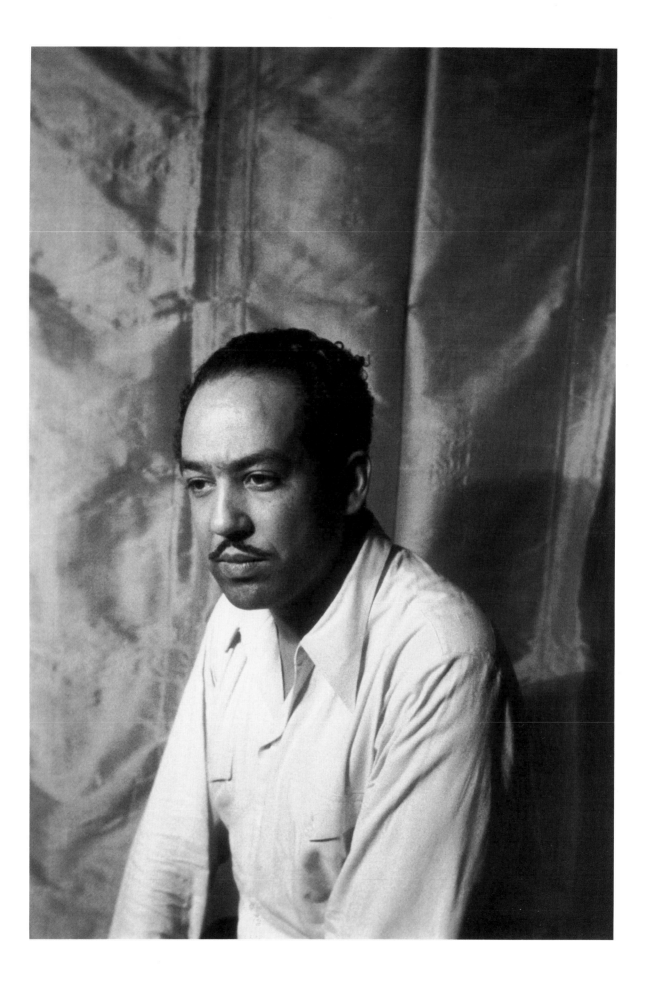

Arna Bontemps

August 15, 1939

Writer, educator, and librarian

Arna Bontemps (1902–73) attended the San Fernando Academy in Los Angeles, California, and in 1923 completed study for his baccalaureate at Pacific Union College. In 1924 he left Los Angeles for Harlem, where he soon met the major figures of the New Negro movement, among them Langston Hughes, with whom he developed a productive and lifelong friendship. Bontemps's early verse appeared in the *Crisis* and *Opportunity,* and he received prizes and awards from both periodicals. In 1930 he accepted his first teaching appointment in the South at Oakwood School in Huntsville, Alabama. In the following year, his first novel, *God Sends Sunday,* was successfully published and soon after came *Black Dust* (1936) and *Drums at Dusk* (1939). After completing his training in library science at the University of Chicago, Bontemps was appointed head librarian at Fisk University, a position he held for twenty-two years. From 1969 to 1972, he was curator of the James Weldon Johnson Memorial Collection of Negro Arts and Letters at Yale University. In the last year of his life, Bontemps was writer-in-residence at Fisk University.

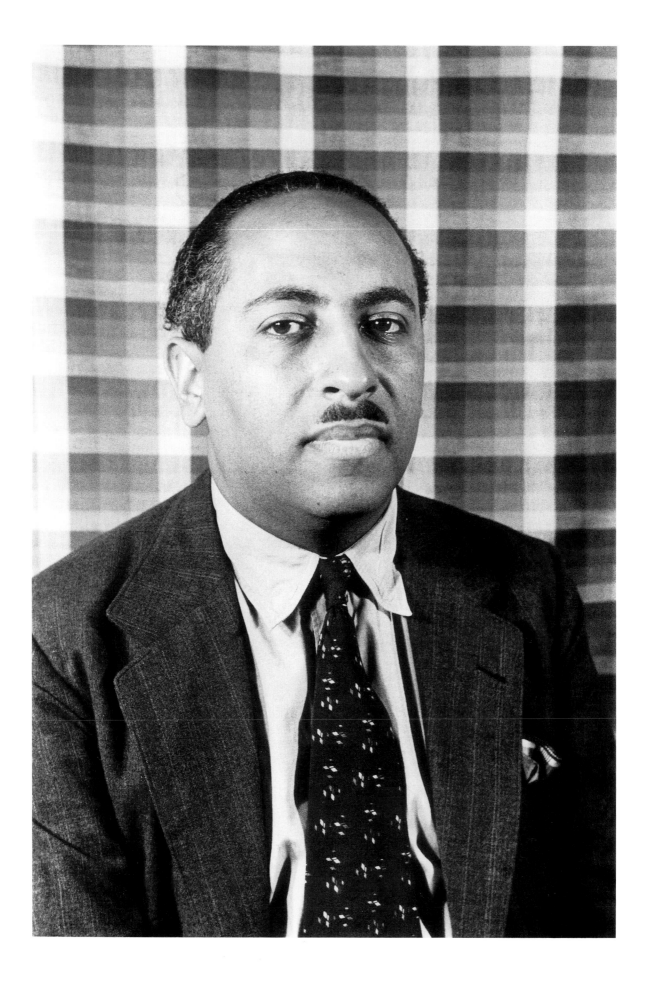

Marian Anderson

January 14, 1940

Opera singer

Although Marian Anderson (1902–93) was singing in church choirs at age six, her formal training in music and singing did not begin until her junior year at William Penn High School in her native Philadelphia, when she began studying with Mary Patterson. Anderson acquired considerable experience in her many recitals and concerts in Philadelphia and performed with Roland Hayes while she was still a teenager. With the sponsorship of Union Baptist Church, where she was a member, Anderson continued vocal studies with Giuseppe Borghetti. Soon afterward Anderson won a vocal competition sponsored by the New York Philharmonic Symphony. This achievement was followed by recitals at Town Hall in New York City and at Witherspoon Hall in Philadelphia. With the support of a Julius Rosenwald Foundation fellowship, Anderson went to Europe to continue her vocal studies, and her recital in Salzburg, Austria, won her the enthusiastic praise of Arturo Toscanini. Although Anderson's success in Europe established her as a major figure in the opera world, the Daughters of the American Revolution in 1939 refused to give her permission to sing in Constitution Hall in Washington, D.C. Stunned by the decision of the D.A.R. to uphold segregation, Eleanor Roosevelt arranged for Anderson to give a performance on the steps of the Lincoln Memorial to an audience of seventy-five thousand people. It turned out to be one of Anderson's most memorable concerts. In 1955, Anderson became the first African American singer to appear with the Metropolitan Opera Company in her role as Ulrica in Verdi's *Un Ballo in Maschera.*

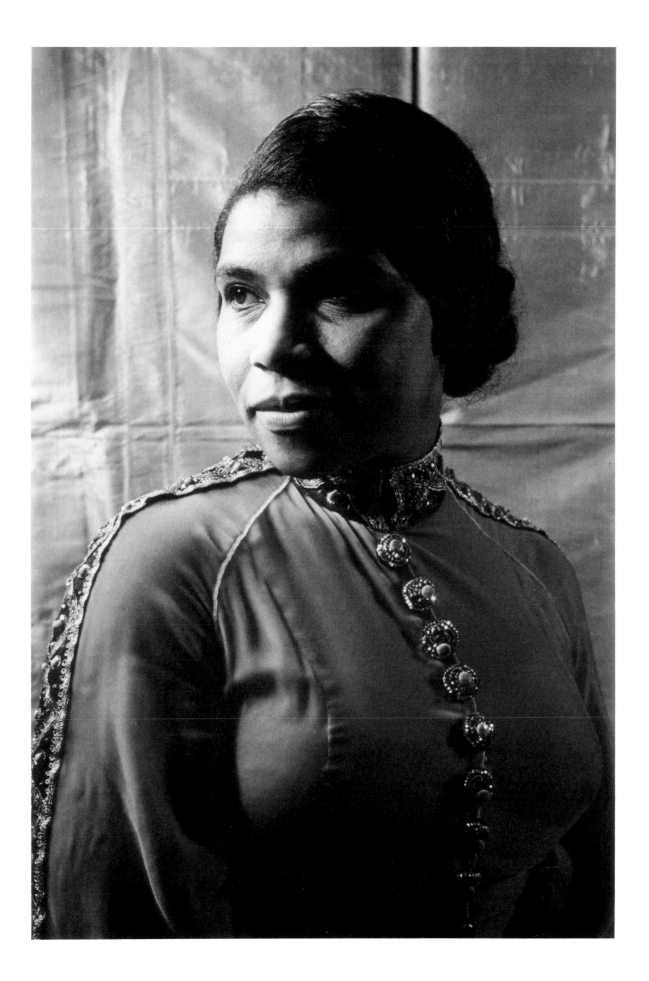

Countee Cullen

September 20, 1941

Poet

While still an undergraduate at New York University, Countee Cullen (1903–46) earned national recognition as a poet when he was awarded the Witter Bynner Poetry Prize. His first volume of poetry, *Color* (1925), was published while he was a graduate student at Harvard University. The book quickly established Cullen as the most important poet of the "younger generation" of writers associated with the New Negro movement, but this distinction soon passed to Langston Hughes, to whom Cullen confided his concerns about being identified as a "Negro poet." Cullen's great admiration of the English Romantic poets is reflected in "Heritage," perhaps his most widely anthologized poem. Without the bitterness of Wallace Thurman's *Infants of the Spring* (1932), Cullen's novel *One Way to Heaven* (1932) captured some of the excitement of the New Negro movement. In 1928, when Cullen married Nina Yolanda Du Bois at the Salem Methodist Episcopal Church in New York City, he became the son-in-law of W. E. B. Du Bois. The ceremony was performed by the Reverend Frederick Ashbury Cullen, the church's pastor and Cullen's foster father. Langston Hughes and Arna Bontemps were ushers, and Harold Jackman, Cullen's best friend, was the best man. The wedding was, perhaps, the second-most important social event of the New Negro movement (the first being the Civic Club Dinner of March 1924 honoring the literary achievements of the writers of the New Negro movement), but the marriage between Nina Du Bois and Cullen ended in divorce in 1930. A year before his death, Cullen published his collected poems *On These I Stand.*

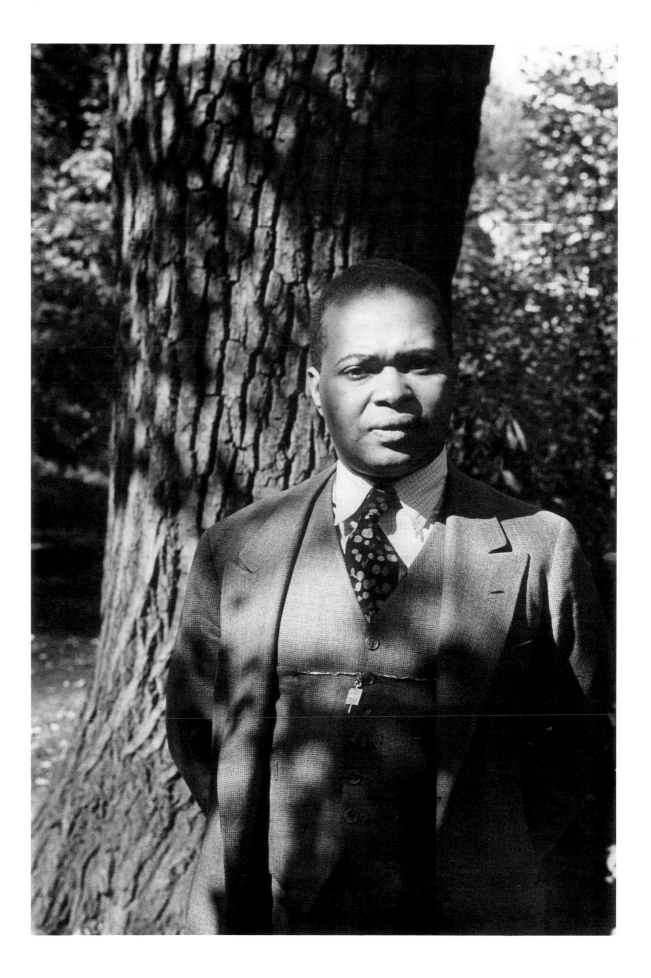

Ralph J. Bunche

May 16, 1951

Diplomat, educator, and humanitarian

Ralph Johnson Bunche (1904–71) earned his bachelor's degree from the University of California at Los Angeles in 1927. In that same year he began his graduate studies at Harvard University, to which, after completing his doctorate in 1934, he returned in 1936 for two years of postdoctoral research. While he was a student at Harvard, Bunche was also a member of the faculty at Howard University and an analyst for the War Department's National Defense Program. In 1944 he joined the State Department, where as a diplomat with a broad knowledge of world affairs he became an expert on Africa. It was also in 1944 that he began his long and distinguished career with the United Nations, when he served as an assistant secretary to the United States delegation at the Dumbarton Oaks Conference. In 1946 Bunche was appointed director of the Division of Trusteeship in the United Nations, helping to lay the foundation for the decolonization movement in Africa during the 1950s and the 1960s and to mediate an Arab-Israeli settlement from 1948 to 1949. In 1955 he was appointed under secretary, and in 1958, undersecretary-general of the United Nations. In these positions Bunche earned international recognition for the leadership he provided in the Middle East, Africa, and Asia. He was president of the American Political Science Association, and for his leadership on the Palestine accord in 1950, Bunche became the first African American to be awarded the Nobel Peace Prize.

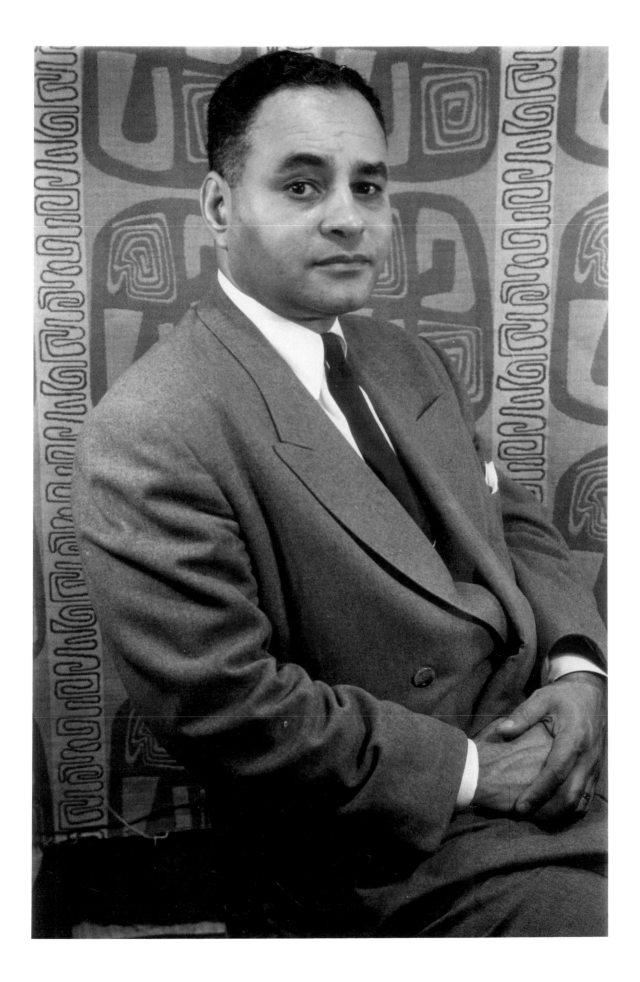

Richard Bruce Nugent

February 16, 1936

Writer and illustrator

Richard Bruce Nugent (1906–85) was a striking figure in the social and literary circles of Harlem and Washington, D.C. Although the bulk of his work remains unpublished, his highly experimental prose work "Sahdji" appeared in Alain Locke's *New Negro* (1925). Nugent collaborated with Locke in writing the choral sections of *Sahdji—An African Ballet,* first staged in 1932 at the Eastman School of Music, with a score by William Grant Still. A small sampling of Nugent's verse appeared in *Opportunity* and in Countee Cullen's anthology *Caroling Dusk* (1927). Like Zora Neale Hurston and Langston Hughes, Nugent served on the editorial board of Wallace Thurman's short-lived journal *Fire,* to which, with Aaron Douglass, Nugent contributed illustrations as well as the story "Smoke, Lillies and Jade." While Nugent was a member of the editorial board of Thurman's second journal, *Harlem,* other illustrations by him were published together with contributions by Walter White, Richmond Barthé, Alain Locke, and George Schuyler.

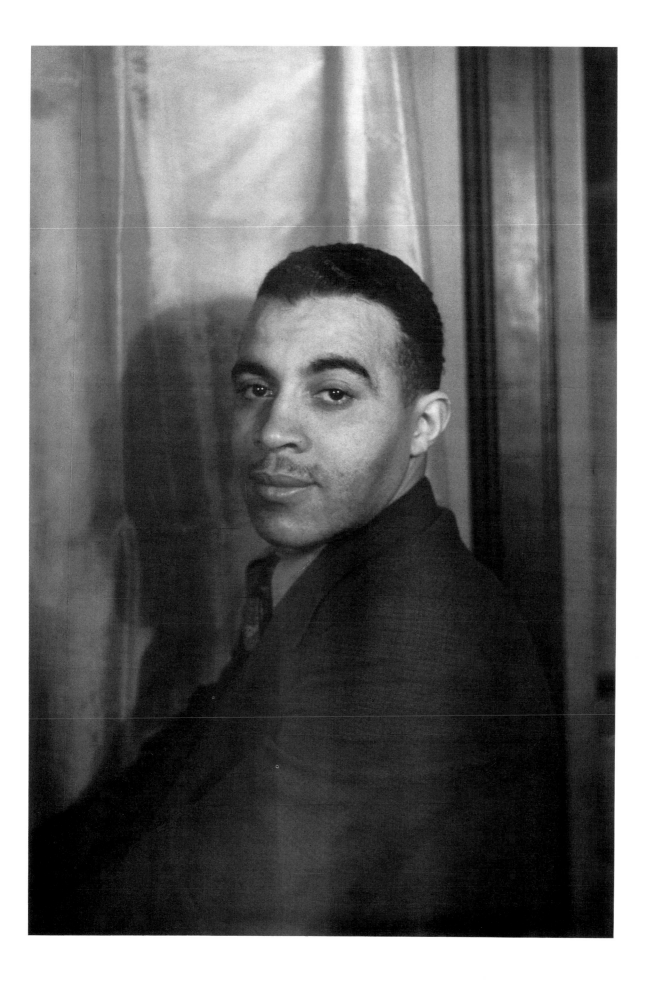

Josephine Baker

October 20, 1949

Singer, dancer, and actress

Josephine Baker (1906–75) began her career in the theater as a dresser in a traveling show that featured the blues singer Clara Smith. Initially refused a part in Noble Sissle and Eubie Blake's *Shuffle Along* (1921), Baker later joined the cast of Sissle and Blake's *Chocolate Dandies* (1924). In this production, Sissle and Blake created a role for Baker that showcased her strengths as a dancer and comedian. A year later Baker once replaced Ethel Waters in *Plantation Revue;* Waters was so threatened by Baker's performance that she used her influence as the review's star performer to make certain that Baker remained an anonymous member of the chorus. Soon afterward, Baker's critically acclaimed performances in the Paris-based *La Revue Negre* (1925) established her as a performer with an international reputation. She appeared in New York City in 1936 as a featured performer in the *Ziegfeld Follies,* but as a consequence of the tepid reception of New York City audiences she decided to return to Paris, where her performances at the Folies Bergere had earned her the enduring admiration of European audiences. At the end of World War II, Baker was awarded the Legion of Honor, the Rosette of Resistance, and the Medallion of the City of Paris for her example of service and contributions to the Resistance movement. In 1973 she returned to New York City, where she performed before enthusiastic and adoring audiences at Carnegie Hall and in Harlem. Four days after the opening of a new revue written to mark and celebrate her fifty years in show business, Baker died in Paris.

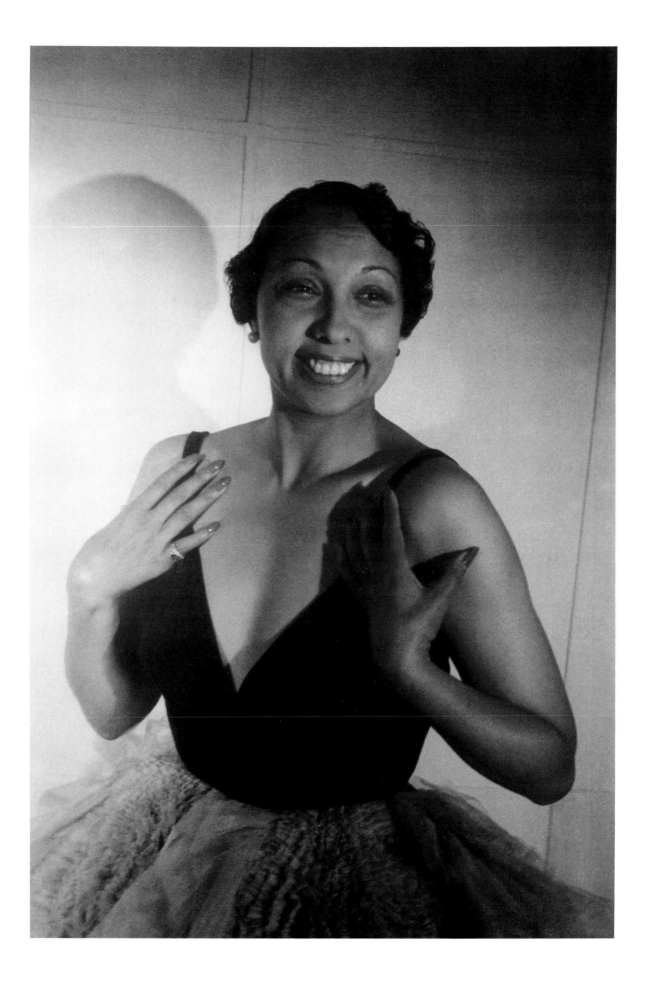

Roi Ottley

August 14, 1943

*Journalist, social historian,
and radio scriptwriter*

Roi Ottley (1906–60) was educated in the public schools of his native New York City and at St. Bonaventure College, the University of Michigan, St. John's University Law School, and Columbia University, where he refined his view of the scope and purposes of journalism. In 1931 he joined the staff of New York's *Amsterdam News,* and by 1935 he was a senior editor, a position he held for two years before joining the New York City Writers' Project as an editor directing research on African American life. The author of six books of fiction and nonfiction, Ottley achieved national prominence with the publication of *New World A'Coming* (1943), a social history of African American life that became the basis for his award-winning radio program of the same title. Featuring original radio scripts, programs on African American culture, and narration by the actor Canada Lee, Ottley's "New World A'Coming" was first broadcast on New York's WMCA in 1944.

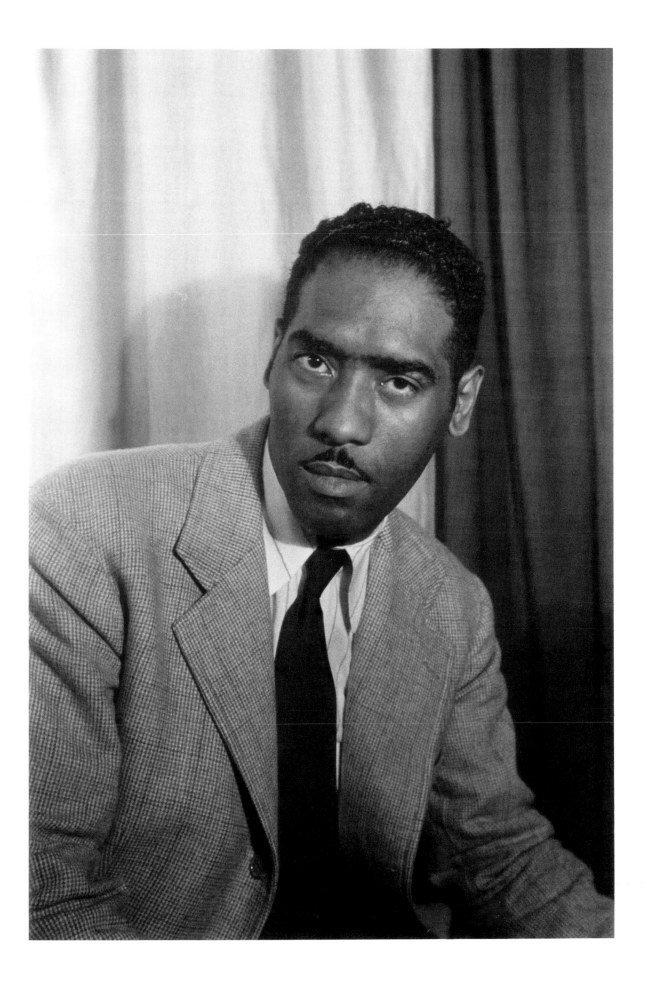

Cab Calloway

(Cabell Calloway)

January 12, 1933

Singer, bandleader, and composer

Cab Calloway (b. 1907) began his musical apprenticeship as a member of the Baltimore Melody Boys, a quartet based in Baltimore, Maryland. Later, when *Plantation Days,* a touring company in which he was first tenor, completed its schedule of performances in the midwest, Calloway briefly studied law at Crane College in Chicago. He set aside his studies in the law to perform as a drummer and vocalist in many local bands, eventually rising to the level of conductor for the Albanians. Calloway traveled to New York City in 1929 and joined Andy Preer's band the Missourians. The Missourians made an extremely favorable impression on New York City audiences when they replaced Duke Ellington's band at the Cotton Club. Calloway's lively, engaging, and humorous style of conducting led to a series of regular engagements at the Cotton Club until 1932. Calloway's band performed before enthusiastic audiences in the United States and in Europe, and during the 1930s and the 1940s it was one of the most successful bands in the music industry. Of the many songs associated with Calloway, "Minnie the Moocher" is his signature piece; his other compositions include "St. James Infirmary," "Lady with a Fan," and "That Man's Here Again." Calloway is best known to audiences around the world for his talent as a singer, conductor, and composer, but he is also an actor whose stage credits include *Porgy and Bess* (1952) and *Hello Dolly* (1969) with Pearl Bailey. He has performed as an actor in several films, including the classic *Stormy Weather* (1943) with Lena Horne, Canada Lee, Bill Robinson, and Katherine Dunham.

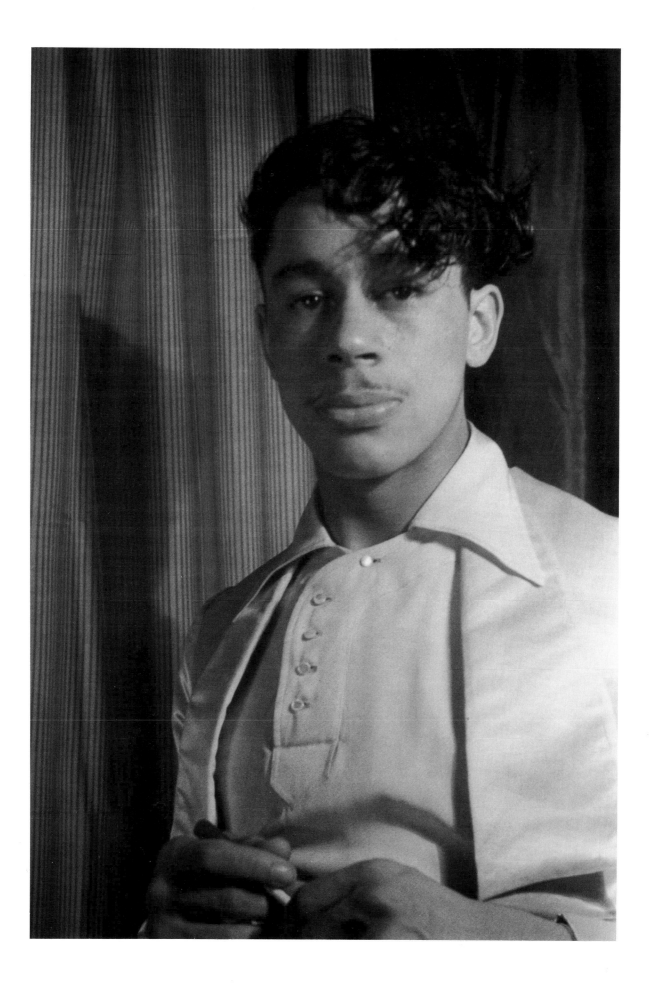

Canada Lee

(Leonard Lionel Cornelius Canegata)

April 7, 1941

Boxer, violinist, and actor

Canada Lee (1907–52) was born in New York City, where he distinguished himself as a film and stage actor. A skilled musician, he studied violin for seven years with J. Rosamond Johnson but set aside his studies in music and left New York City for Saratoga, New York, to become a jockey. Later Lee exchanged his riding boots for boxing gloves. After winning ninety out of one hundred fights, he became a professional boxer in 1926. He won a national amateur lightweight competition, but a detached retina ended his boxing career in 1933. Soon afterward Lee turned from boxing to acting, acquiring experience and training in productions sponsored by the Works Progress Administration. Lee made his acting debut at the Harlem YMCA in 1934 in a WPA production of *Brother Mose*. Of his many roles, Lee is remembered most for his portrayal of Bigger Thomas in the 1941 Broadway production of Richard Wright's *Native Son* and for his performances in such films as *Stormy Weather* (1943), which featured Lena Horne, Bill Robinson, Cab Calloway, and Katherine Dunham, Alfred Hitchcock's *Lifeboat* (1944), and *Cry, the Beloved Country* (1952). In addition to his work as an actor on both stage and screen, Lee was often featured as a narrator for Roi Ottley's popular radio program, "New World A'Coming."

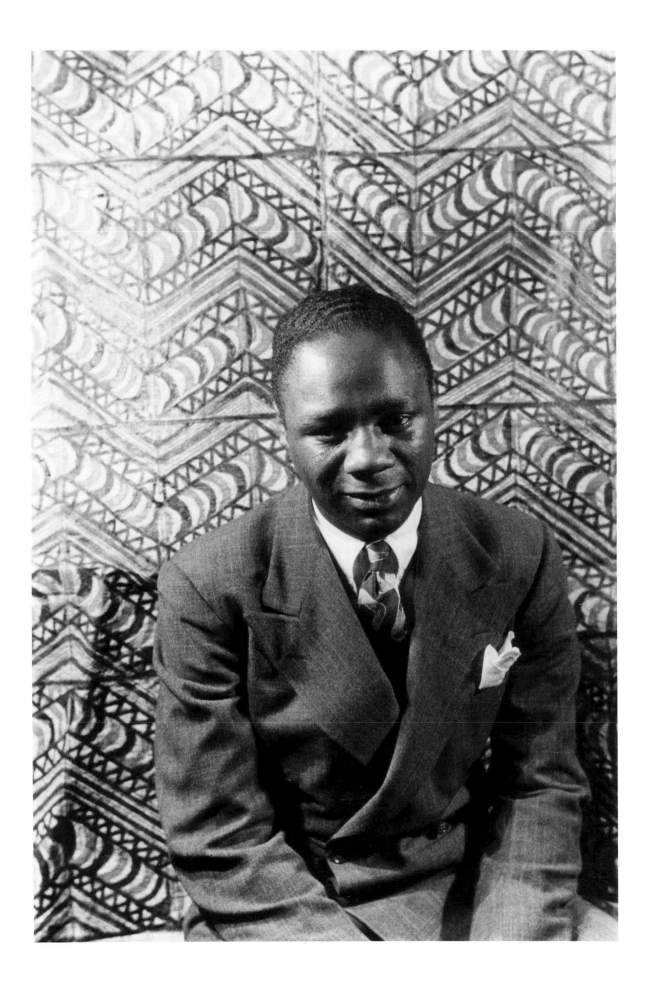

Richard Wright

June 23, 1939

Novelist

Richard Wright (1908–60) attended primary and secondary schools in Natchez, Mississippi, near Roxie, where he was born. Eager to leave the repressive environment of Natchez described in his classic autobiography *Black Boy* (1945), Wright moved to Chicago and there began the slow and difficult work of establishing himself as one of the most important writers of naturalism since Theodore Dreiser. During his apprenticeship as a writer in Chicago, Wright joined the Communist party, though sometime later he renounced his membership because of the party's failure to provide principled leadership on racial issues. With the publication of his collection of stories *Uncle Tom's Children* (1938) Wright demonstrated his ability and promise as a man of letters, but *Native Son* (1940), his most important work of fiction and the first book by an African American writer to become a Book-of-the-Month Club selection, established him as a writer of national and international significance. While living in Chicago, Wright met William Attaway and later Margaret Walker, with whom he discussed the early versions of *Native Son.* Canada Lee portrayed Bigger Thomas in the successful Broadway adaptation of *Native Son,* and Wright himself attempted but failed to meet the high standards of Lee's performance in the first film version of the novel. In 1947 Wright left the United States for France, where he lived the remaining fifteen years of his life. While in Paris Wright's eminence as a writer grew. He published three more novels, though none was as successful as *Native Son,* and four works of nonfiction, including *White Man, Listen!* (1957). As the most influential African American writer of his generation and the author of fifteen books of both fiction and nonfiction, Wright dismissed the fiction of Zora Neale Hurston as romantic and ahistorical and served as a model and mentor to such writers as Margaret Walker, James Baldwin, and Chester Himes.

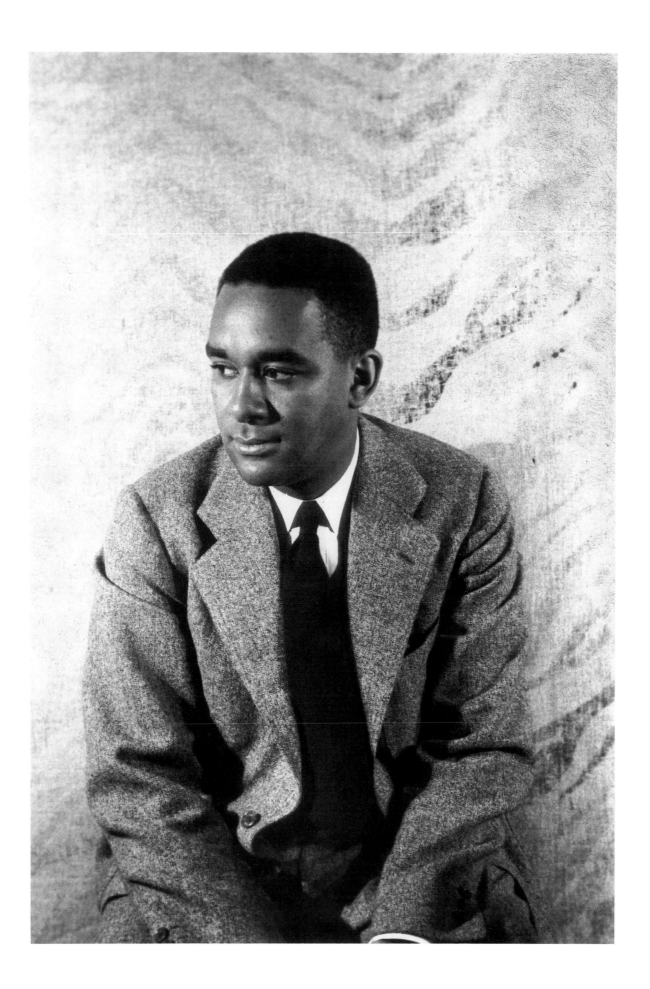

Chester Himes

July 10, 1962

Novelist

Born in Jefferson City, Missouri, Chester Himes (1909–1984) received his early education there and later attended Ohio State University. He began his apprenticeship as a writer in the Ohio State Penitentiary while he was serving a twenty-year sentence for armed robbery. Released from prison in 1935 after serving seven years of his sentence, Himes joined the Work Projects Administration, where he continued to refine his skills as a writer. With the support of a Julius Rosenwald fellowship, Himes completed his first novel, *If He Hollers Let Him Go* (1945). A recipient of the Grand Prix Policier Award for mystery writing, Himes was the author of fifteen detective and mystery novels, including *Cotton Comes to Harlem* (1965), which was brought to the screen under the directorship of the actor and dramatist Ossie Davis. Like Richard Wright and James Baldwin, Himes chose to live much of his life in Europe, where he found that opportunities for African American intellectuals were greater. After living for a number of years in Paris, where he met Wright, Himes died in Morara, Spain.

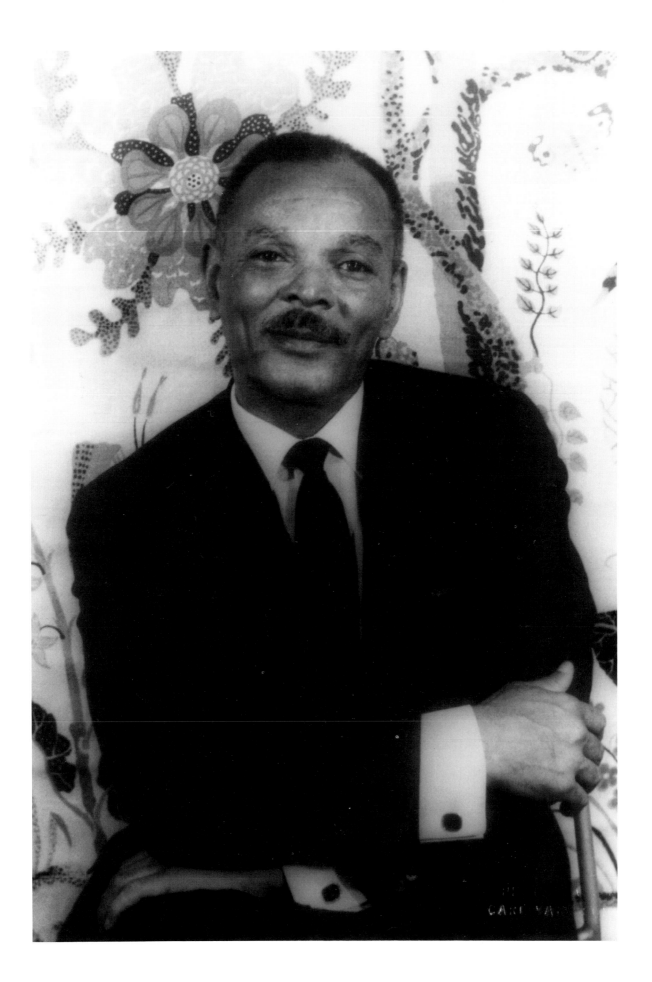

Katherine Dunham

May 10, 1940

Dancer, choreographer, anthropologist, and educator

An influential figure in American dance, Katherine Dunham (b. 1909) masterfully established and synthesized the patterns of dance and other forms of expressive culture in the African diaspora. She was educated at Joliet Township Junior College, the University of Chicago, and Northwestern University, where she studied with the anthropologist Melville Herskovits. She began her studies in dance with Madame Ludmila Speranzeva, who supported Dunham in her efforts to establish her first school of dance in Chicago in 1929. Subsequently, Dunham founded the Negro Dance Group, but she temporarily set aside her responsibilities as head of a dance school to accept a Rosenwald fellowship, which enabled her to study dance in Jamaica, Trinidad, Martinique, and Haiti. In 1940 the Katherine Dunham Dance Company opened at the Windsor Theatre in New York City. Soon after the critically acclaimed performances at the Windsor, the Dunham dance company joined the New York City cast of the musical *Cabin in the Sky*. The company has toured extensively in the United States, Mexico, South America, Europe, the Caribbean, Asia, and Africa. In 1965 and 1966, at the request of President Leopold Senghor, Dunham served as a dance instructor to the Senegalese National Ballet and as a cultural advisor for the First World Festival of Negro Arts at Dakar, Senegal. In the following year, she was appointed Visiting Artist at the Edwardsville's campus of Southern Illinois University, as well as director of the Performing Arts Training Center and the Dynamic Museum. After her retirement, Dunham established the Katherine Dunham Center, a museum and a school of dance that offers instruction in the Dunham technique in East Saint Louis, Missouri.

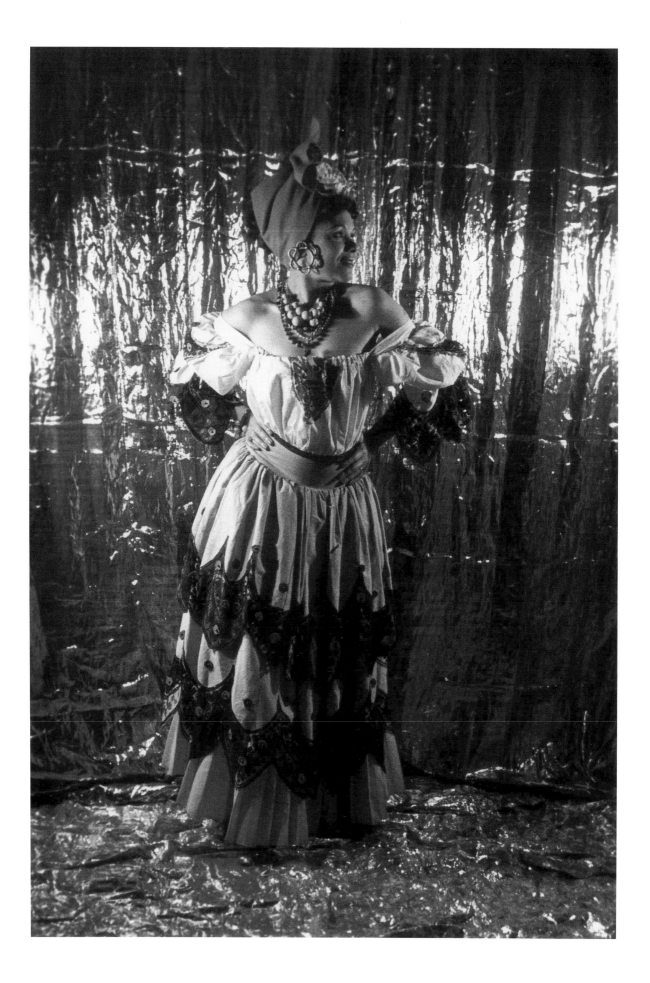

Beauford Delaney

March 18, 1953

Painter

Beauford Delaney (1901–79) was born in Knoxville, Tennessee, and studied art at the Massachusetts Normal Art School, the South Boston School of Art, and the Copley Society. During the years of his apprenticeship, he studied with Thomas Hart Benton, John Sloan, and Don Freeman. In 1941 Delaney exhibited his paintings at the Vendome Galleries in New York City in his first one-man show. He was the model for novelist Henry Miller's exploration of bohemia in *Remember to Remember* (1947). A prolific artist, Delaney produced landscapes, still lifes, and portraits of such individuals as W. C. Handy and Ethel Waters, and his paintings have been exhibited at galleries and museums in such cities as Baltimore, London, and Paris, where Delaney lived from 1954 until his death. His paintings are part of the permanent collections of Morgan State College in Baltimore, the Newark Museum in New Jersey, and the Whitney Museum of American Art in New York.

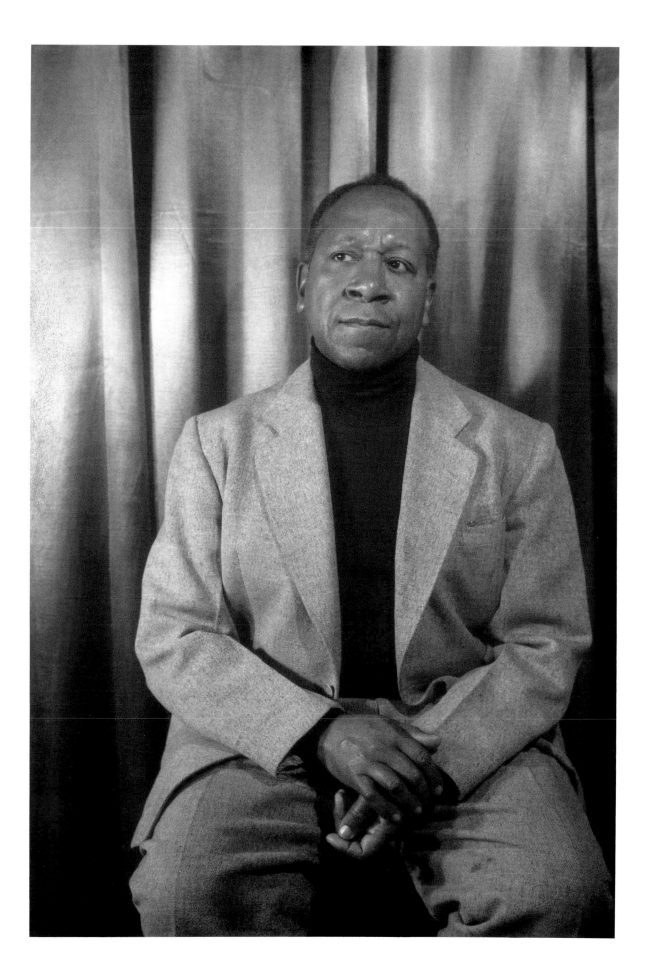

Mahalia Jackson

April 16, 1962

Gospel singer

Mahalia Jackson (1911–72) received her instruction in black sacred music as a member of the Mount Moriah Baptist Church, where her family worshipped. Born and reared in New Orleans, Jackson was exposed to the blues and jazz of Storyville, a black cultural enclave that produced Louis Armstrong, who was unsuccessful in his efforts to persuade Jackson to sing the blues in the early years of her musical career. Jackson, with her rich contralto voice, rose to national prominence through her collaborations with Thomas A. Dorsey, a founding figure in gospel music. Dorsey was Jackson's musical advisor and accompanist from 1937 to 1946, during which time she performed many original compositions by Dorsey, including "Precious Lord Take My Hand." In 1947 Jackson was appointed the official soloist of the National Baptist Convention. She performed at Carnegie Hall and at the Newport Jazz Festival and toured extensively in Europe, Africa, and Asia. An unwavering supporter of the civil rights movement, Jackson participated in the historic march on Washington in 1963, where she sang "How I Got Over" on the steps of the Lincoln Memorial. Through her many recordings with Apollo Records and Columbia Records, Jackson established herself as a dominant figure in gospel music, and in the process demonstrated that gospel music was a distinctive new idiom in the evolving tradition of African American sacred music.

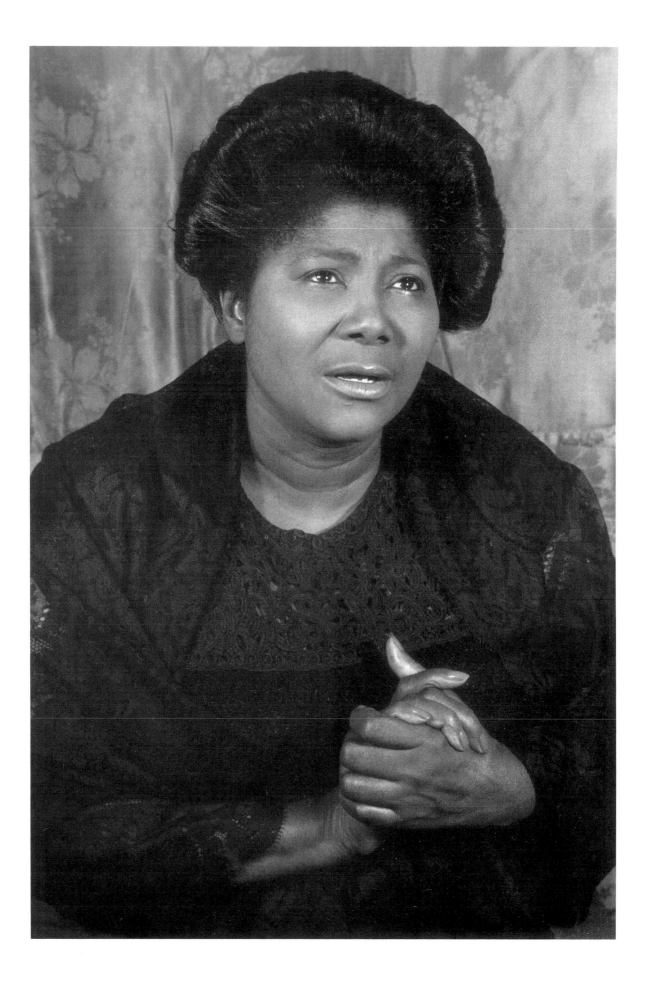

Henry "Homicide Hank" Armstrong

(Henry Jackson, Jr.)

July 15, 1937

Boxer

Born on a plantation owned by his white grandfather in Columbus, Mississippi, Henry Armstrong (1912–88) graduated from Toussaint L'Ouverture School and Vashon High School in St. Louis, Missouri. He was initially interested in becoming a physician but decided to enter the ring after discovering the size of purses earned by professional boxers. As an amateur boxer, Armstrong boxed in St. Louis, Chicago, Pittsburgh, and Inglewood, California. During these years, Armstrong was under the management of trainer Harry Armstrong, whose name he took in an unsuccessful effort to make the United States Olympic boxing team. Following a professional fight in which he defeated Baby Arizmendi of Mexico, Armstrong met the singer Al Jolson, who, with the actor George Raft, bought his contract and hired Eddie Mead to train and manage him. Under the management of Raft, Jolson, and Mead, Armstrong returned to New York City to box in Madison Square Garden as "Al Jolson's Mammy Boy." With his "blackout" punch, Armstrong became the first professional boxer to hold three world titles simultaneously. In October 1937 Armstrong defeated Petey Sarron and assumed the featherweight title. In a match against Barney Ross in May 1938, Armstrong earned the welterweight title. Only three months later, Armstrong defeated Lou Ambers and won the lightweight title. By 1940 he had lost or relinquished all three titles, but in March of the same year, in a fight against Ceferino Garcia in Los Angeles, he won the middleweight championship, his fourth title. Armstrong held the record of three simultaneous titles for fifty years, until it was surpassed by Thomas Hearns and Sugar Ray Leonard. Armstrong retired from professional boxing in 1945. In 1951 Armstrong became an ordained minister in the Baptist church and for many years ministered to and counseled the youth of Los Angeles. In 1954 he was elected into the Boxing Hall of Fame. As a pastor in St. Louis, Armstrong became director of the Herbert Hoover Boys Club in 1972.

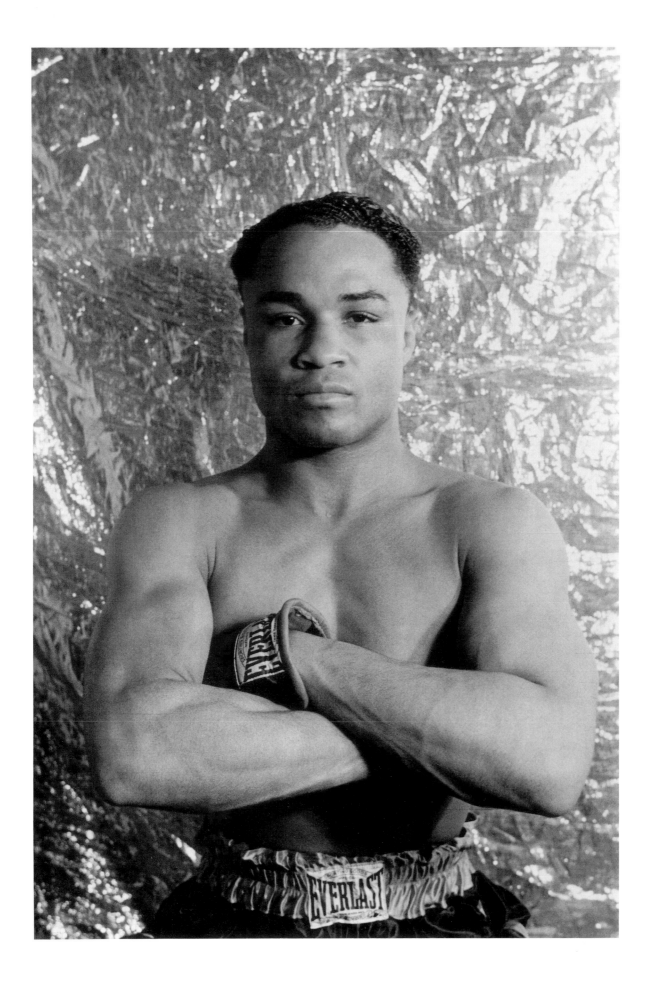

Joe "The Brown Bomber" Louis

(Joseph Louis Barrow)

September 15, 1941

Heavyweight boxing champion

Although Joe Louis (1914–83) attended Mount Sinai Baptist Church School in his native Lafayette, Alabama, and Detroit's Bronson Trade School, his early successes in local boxing matches led to his choice of professional boxing as a career. Louis began as an amateur boxer in 1932 in Detroit, Michigan, and in 1934 he turned professional under the management of John Roxborough, a member of Detroit's black business community. As the world heavyweight champion between 1934 and 1949, Louis defended his title a record twenty-five times, losing only once to the German boxer Max Schmeling in 1936. In 1938 he defeated Schmeling in an electrifying one-round knockout and once again became the world heavyweight champion in a rematch that was described as American democracy's victory over the evil of German nazism. With a professional record of sixty-nine victories (including forty-nine knockouts) and only three defeats, Louis was boxing's greatest heavyweight and a unifying symbol of black courage, resistance, and strength.

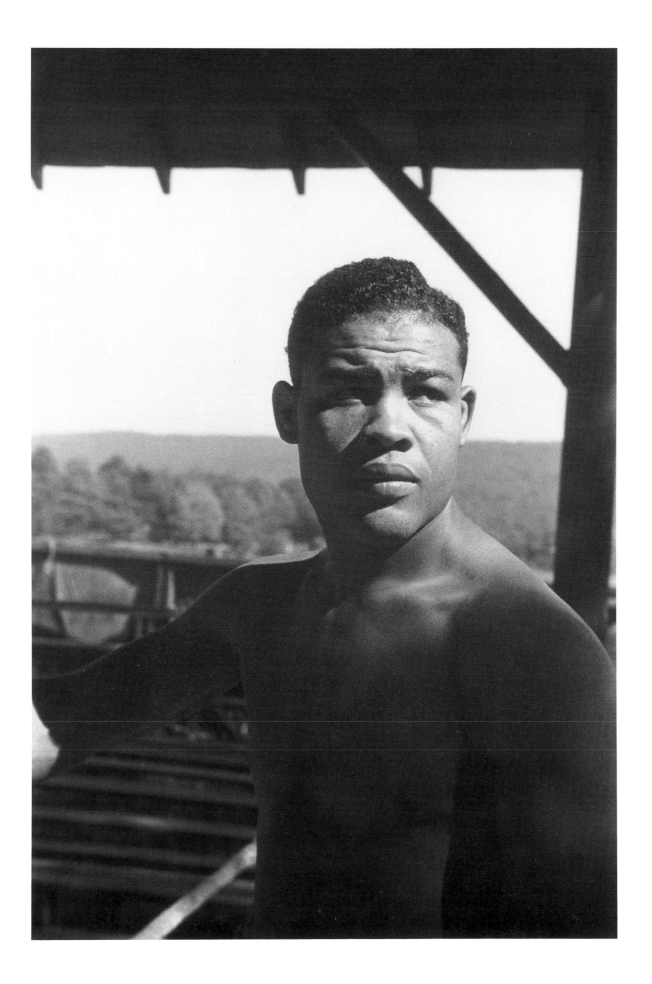

Ann Petry

November 12, 1948

Pharmaceutical chemist, journalist, and writer

Ann Petry (b. 1911) attended public schools in her native Old Saybrook, Connecticut. At the age of fourteen, she decided that she wanted to become a writer but yielded to family tradition by enrolling, like her grandfather and other family members, in the Connecticut College of Pharmacy. Petry completed the degree requirements for the pharmacy program in 1931 and was a practicing pharmacist in Old Saybrook until 1938, when she married George David Petry and moved to New York City. While in New York City, Petry supported herself not as a pharmacist but as a journalist for the *Amsterdam News* and later for its rival, *People's Voice*. In 1943 Petry's first published short story, "On Saturday the Siren Sounds at Noon," appeared in the *Crisis*. Other short stories by Petry appeared in subsequent issues of the *Crisis,* including "Like A Winding Sheet," which was named best American short story of 1946. In 1945 Petry was awarded a Houghton Mifflin Literary Fellowship, which enabled her to complete *The Street* (1946), which was the first of her three novels, and a collection of short stories. Petry is also the author of three books of children's literature, including *Tituba of Salem Village* (1964). A prolific writer whose work is of special importance to contemporary African American women writers, Petry has taught at the University of Hawaii and has received honorary degrees from Suffolk University, the University of Connecticut, and Mount Holyoke College.

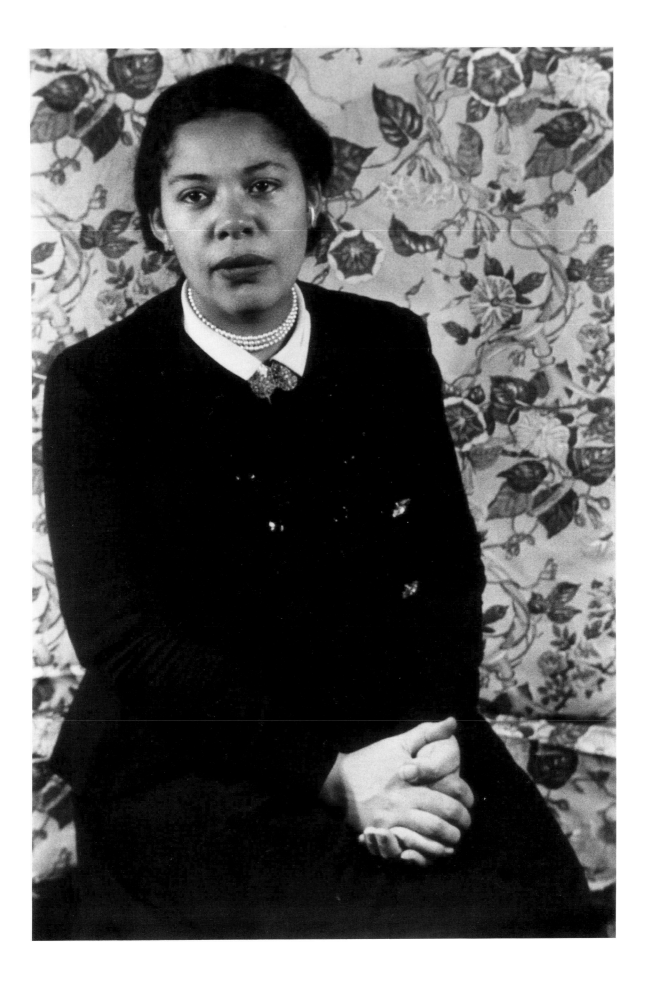

William Alexander Attaway

October 29, 1941

Novelist, composer, and scriptwriter

William Alexander Attaway (1911–86) was born in Greenville, Mississippi, and attended public schools in Chicago, Illinois. At first interested in becoming an automotive mechanic, Attaway decided to become a writer after being introduced to the poetry of Langston Hughes in high school. While a student at the University of Illinois at Chicago, where he earned his baccalaureate, Attaway held a position as a researcher at the Federal Writers' Project, where he met Richard Wright. After graduating from college, Attaway left Chicago for New York City and for two years worked as an actor there. While a member of the traveling company of George S. Kaufman's *You Can't Take It With You,* Attaway learned that his first novel, *Let Me Breathe Thunder* (1939), had been accepted for publication. The reviews of this novel were full of praise, as were those for his second and last novel, *Blood on the Forge* (1941). The author of two books of music, including *Calypso Song Book* (1957), Attaway composed and arranged songs for the actor and singer Harry Belafonte. Attaway also wrote scripts for radio, television, and film. In the year before his death, Attaway completed the script for *The Atlanta Child Murders* (1985).

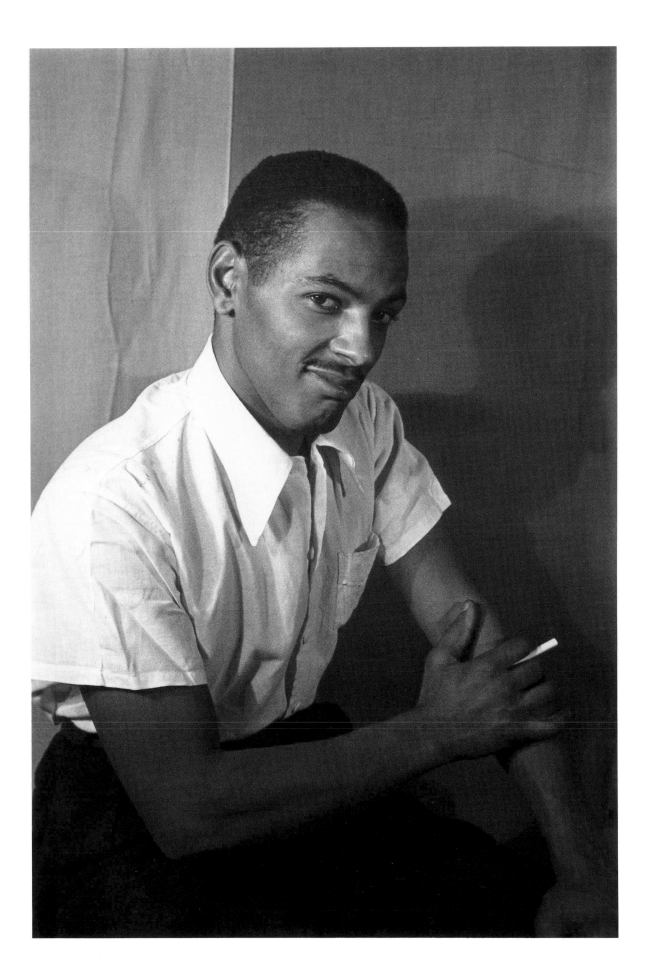

Romare Howard Bearden

April 15, 1944

Painter and collagist

Born in Charlotte, North Carolina, Romare Howard Bearden (1912–88) attended primary and secondary schools in New York City and Pittsburgh, Pennsylvania. He studied mathematics at New York University, where he earned his baccalaureate, and studied advanced mathematics at Columbia University. Although a friend of and a frequent visitor to the studio of the painter Charles Alston, Bearden did not begin his formal study of art until 1936, when he enrolled at the Art Students League of New York and studied with George Grosz. After serving in the 372nd Infantry Division of the United States Army, Bearden studied art history and philosophy at the Sorbonne in Paris. In 1935 he exhibited his work in the first of many one-man exhibitions at the "G" Place Gallery in Washington, D.C. In later years Bearden cofounded Cinque Gallery in New York Public Theater and was a set and costume designer for the Alvin Ailey American Dance Theater. Bearden's most well known works include *Golgotha/Christ on the Cross, Prevalence of Ritual: Conjure Woman,* and *The Fall of Troy.* Emerging from the traditions of cubism and the blues, Bearden's work has been exhibited in the major galleries and museums of the United States and Europe and is part of the permanent collections of such museums as the Boston Museum of Fine Arts; the Hirshhorn Museum and Sculpture Garden of the Smithsonian Institution of Washington, D.C.; the Whitney Museum of American Art, the Metropolitan Museum of Art, and the Museum of Modern Art in New York; the Philadelphia Museum of Art; and the High Museum of Art in Atlanta. Among Bearden's many honors was a Guggenheim fellowship and a James Weldon Johnson Award. He was elected a member of the American Academy of Arts and Letters.

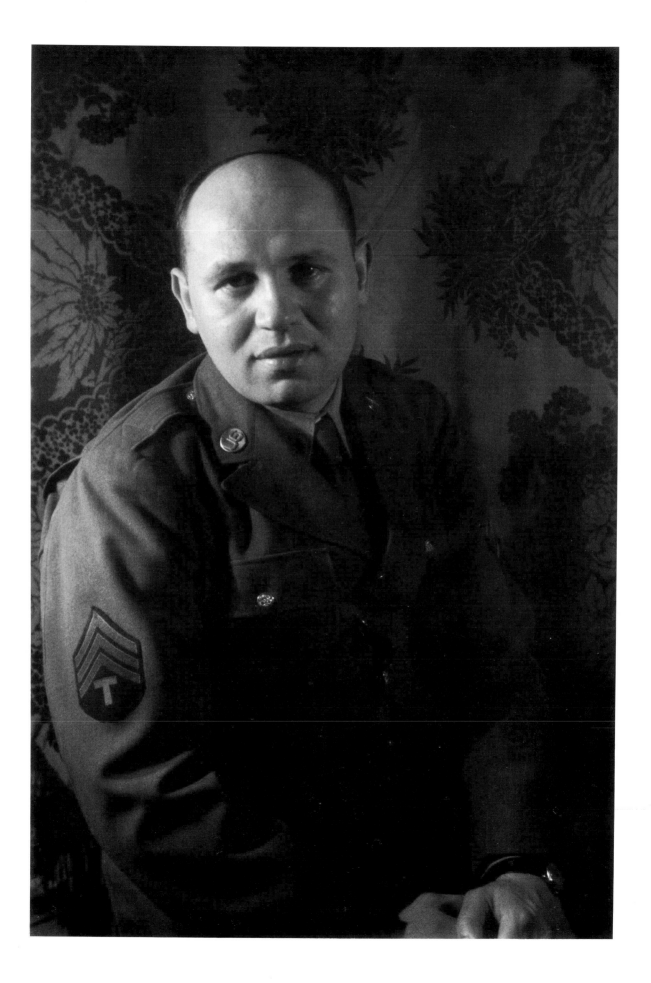

Billie "Lady Day" Holiday

(Eleanora Fagan Holiday)

March 23, 1949

Jazz singer

Possessing a voice that recalls the manner of Bessie Smith and the style of Louis Armstrong, Billie Holiday (1915–59) was one of the most important and influential singers in the evolving traditions of blues and jazz. Holiday acquired her broad knowledge of life from the streets, and her love of music, from the brothels where she first heard the music of Bessie Smith and Louis Armstrong. At the age of thirteen Holiday was a prostitute, and at the age of fifteen she made her singing debut at Pod and Jerry's (also known as the Log Cabin), a Harlem speakeasy. For the next fifteen years, she sang to loyal audiences in the jazz clubs of Manhattan, most notably Cafe Society in Greenwich Village, where she first appeared as a solo performer. In later years, she performed in New York City at the Apollo Theatre, the Metropolitan Opera House, Town Hall, and Carnegie Hall; she appeared at the Newport Jazz Festival and toured extensively in Europe and Scandinavia. Holiday made her film debut in *Symphony in Black* (1935) with Duke Ellington's orchestra and later appeared with Louis Armstrong in *New Orleans* (1947). Her signature songs include "God Bless the Child," "Don't Explain," "Fine and Mellow," and "Strange Fruit." Weakened by years of heroin and alcohol addiction, Holiday gave her last public performance at New York City's Phoenix Theatre in 1959.

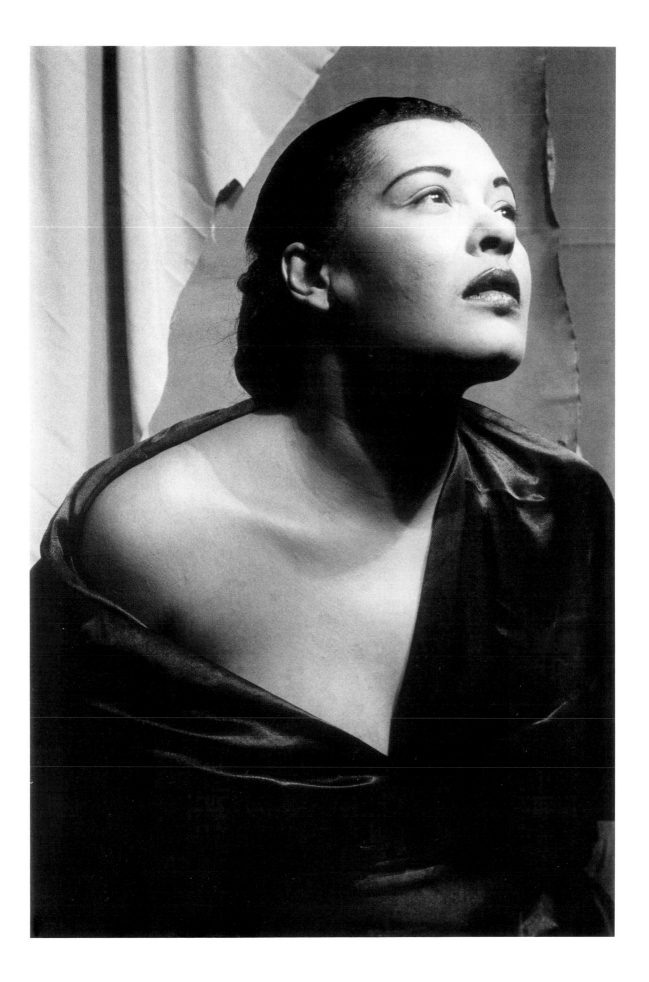

Billy "Swee' Pea" Strayhorn

(William Thomas Strayhorn)

August 19, 1958

Composer, arranger, and pianist

Billy Strayhorn (1915–67), a native of Dayton, Ohio, spent his adolescent years in Pittsburgh, Pennsylvania, where he studied music at Westinghouse High School. In December 1938 he met Duke Ellington at the Stanley Theatre in Pittsburgh and shared his music with the master composer. Less than a year later, Strayhorn joined the Duke Ellington Band as a lyricist and arranger. Very soon after, Strayhorn became a full partner and collaborator with Ellington, often replacing Ellington at the piano. He remained with Ellington's band until his death. Ellington honored his fellow musician and collaborator of twenty-eight years with the album *And His Mother Called Him Bill* (1967). Strayhorn was a prolific composer whose musical style was both impressionistic and introspective. Many of his compositions have become jazz classics, including "Lush Life," "Take the A Train," "Passion Flower," and "Ballade for Very Sad and Very Tired Lotus Eaters."

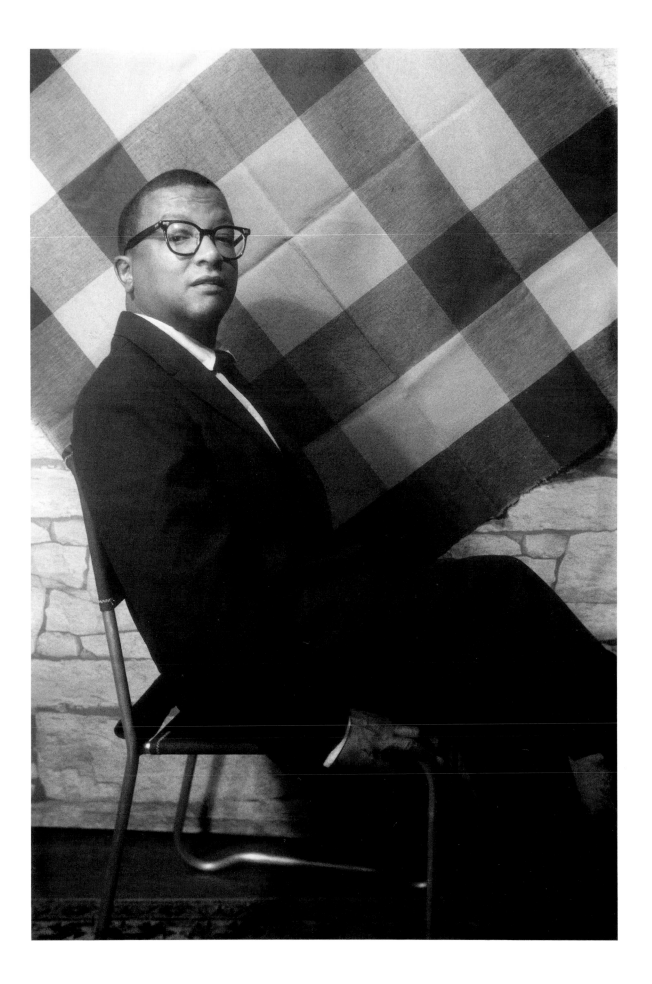

Margaret Abigail Walker

November 27, 1942

Poet, novelist, and educator

Margaret Walker (b. 1915) began writing at the age of eleven, when she was enrolled in Gilbert Academy in New Orleans, Louisiana. Encouraged by Langston Hughes to pursue her interests in writing and to leave the South, Walker attended Northwestern University and the University of Iowa. During her years in Chicago, Walker joined Richard Wright's South Side Writers' Group, which provided an artistic and intellectual experience that receives full treatment in her biography of Wright, *The Daemonic Genius of Richard Wright* (1987). While Walker was an apprentice writer, her poetry was accepted by W. E. B. Du Bois for publication in the *Crisis*. The author of ten books of fiction, poetry, and literary criticism, Walker achieved national prominence with the publication of her volume of poems *For My People*, winner of the Yale Series of Younger Poets Award in 1942. She is the author of the novel *Jubilee* (1966), an exploration of slavery and reconstruction based upon the life of her maternal great-grandmother that has been made into an opera. Walker has taught at Livingstone College, in Salisbury, North Carolina, and Jackson State University, in Jackson, Mississippi, where she is now a professor emeritus. Her honors include Ford Foundation and Houghton Mifflin fellowships as well as honorary degrees from several universities, including Northwestern.

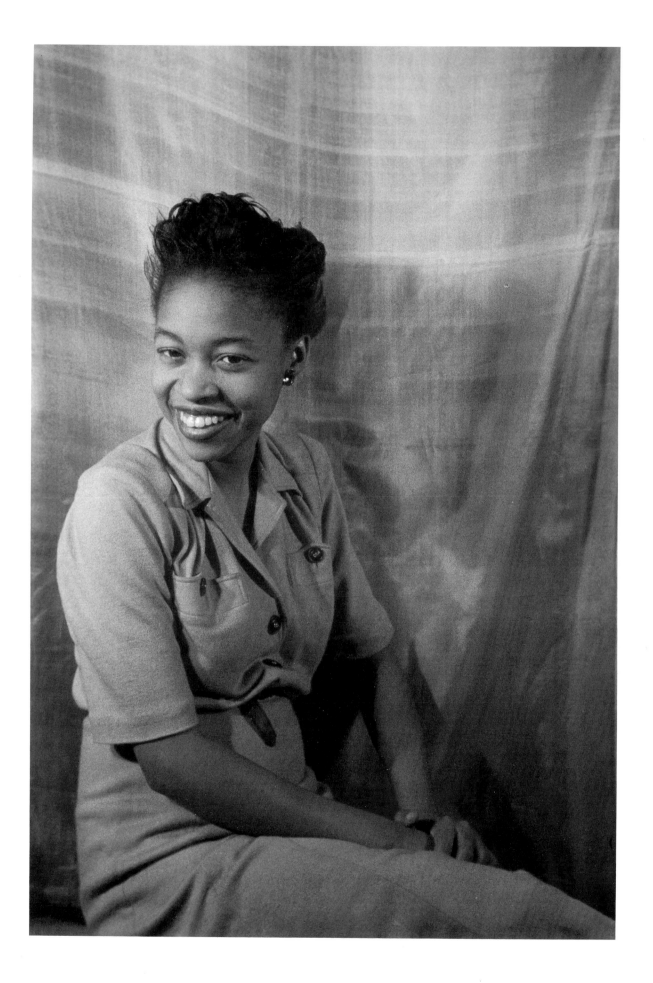

John O. Killens

June 8, 1954

Writer, union organizer, and educator

John O. Killens (1916–1988) was introduced to African American culture at home in Macon, Georgia. His father required him to read Langston Hughes's weekly column in the *Chicago Defender,* and his mother, the president of Macon's Dunbar Literary Club, introduced him to the poetry of Paul Laurence Dunbar. Killens left Macon in 1936 and settled in Washington, D.C., where he held a position with the National Labor Relations Board. He was an impassioned advocate of unions for the American worker, and his belief in the power of organized labor to transform American life is given full expression in his first novel, *Youngblood* (1954). In Ann Petry's review of *Youngblood* in the *New York Herald-Tribune,* she criticized Killens for his preoccupation with violence but also praised him for his skill in creating a fictional world in which each character possesses force and significance. From 1954 to 1970, Killens was active in the civil rights movement, and the militancy and idealism of that era are captured in his third novel, *'Sippi* (1967), which focuses on the voter registration movement and has such figures as Harry Belafonte and Paul Robeson as part of its plot. The author of four novels, three plays, and two screenplays, Killens identified Langston Hughes, Richard Wright, and Margaret Walker as his most important literary ancestors. In the late 1940s, with the historian John Henrik Clarke and the writers Rosa Guy and Walter Christmas, Killens founded the Harlem Writers Guild, where the actor, writer, and director Ossie Davis read the earliest drafts of his musical and film *Purlie Victorious*. Killens was appointed writer-in-residence at Fisk University, Howard University, and Medgar Evers College in Brooklyn, New York.

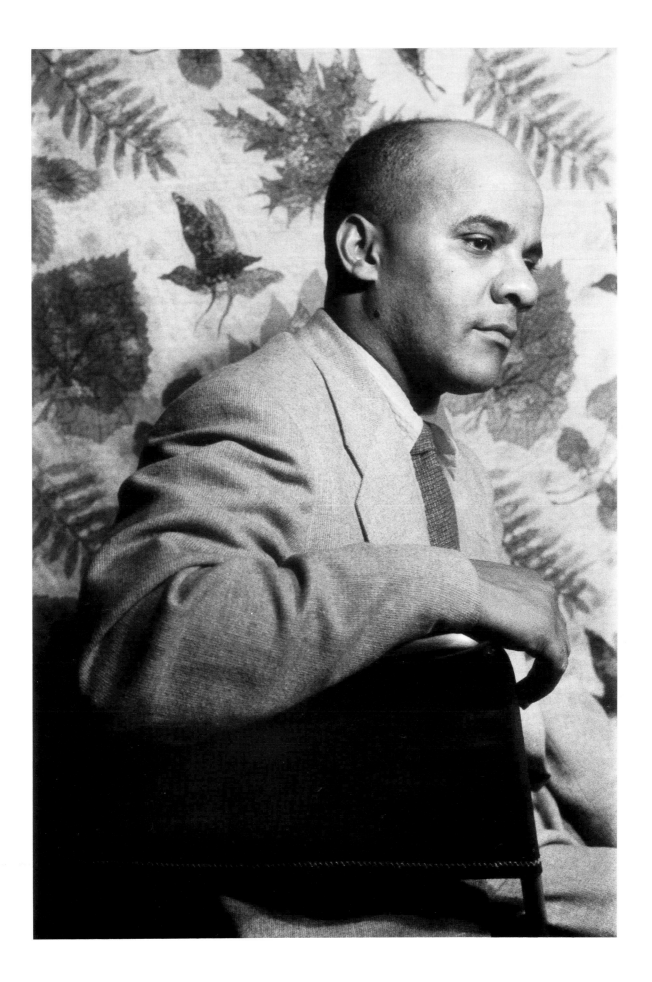

Jacob Lawrence

July 31, 1941

Painter and educator

Jacob Lawrence (b. 1917) was born in Atlantic City, New Jersey, and began his training as a painter in the Harlem workshops conducted by Charles Alston and Henry Bannarn in 1932. He pursued advanced study at the Harlem Art Center and at the American Art School. Quickly establishing himself as a painter of considerable promise and ability, Lawrence was awarded in 1940 the first of three Rosenwald fellowships and a Guggenheim fellowship. Lawrence is a prolific artist drawn to historical themes: his most well known works are *The Life of Harriet Tubman, Frederick Douglass, Death of Toussaint in Le Joux Prison,* and *The Migration of the Negro,* which established Lawrence, at the age of twenty-four, as an important and influential American painter. From 1971 until his retirement in 1983 he was a professor of art at the University of Washington. Since leaving the university he has completed several commissions, one of which is a mosaic mural of the life of Harold Washington, Chicago's first African American mayor. Lawrence's paintings have been exhibited at the major institutions in the American art world, including the Studio Museum of Harlem, the Metropolitan Museum of Art, the Museum of Modern Art, and the Chicago Art Institute, and are part of the permanent collections of many universities and museums, including Atlanta University, Spelman College, Fisk University, Howard University, Hampton University, the Baltimore Museum of Art, the Smithsonian Institution, and the Whitney Museum of American Art. In 1970 Lawrence was awarded the Spingarn Medal from the National Association for the Advancement of Colored People, becoming the first painter to be so honored.

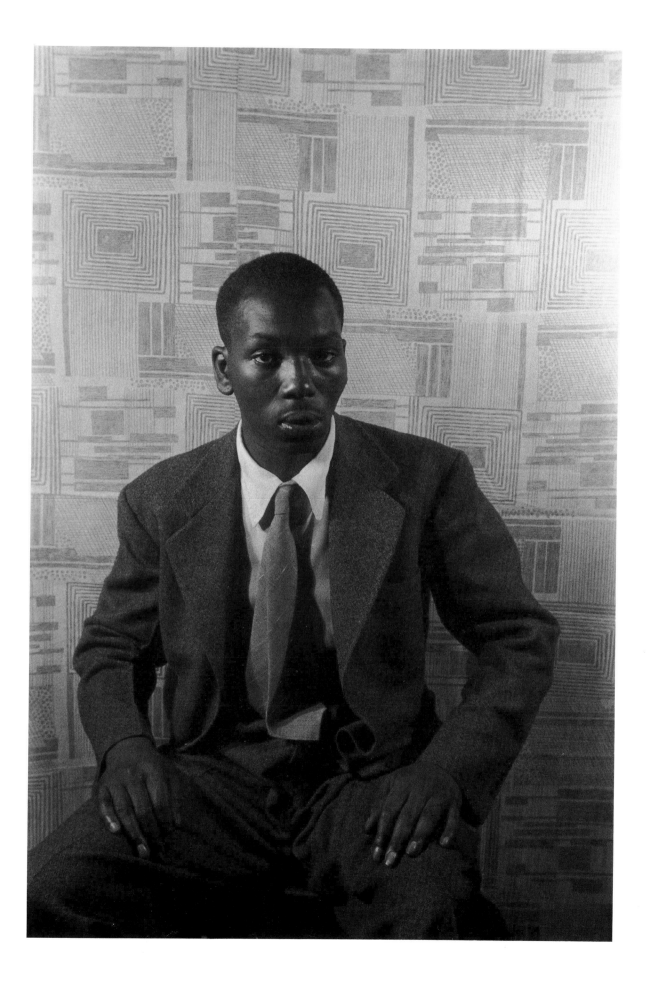

Lena Horne

September 15, 1941

Singer and actress

Until the age of fourteen, when she moved to the Bronx with her mother, Edna Scottron Horne, Lena Horne (b. 1917) attended public schools in the Bedford-Stuyvesant section of Brooklyn, New York, where she was born. Although she was initially interested in a career as a teacher, Horne began singing at the age of sixteen in the segregated Cotton Club of Harlem to provide some financial relief to a household devastated by the Great Depression. As a singer at the Cotton Club, Horne met and worked with Cab Calloway, Billie Holiday, Ethel Waters, Duke Ellington, and Count Basie. Horne left the Cotton Club in 1935 to join Noble Sissle's Society Orchestra in Philadelphia, a collaboration that led to a starring role in the revue *Blackbirds of 1939.* In 1941, when she was dating Joe Louis, Horne was the featured singer at the Cafe Society Downtown, where she met Paul Robeson and Walter White, who, in spite of Horne's reluctance, encouraged her to pursue a career in film to combat the stereotyping of African Americans in American cinema. When she signed her contract with Metro-Goldwyn-Mayer in 1942, Horne became the second African American woman to establish a contractual relationship with a motion picture company in Hollywood (the first was Madame Sul-Te-Wan, who was signed by D. W. Griffith in 1915). Of her many films, *Cabin in the Sky* (1943) and *Stormy Weather* (1943), a musical based on the life of Bill "Bojangles" Robinson, are the most well known and are now classics in American cinema. As a performer who excels in the media of film, television, and radio, Horne has collaborated with such singers as Perry Como, Frank Sinatra, and Harry Belafonte. In 1981 Horne emerged from a voluntary retirement to star in *Lena Horne: The Lady and Her Music,* which remained on Broadway longer than any other one-woman show had before. Widely acclaimed as one of the most important figures in American entertainment, Horne has received many honors, including the Kennedy Center Award for Lifetime Contribution to the Arts as well as an honorary degree from Howard University.

Ossie Davis

April 12, 1951

Actor, director, and writer

Ossie Davis (b. 1917) was born in Cogdell, Georgia, and attended Howard University and later Columbia University. He studied acting with the Rose McClendon Players in Harlem, making his Broadway debut in 1946 in *Jeb Turner,* where he met the actress Ruby Dee, a fellow cast member whom he married two years later. Davis's stage credits include the Broadway production of *The Green Pastures* (1951). He has appeared in such television series as "The Defenders," "The Doctors," "Slattery's People," "The Fugitive," "Bonanza," "The Name of the Game," "Night Gallery," and "Evening Shade." His film career began with an appearance in *The Cardinal* in 1963, and more recently he appeared in *Do the Right Thing* (1989) and *Jungle Fever* (1991) under the direction of Spike Lee. Davis has distinguished himself as both an actor and a director. His directing career began in 1970 with *Cotton Comes to Harlem,* the first of the five films he has directed, which also include *Kongi's Harvest* (1971), a cinematic treatment of a play by the African playwright and Nobel laureate Wole Soyinka. As an actor whose principal interest is writing, Davis was an early member of the Harlem Writers Guild founded by the historian John Henrik Clarke and the writers Rosa Guy, Walter Christmas, and John O. Killens. It was as a member of the Guild that Davis read the first versions of his successful Broadway play *Purlie Victorious.* Among his many honors for his work as a director, writer, and actor is the Ruby Dee and Ossie Davis Collection of Black Film, established by the Afro-American Studies Program of Yale University in April 1992.

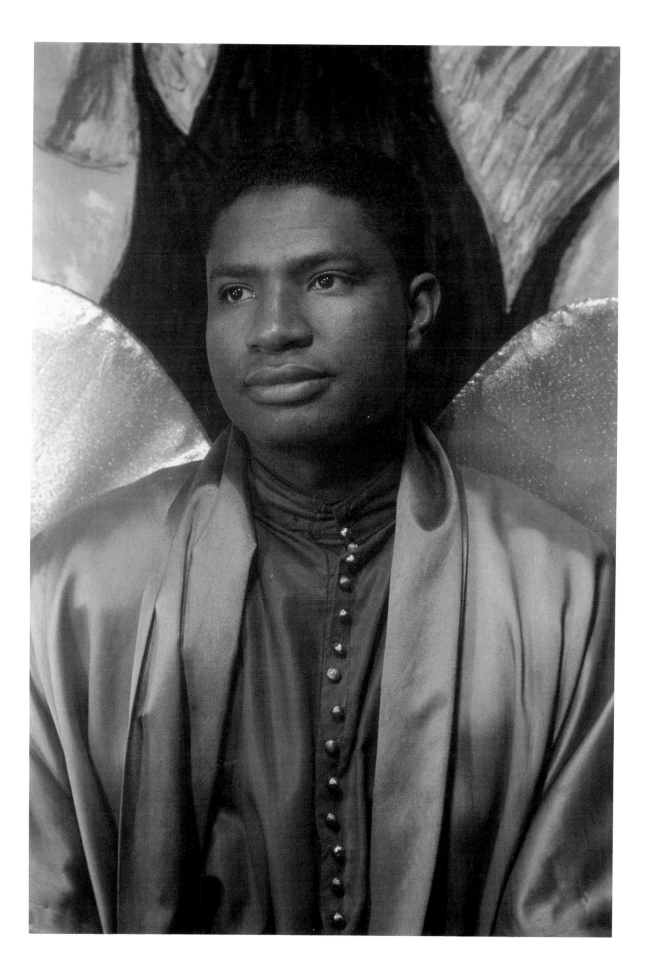

Dizzy Gillespie

(John Birks Gillespie)

December 2, 1955

Trumpeter, composer, and bandleader

Dizzy Gillespie (1917–92) began his musical training at home in Cheraw, South Carolina. Inspired by the example of his father, who was a part-time bandleader, Gillespie taught himself to play trombone, trumpet, and cornet. His dedication and musical ability enabled him to attend Laurinburg Institute, a black preparatory school in Laurinburg, North Carolina. In 1935 he joined a Philadelphia band led by Frankie Fairfax, and his energetic and comedic playing in that band earned him the sobriquet by which he was known throughout the world of jazz. Gillespie was an admirer of the trumpeter Roy Eldridge but began developing his own distinctive style known as "bop" as a participant in jam sessions with Charlie Parker, Thelonious Monk, and Kenny Clark. He collaborated with the jazz singer and bandleader Ella Fitzgerald and played in bands under the direction of Cab Calloway, Duke Ellington, and Coleman Hawkins. Gillespie was a prolific composer, and many of his compositions are regarded as jazz classics: some of the most enduring are "A Night in Tunisia," "Cool World," "Salt Peanuts," and "Hot House." He is widely acclaimed as one of the major figures in modern jazz, and his many honors include the Jazz Master Award, the Jazzmobile's Paul Robeson Award, and being named Downbeat Magazine Musician of the Year.

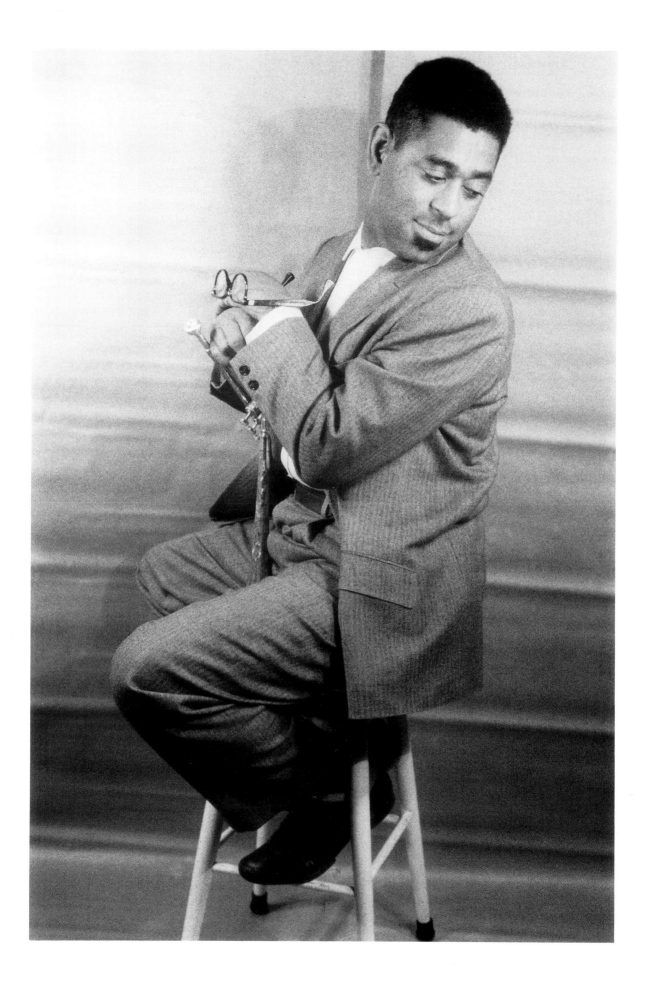

Ella Fitzgerald

January 19, 1940

Jazz singer, songwriter, and bandleader

Ella Fitzgerald (b. 1918) is a native of Newport News, Virginia, but spent her childhood and adolescence in Yonkers, New York, where she briefly attended an orphanage school after her mother's death. In 1934 she sang in an amateur contest sponsored by the Apollo Theatre in Harlem, and her winning performance earned her an engagement with Chick Webb, who subsequently became her mentor and legal guardian. As the principal vocalist for Webb's band, Fitzgerald made her debut at the Savoy Ballroom at the age of seventeen and soon established herself as the leading figure in the swing era with such classics as "A-tisket, A-tasket" and "Undecided." When Webb died in 1939, Fitzgerald led the band for three years, thereafter embarking upon a successful solo career. In 1946 Fitzgerald began a fruitful collaboration with Norman Granz's Jazz at the Philharmonic, a collaboration that led to her decision not to renew her contract with Decca Records but to join Granz's newly established Verve label. During this period, Fitzgerald and Granz produced with Nelson Riddle a series of albums known as "songbooks" dedicated to American songwriters. In addition to her work with Granz, Fitzgerald continued to perform in a jazz band led by her former husband, Ray Brown, and in succeeding years was frequently a guest performer with Duke Ellington, Count Basie, Oscar Peterson, and Joe Pass. A jazz singer of international stature, she is also an accomplished songwriter whose compositions were recorded by Billie Holiday, Duke Ellington, and Nat King Cole. Fitzgerald is admired for her improvised scat solos as well as for her talent for mimicry. Her many honors include a dozen Grammy Awards, the National Medal of the Arts, honorary degrees from Howard University, Dartmouth College, and Talladega College. Fitzgerald's extensive collection of scores, photographs, and memorabilia are part of the Department of Special Collections of the Mugar Memorial Library at Boston University.

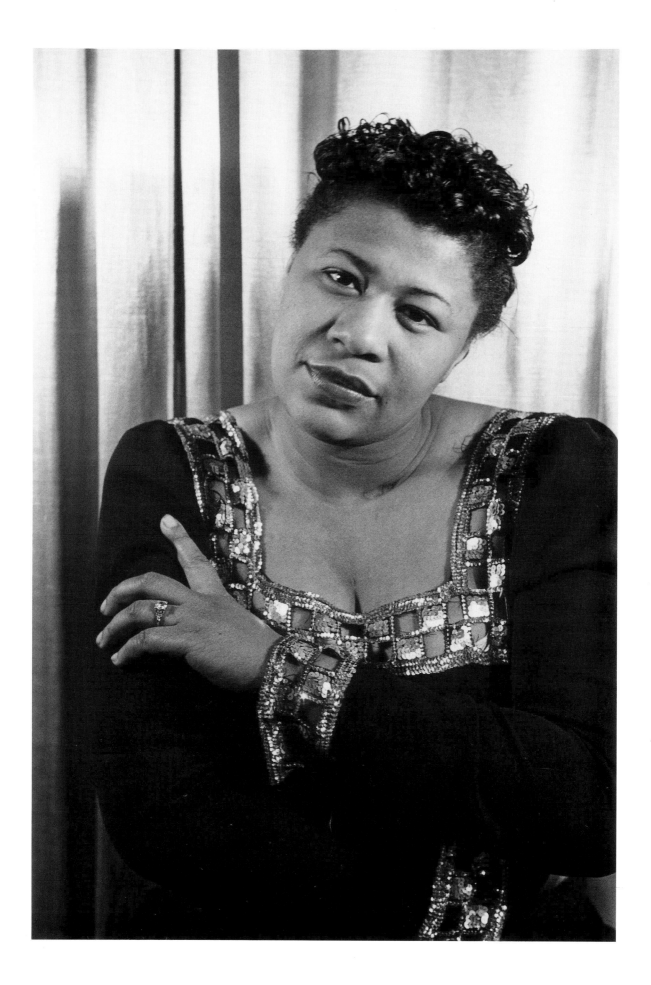

Pearl Bailey

July 5, 1946

Singer, actress, and humanitarian

Pearl Bailey (1918–90), born in Newport News, Virginia, spent the early years of her life in Philadelphia, where she attended the Joseph Singerly School and William Penn High School. Her career in entertainment began in 1933 when she won an amateur contest at the Pearl Theatre in Philadelphia, and her passion for entertainment soon took her to New York City, where she, like Ella Fitzgerald, won an amateur contest at Harlem's Apollo Theatre. By the mid 1930s Bailey was performing with bands led by Noble Sissle, Cootie Williams, and Count Basie. Her critically acclaimed solo performances at New York City's Village Vanguard and Blue Angel in 1944 led to collaborations with the bandleader and singer Cab Calloway at the Strand Theater. In 1946 she made her Broadway debut in the successful *St. Louis Woman,* a musical inspired by the compositions of W. C. Handy. Her moving and imaginative renditions of "Legalize My Name" and "Its a Woman's Prerogative" established her as a major figure in the performing arts. In 1954 Bailey returned to Broadway to perform in Truman Capote and Harold Arlen's *House of Flowers,* which at various periods during its run featured Diahann Carroll, Alvin Ailey, Carmen de Lavallade, and Geoffrey Holder. Of Bailey's many film credits, *Carmen Jones* (1954) featuring Harry Belafonte, *That Certain Feeling* (1956), *St. Louis Blues* (1958), and *Norman . . . Is That You?* (1976) are the most notable. In 1952 Bailey married the jazz drummer Louie Bellson, her third husband, with whom she recorded and performed throughout the 1960s. During this period she returned to the stage to perform with Cab Calloway in an all-black version of *Hello Dolly* for which she received a Tony Award in 1968. A performing artist whose talent enlarged the worlds of theater, film, and television, Bailey was appointed "Ambassador of Love" by President Richard Nixon in 1970, and in 1975 she was appointed special representative to the United States delegation to the United Nations. Two years before her death, President Ronald Reagan awarded Bailey the Medal of Freedom.

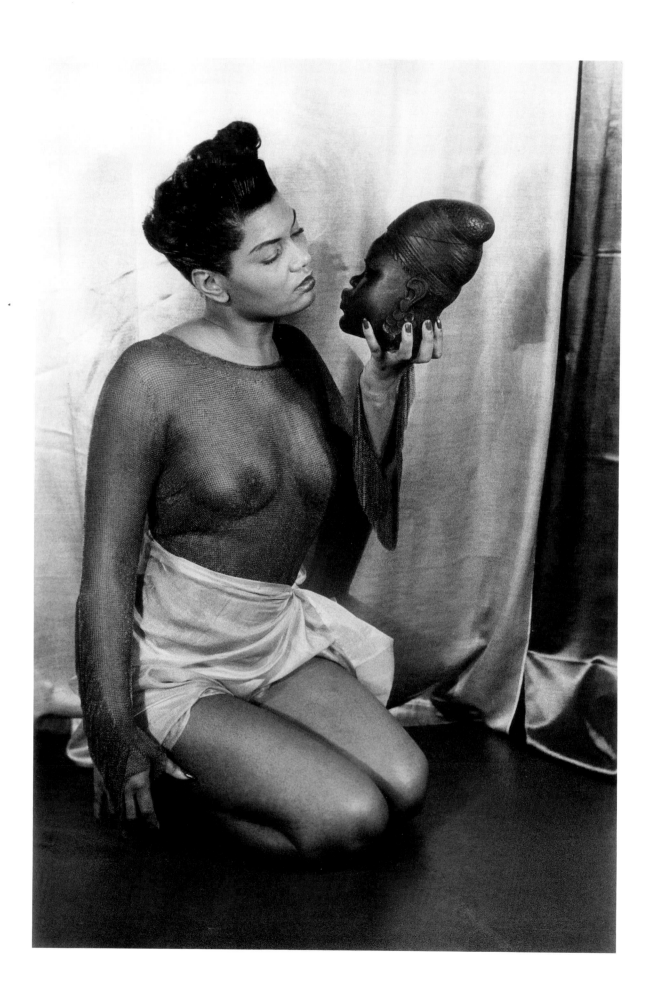

Pearl Primus

October 11, 1943

Dancer and choreographer

A pioneer in American dance, Pearl Primus was born in 1919 in Trinidad but grew up in New York City. She attended Hunter College High School and Hunter College, where she prepared for a career in health education. She had neither interest in nor exposure to dance until early adulthood. Unable to find employment in health education, Primus signed on as an understudy in a dance performance sponsored by the National Youth Administration. Captivated by this first encounter with the art form she would eventually revolutionize, Primus successfully competed for a dance scholarship offered by the New Dance Group, and in July 1941 she became the first black student to study dance at this New York–based institution. Nearly two years later, she made her New York City debut as a dancer in a performance at the New York Young Men's Hebrew Association on February 14, 1943. This successful debut was followed by solo performances at the Cafe Society Downtown, Cafe Society Uptown, and again at the YMHA. In 1948 Primus was awarded the last fellowship of the Rosenwald Foundation, which several years earlier had supported the research of Katherine Dunham, another pioneer in American dance. Initially, Primus had planned to spend her year as a Rosenwald Fellow choreographing a dance based on a sermon from James Weldon Johnson's *God's Trombones* (1927); instead, Primus spent her fellowship year studying traditional African dance in Liberia. She subsequently studied African dance in Ghana, Angola, Cameroon, Senegal, and Zaire. In 1959 she established with her husband, Percival Borde, a dance group called Pearl Primus, Percival Borde, and Company. Incorporating dance techniques from Africa and the Caribbean, Primus and Borde performed in the United States and Europe. Primus has developed dance curricula for primary and secondary schools and was appointed professor of ethnic studies at the Five Colleges, an educational consortium that includes Amherst, Smith, Hampshire, and Mount Holyoke colleges and the University of Massachusetts.

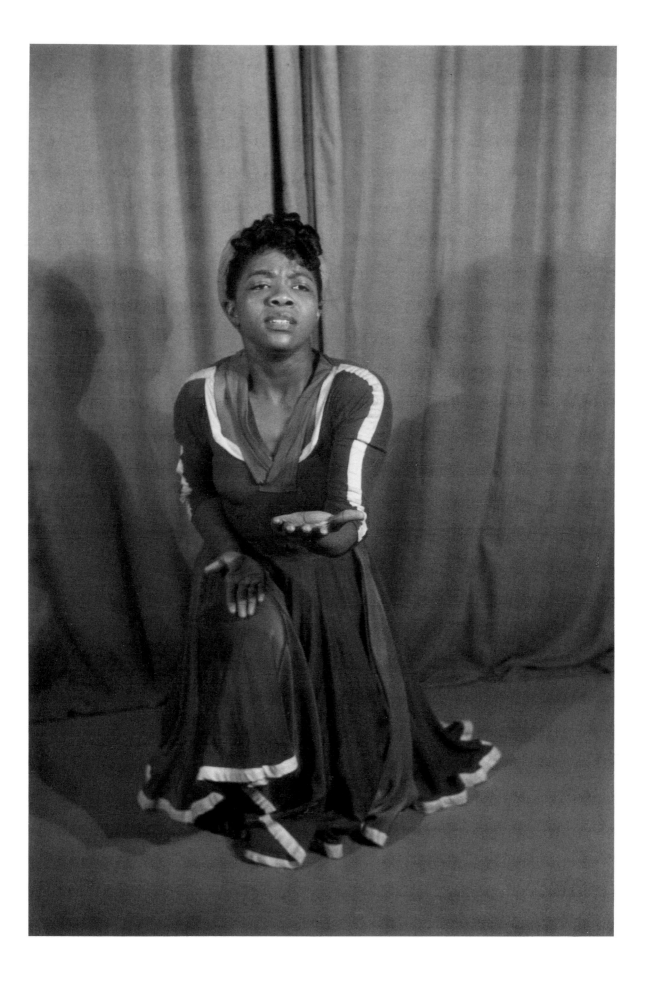

William Warfield

February 7, 1951

Opera singer

William Warfield, one of the greatest baritones of this century, was born in 1920 in West Helena, Arkansas. He received his training in voice and music at the Eastman School of Music at the University of Rochester, where he completed his baccalaureate in 1942. Warfield subsequently pursued advanced studies in music and voice at the American Theatre Wing from 1948 to 1950, studied voice from 1958 to 1965 with Rosa Ponselle, and earned a doctor of music from Millikin University. He made his debut as Aneas in *Set My People Free* in 1948. Four years after this successful debut Warfield appeared in the Broadway production of the opera *Porgy and Bess* with Leontyne Price, to whom he was married from 1952 to 1954. In addition to *Porgy and Bess,* Warfield's many stage credits include *Show Boat* and solo performances at Alice Tully Hall and Carnegie Hall. In 1951 he appeared in the film adaptation of *Show Boat,* and six years later he appeared in the television adaptation of *The Green Pastures.* In 1990 Warfield retired as chair of the department of voice at the University of Illinois at Urbana-Champaign, where he had been a member of the faculty since 1975. Warfield's many honors include the Governor's Award for the State of Illinois, induction into Illinois's Lincoln Academy, and a Grammy Award for his narration of Aaron Copland's *Lincoln Portrait.* He is the author of an autobiography entitled *William Warfield: My Music and My Life* (1991).

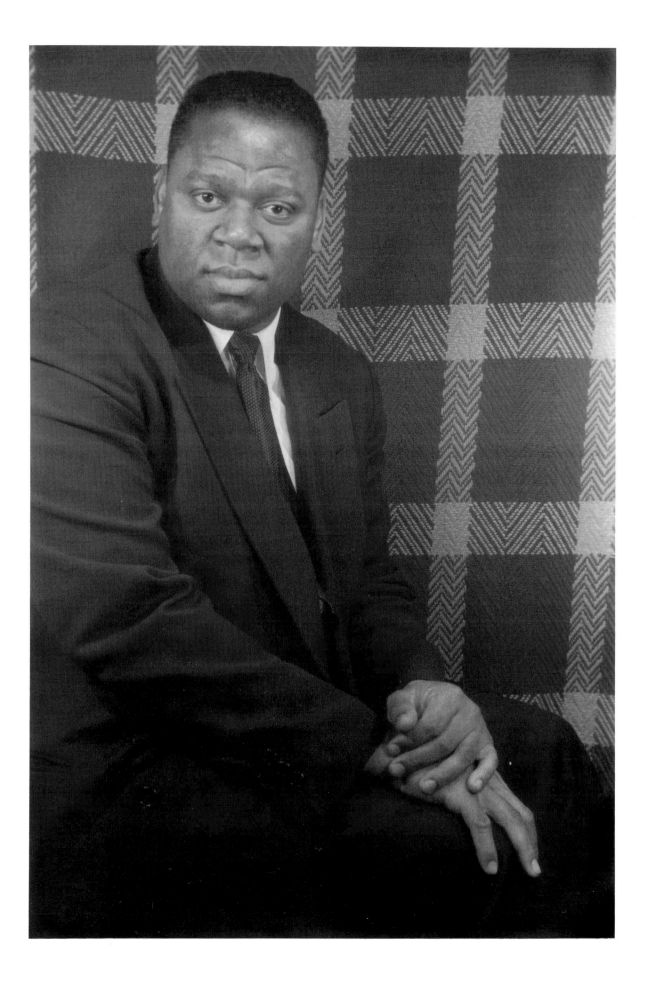

William Demby

March 13, 1956

Novelist

William Demby (b. 1922) left his native Pittsburgh, Pennsylvania, to attend West Virginia State College. His undergraduate education was interrupted by a period of service in the United States Army during World War II. It was during his period of military service that Demby began practicing the craft of writing as a contributor to the Army's *Stars and Stripes*. After completing his military service, Demby resumed his undergraduate education at Fisk University. Graduating from Fisk University in 1947, he traveled to Italy, where he studied art at the University of Rome. He remained in Italy until 1969 and while there wrote *Beetlecreek* (1950) and *The Catacombs* (1965); the latter novel earned him high praise and established him as an important writer of the 1960s. After returning to the United States, Demby taught at the College of Staten Island. His most recent novel, published in 1978, is *Love Story Black*.

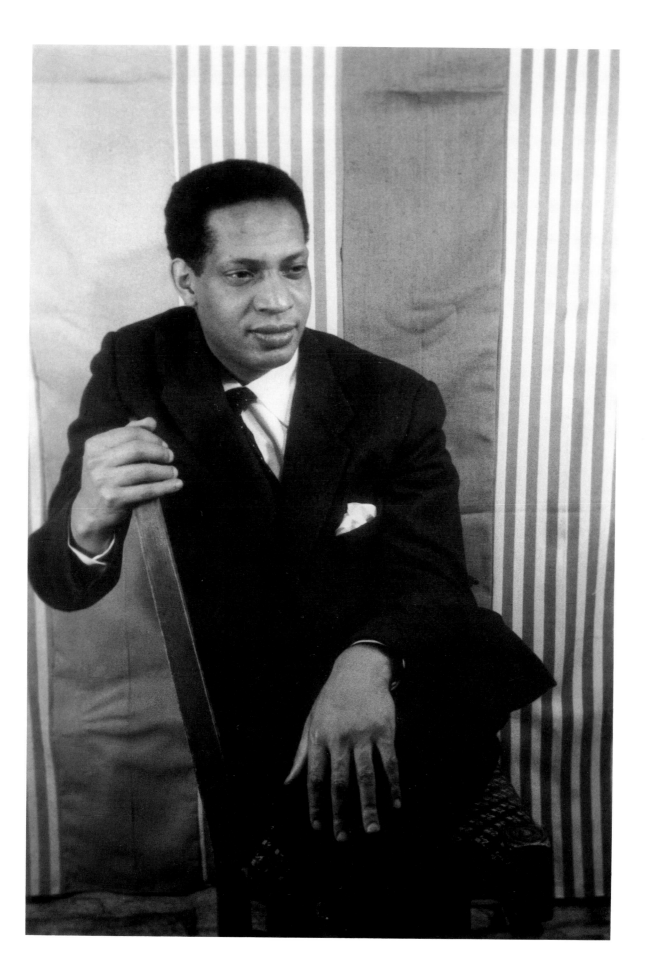

Ruby Dee

(Ruby Ann Wallace)

September 25, 1962

Actress

Ruby Dee (b. 1924) is a native of Cleveland, Ohio, but was reared in Harlem. Her love of language and performance was nurtured at home, for family members often read aloud to each other from the works of such poets as Paul Laurence Dunbar and William Wordsworth. Dee attended Hunter College High School and Hunter College. In 1941 she began her apprenticeship as an actress with the American Negro Theatre and there met Sidney Poitier, Hilda Simms, and Harry Belafonte. Her stage debut was in 1943 in *South Pacific.* Three years later she appeared with Ossie Davis in *Jeb Turner,* and in December 1948, during a break in the rehearsals for their roles in Garson Kanin's *Smile in the World,* she and Davis were married. Dee's many stage credits include Lorraine Hansberry's *Raisin in the Sun* (1959), *Boseman and Lena* (1970), for which she received an Obie Award, and *Purlie Victorious* (1961), written by Davis. In 1965 she became the first African American actress to appear in major roles at the American Shakespeare Festival at Stratford, Connecticut. She is a commanding presence on the stage as well as on the screen, and her many films include *The Jackie Robinson Story* (1950), *Edge of the City* (1957), *St. Louis Blues* (1958), *A Raisin in the Sun* (1961), and *Do the Right Thing* (1989) and *Jungle Fever* (1991), by the director Spike Lee. Her television credits are impressive and include an Emmy award–winning performance in "East Side, West Side" and a solo performance in an adaptation of the life and work of Zora Neale Hurston for public television. A strong advocate for civil rights, Dee has been active in the Southern Christian Leadership Conference and has staged benefits for the Black Panthers. To encourage African American women to enter the acting profession, Dee established the Ruby Dee Scholarship in Dramatic Art. Her many honors include not only an Emmy and an Obie but also the Operation Push Award, the Drama Desk Award, and the Ruby Dee and Ossie Davis Collection of Black Film, established in April 1992 by the Afro-American Studies Program of Yale University.

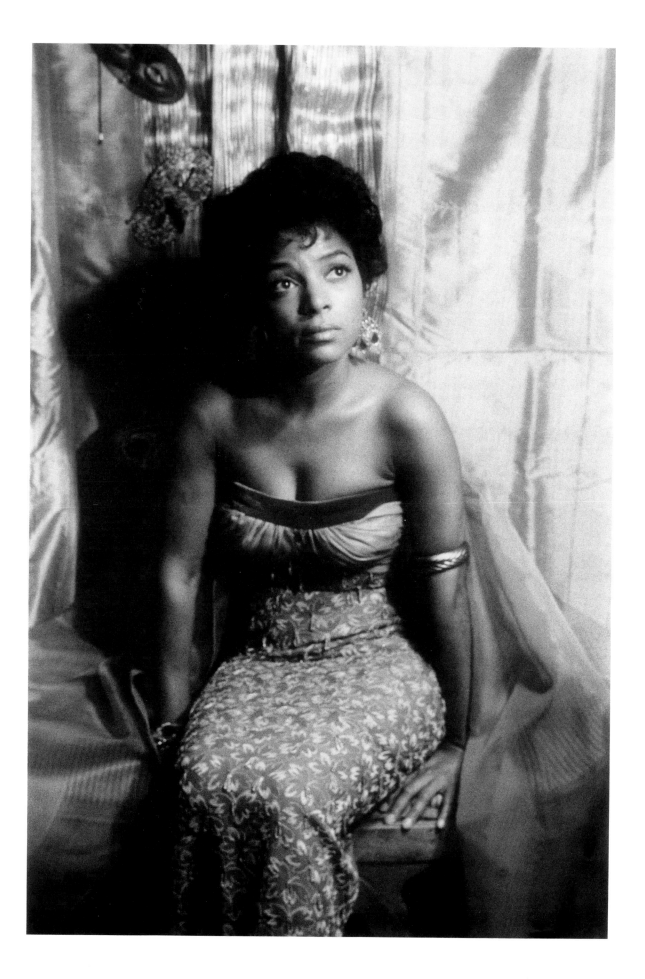

James Baldwin

September 13, 1955

Novelist, dramatist, and essayist

Born in Harlem, James Baldwin (1924–87) attended public schools in New York City, including De Witt Clinton High School in the Bronx. Deeply interested in writing and reading, he found support for these interests in high school through contact with the poet Countee Cullen. Baldwin made his debut as a writer in 1946 with the publication of a book review in the *Nation*. Subsequently, he wrote reviews for *New Leader* and *Commentary*. With support from a Rosenwald fellowship Baldwin completed his first short story, "Previous Condition," which appeared in *Commentary* in October 1948. With his last check from the Rosenwald Foundation, Baldwin left New York City for Paris in November 1948, where he renewed his acquaintance with Richard Wright, through whose advocacy Baldwin had received in 1945 the Eugene F. Saxton Memorial Trust Award to complete *Go Tell It on the Mountain* (1953). During the five years before the publication of *Go Tell It on the Mountain,* Baldwin remained in Paris and supported himself by writing book reviews, the most controversial of which was "Everybody's Protest Novel." Baldwin miscalculated the effect this assessment of *Native Son* would have upon Wright, and the publication of the review marked the end of their friendship. *Go Tell It on the Mountain* established Baldwin as a writer of national importance, and this achievement in fiction was soon followed by such novels as *Giovanni's Room* (1956), *Another Country* (1962), *Tell Me How Long the Train's Been Gone* (1968), *If Beale Street Could Talk* (1974), and *Just Above My Head* (1979). Baldwin was the author of several plays, the most notable of which is *The Amen Corner* (1968), a drama that marks his return to the questions of faith and identity he first addressed in *Go Tell It on the Mountain*. Baldwin worked in several genres, but he was a master of the essay, and *Notes of a Native Son* (1955), *Nobody Knows My Name* (1961), *The Fire Next Time* (1963), and *The Price of the Ticket* (1985) are proof not only of this mastery but also of the depth of his involvement in such issues as race, culture, and politics. Baldwin lectured at colleges and universities across the country, including the University of Massachusetts, Howard University, Yale University, and Emory University. Among his many honors are the Paul Robeson Medal and France's Legion of Honor and Monarch Award.

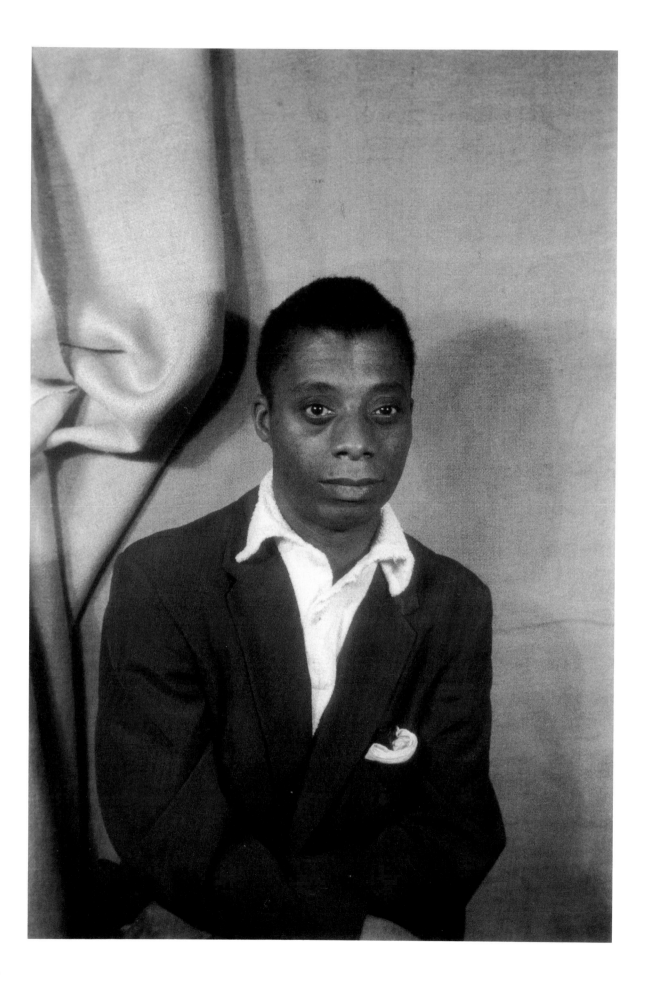

Bobby Short

(Robert Waltrip)

January 3, 1962

Jazz singer and musician

A native of Danville, Illinois, Bobby Short (b. 1926) established his reputation as one of the nation's most popular and sought after cafe singers at such jazz clubs as the Gala in Hollywood, the Haig in Los Angeles, and the Blue Angel in New York City. Since 1968 he has performed with his own trio at the Carlyle Hotel in New York City, and it is from this venue that he has appeared at Avery Fisher Hall and Carnegie Hall, in New York; at the Westwood Playhouse in Los Angeles; at the Fox Theatre, in Atlanta; and at Theatre on the Square, in San Francisco. Specializing in the songs of Cole Porter, Noel Coward, Ira Gershwin, Duke Ellington, and Billy Strayhorn, Short has also performed at the most exclusive jazz clubs in the United States and in Europe. He is a prolific artist, and among his many albums is *Guess Who's in Town*. He has received the Harold Jackman Memorial Award and numerous other honors. Fully committed to preserving the musical tradition that has been his life's work, Short is the founder of the Duke Ellington Memorial Fund and is a member of the board of directors of the Third Street Musical Settlement.

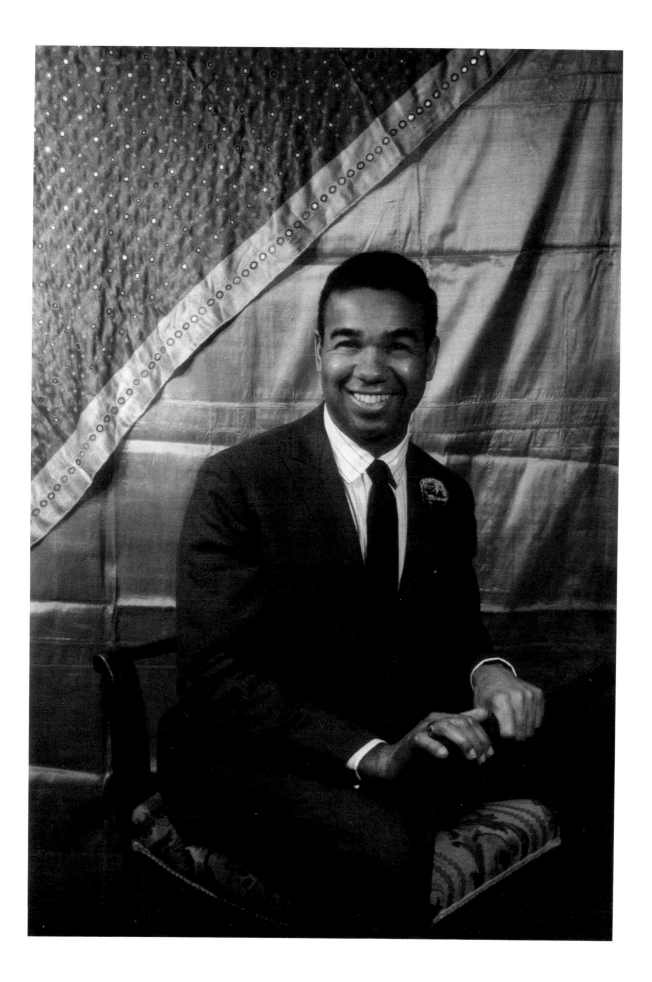

Mattiwilda Dobbs

January 26, 1955

Opera singer and educator

Mattiwilda Dobbs (b. 1925) credits her father, John Wesley Dobbs, with inspiring her to pursue a career in music. She received her training in music and foreign languages at Spelman College in Atlanta, Georgia, the city of her birth, and studied voice with Naomi Maise and Willis Lawrence. In 1948 Dobbs was awarded the Marian Anderson Scholarship, and a year later she was awarded a scholarship to the opera workshop of the Berkshire Music Center at Tanglewood. In 1950 she won a John Hay Whitney Fellowship, which enabled her to study voice in Paris with Pierre Bernac. While on the Continent, Dobbs won first prize in the International Music Competition in Geneva. This triumph in Geneva was followed by another three years later in Genoa, where Dobbs, at the invitation of Herbert von Karajan, was the first African American to sing at La Scala. This victorious departure from tradition at La Scala was repeated during her American debut at the San Francisco Opera, where she was the first African American to play a major role in that company, and at the Metropolitan Opera in New York City, where she was the first African American to sing a romantic lead. In the Soviet Union, Dobbs was the first artist in the Metropolitan Opera's long history to perform at Moscow's renowned Bolshoi Theater. As one of the most accomplished lyric sopranos of this century, she has performed at the great opera houses of Europe, including a command performance before Queen Elizabeth II at the Royal Opera in London. In 1962 Dobbs returned to Atlanta, where she gave a concert at the municipal auditorium, thus avoiding the insult of segregated seating arrangements at the Fox Theatre. For this memorable concert and triumphant return, Dobbs was awarded the key to the city. In 1974 she again sang in Atlanta, at the inauguration of Maynard H. Jackson, her nephew and the first African American mayor of that city. She has held distinguished visiting professorships at the University of Texas at Austin, the University of Illinois at Urbana-Champaign, Howard University, and Spelman College. Among her many awards are the Order of the North Star, given to her by King Gustav Adolf of Sweden; the James Weldon Johnson Award in Fine Arts, from the Atlanta chapter of the National Association for the Advancement of Colored People; and an honorary doctorate from Spelman College.

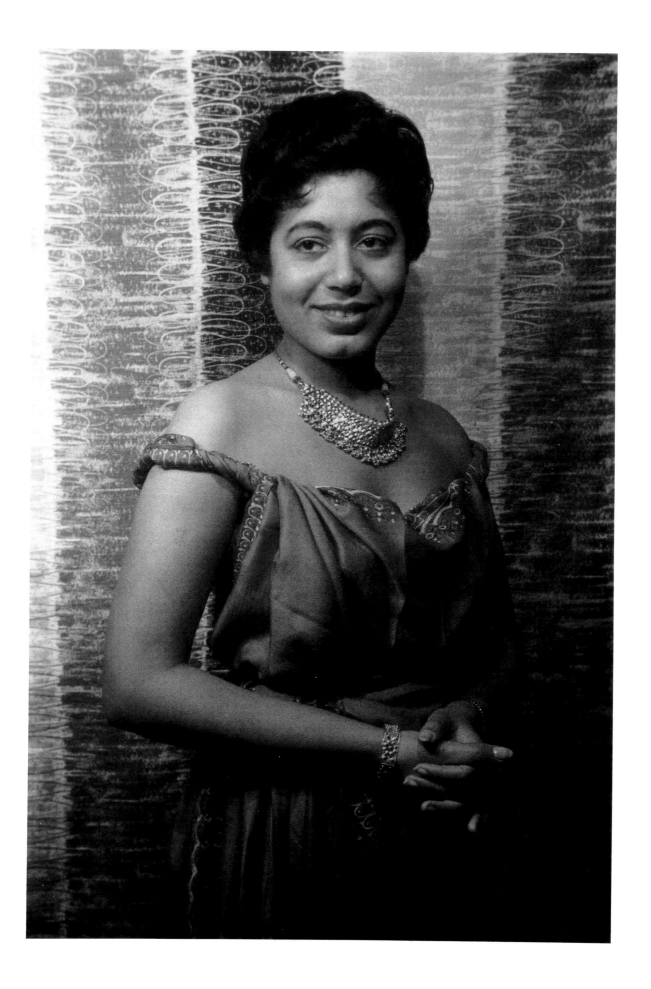

John Alfred Williams

July 3, 1962

Novelist and educator

John Alfred Williams was born in Jackson, Mississippi, in 1925. After service in the navy, he earned his bachelor's degree in English and journalism from Syracuse University in 1950. It was during his tenure as an assistant to the publisher at the publishing house of Abelard-Schuman that Williams wrote and published his first novel, *The Angry Ones* (1960). This novel was followed by eight more, including the celebrated *The Man Who Cried I Am* (1967), which earned Williams an honored place among the many talented writers of the 1960s. Williams is the author of several books of nonfiction and the co-author, with Dorothy Sterling, of *The Most Native of Sons: A Biography of Richard Wright* (1970). He has taught at the College of the Virgin Islands, the City College of New York, and Sarah Lawrence College and is currently a professor of English at Rutgers University. A recipient of Syracuse University's Centennial Medal for Outstanding Achievement, Williams is a member of the National Institute of Arts and Letters.

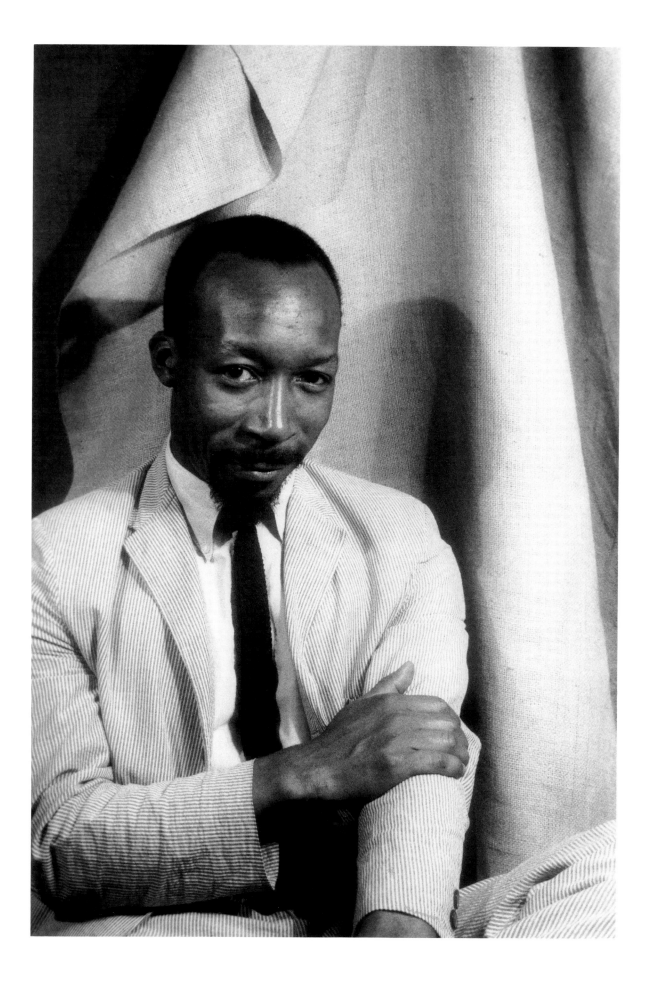

Earle Hyman

April 30, 1956

Actor

Earle Hyman (b. 1926), an actor who first established his reputation in the theater for his skill in interpreting the classic roles created by Shakespeare, is a native of North Carolina. He received his training as an actor at the American Negro Theatre and at the age of seventeen made his Broadway debut in *Anna Lucasta* (1944). During the 1960s Hyman earned high praise for his Broadway performance in *Mister Johnson* (1956). Between 1955 and 1960, he performed leading roles with the American Shakespeare Theatre and with Shakespearian companies in Norway, where he was the first American to perform a title role in a Scandinavian language. Hyman's outstanding stage performances in Norway earned him membership in the Norwegian Society of Artists; he is the first American to be so honored. While Hyman has had a long and distinguished career in the theater, he is best known to contemporary audiences for his many appearances on "The Cosby Show." He was awarded the State Award, in Oslo, Norway, for his portrayal of the leading role in *The Emperor Jones* (1965).

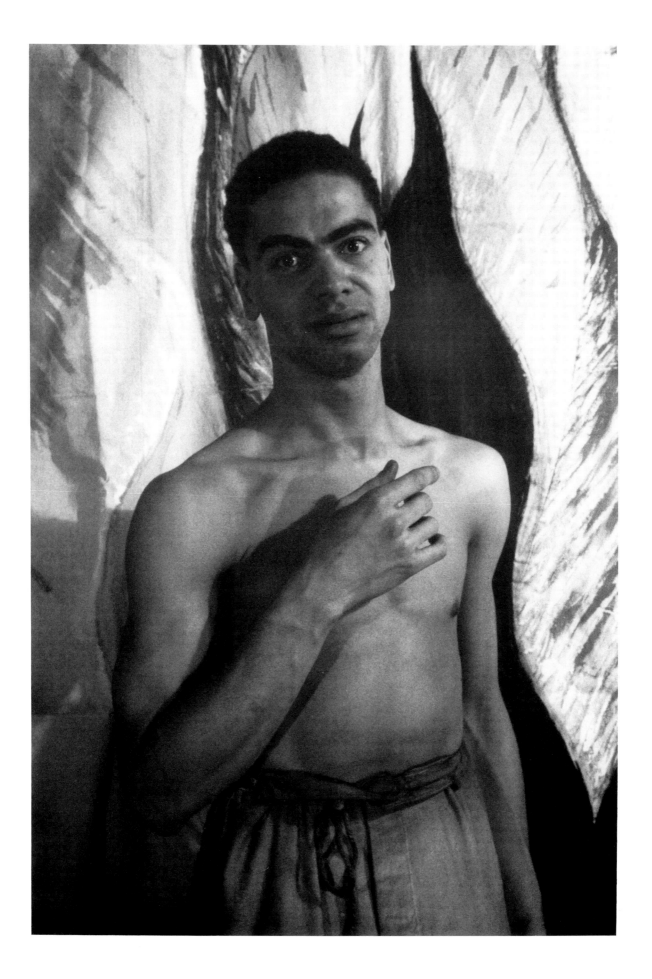

Althea Gibson

November 18, 1958

Tennis champion and golfer

Althea Gibson (b. 1927) was born in Silver, South Carolina, but spent her childhood and adolescence in Harlem. She came to tennis by way of paddleball, which she played on the streets. In 1940 Gibson was given her first tennis racket by Buddy Walker, a community-based athletic director who encouraged her to take tennis lessons from Fred Johnson at the Harlem River Courts. Gibson began her tennis lessons with Johnson in 1941. A year later she won first prize in a tournament sponsored by the American Tennis Association, the black counterpart of the United States Lawn Tennis Association. While playing in the 1946 ATA Nationals, Gibson met Dr. Hubert A. Eaton and Dr. R. Walter Johnson, two physicians who became her mentors. They encouraged her to complete her high school education and provided her with the moral and financial support to compete at the highest levels of tennis. With the backing of Eaton, Johnson, and the world welter-weight champion Sugar Ray Robinson, Gibson successfully overcame the racial barriers of tennis, just as Jackie Robinson, her contemporary, overcame the racial barriers in baseball. Only four years after her victory at the 1946 ATA Nationals, Gibson became the first African American to compete at the United States Open. One victory quickly followed another, and in 1951 Gibson became the first African American to compete at Wimbledon, England. Six years later, Gibson was the first African American to win in both singles and doubles at Wimbledon. In that same year Gibson emerged as the undisputed champion in the United States women's singles competition at Forest Hills. In 1958 Gibson repeated this unprecedented round of victories by emerging again in first place at the United States Open, Wimbledon, and Forest Hills. She joined the Ladies Professional Golf Association in 1963 but remains an avid player and fan of tennis. Deeply committed to fairness and opportunity in sports, Gibson was named special consultant to the New Jersey Governor's Council of Physical Fitness in Sports in 1988.

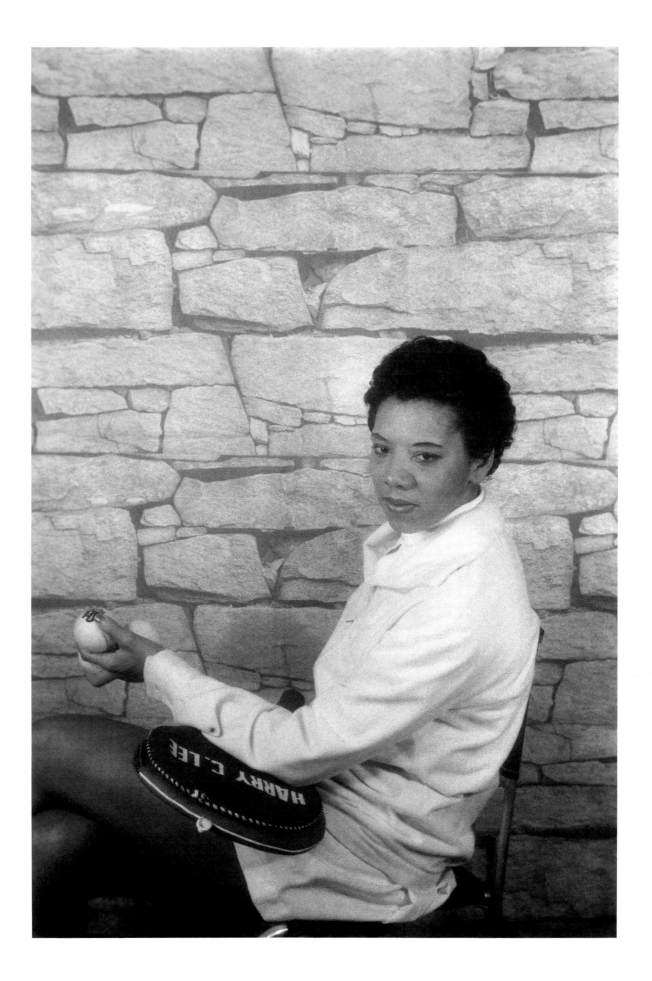

Harry Belafonte

February 18, 1954

Singer, actor, and humanitarian

Harry Belafonte (b. 1927) was born in New York City, where he attended George Washington High School. After completing two years of service in the United States Navy in 1945, he enrolled in the Dramatic Workshop at Manhattan's New School for Social Research. Belafonte participated in this acting workshop from 1946 to 1948 while acquiring additional training as an actor through the American Negro Theatre, where he met such actors as Sidney Poitier and Ruby Dee. Soon thereafter Belafonte made his stage debut at the Village Vanguard in Greenwich Village. While Belafonte captivated American audiences with his fine stage performances and his sensual and authentic renditions of Caribbean folk songs, it is through film that he established a national reputation as a performing artist. His many films include *Bright Road* (1953), *Carmen Jones* (1954), *Island in the Sun* (1957), and *The World, the Flesh, and the Devil* (1959). Belafonte set aside his work as a performing artist to assume important leadership positions in the civil rights movement in the 1960s but returned to film in the 1970s as both a producer and an actor in such films as *The Angel Levine* (1970) and *Buck and the Preacher* (1972). He has produced and acted in television features, most notably "A Time for Laughter: A Look at Negro Humor," which featured such performers as Richard Pryor, Sidney Poitier, and Diahann Carroll. Belafonte's long career reflects a commitment to social activism. In 1987 he was appointed Ambassador for the United Nations International Children's Emergency Fund. He is a member of the New York State Martin Luther King Jr. Institute for Nonviolence, and his many honors include an Emmy, the Mandela Courage Award, and an honorary doctor of arts from the New School for Social Research.

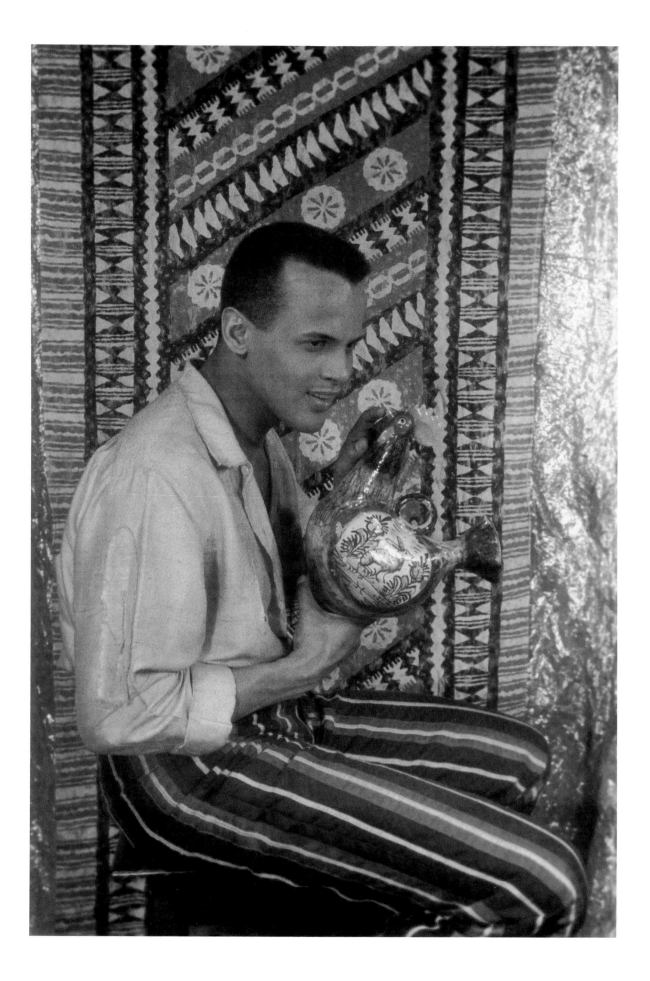

Leontyne Price

May 19, 1953

Opera singer

One of the greatest lyric sopranos of this century, Leontyne Price (b. 1927) was born in Laurel, Mississippi. She began her study of music with piano lessons at the age of three, but the pivotal event in her childhood was a concert featuring Marian Anderson. After hearing Anderson, Price wished to do nothing but sing. Graduating from Oak Park Vocational High School, where she excelled in music, she left Laurel to study music and voice at Wilberforce University in Ohio. In 1949 she began her advanced training in voice and music at the Juilliard School of Music, studying vocal technique with Florence Page Kimball. In 1952, while married to William Warfield, Price appeared with him in the opera *Porgy and Bess*. In 1961, following in the wake of Marian Anderson and Mattiwilda Dobbs, Price performed at New York City's Metropolitan Opera. At the conclusion of her performance in Verdi's *Il Trovatore,* she received an unprecedented forty-two-minute standing ovation. She delivered 118 stellar performances at the Metropolitan Opera before her farewell performance on the same stage in *Aïda* in 1985. Price has performed at London's Covent Garden, the Vienna Arena, the Salzburg Festival, and La Scala. She was the first African American to appear in a televised production of an opera when, in 1955, she made her operatic debut in *Tosca*. Among her many honors are eighteen Grammy Awards, the Presidential Medal of Freedom, and membership in the American Academy of Arts and Sciences.

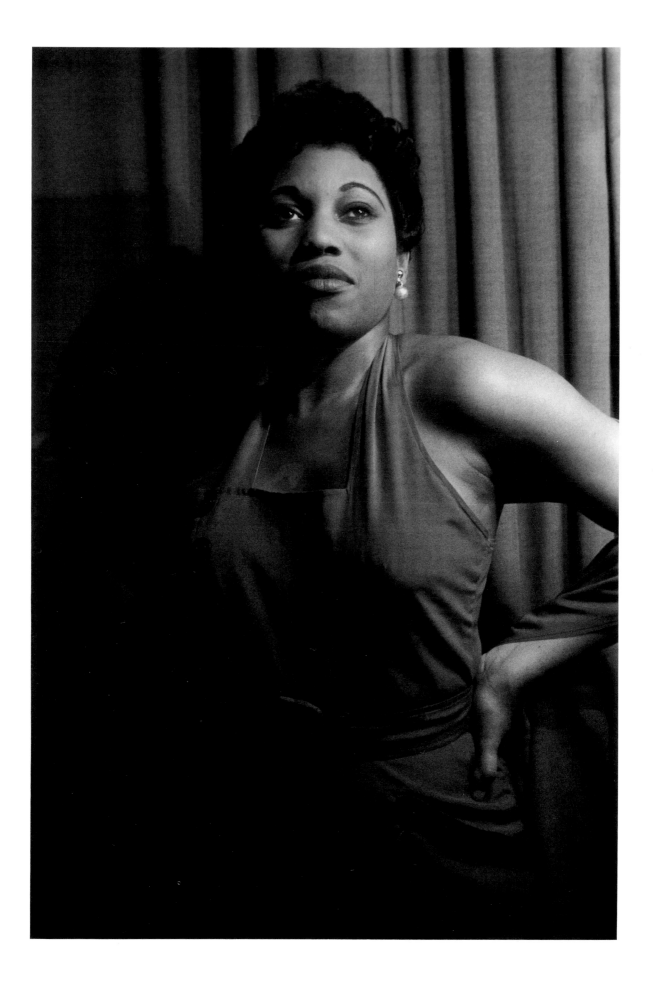

Eartha Kitt

October 19, 1952

Actress, singer, and dancer

Eartha Kitt (b. 1928) is a native of North, South Carolina. She received her early training in the performing arts at New York's High School of Performing Arts. While Kitt was still a teenager, Katherine Dunham selected her for the Dunham dance company and featured her in solo roles before audiences in the United States, Mexico, South America, and Europe. When the dance company returned to the United States, Kitt decided to remain in Paris, where she was engaged as a singer at Carroll's, one of Paris's most fashionable nightclubs. Kitt's success as a nightclub singer was replicated in New York City, where she performed before large and admiring audiences at the Village Vanguard and at the Blue Angel. Through the years, Kitt has appeared in such films as *St. Louis Blues* (1958) and, under the direction of Reginald and Warrington Hudlin, *Boomerang* (1992), performing alongside the dancer and choreographer Geoffrey Holder. Many of Kitt's memorable performances have been for the stage. She rose to national prominence in such productions as *New Faces* (1952), *Mrs. Patterson* (1954), *Shinbone Alley* (1957), and *Jolly's Progress* (1959). An unfortunate misinterpretation of comments she made at a White House luncheon hosted by Lady Bird Johnson concerning juvenile delinquency and the Vietnam War nearly extinguished Kitt's career as a performing artist, though she continued to work in Europe. Geoffrey Holder's successful Broadway musical *Timbuktu* (1978) marked the rebirth of Kitt's career in the United States. In addition to her many achievements in the theater and in film, Kitt is the author of two autobiographies, *Thursday Child* (1956) and *Alone with Me* (1976).

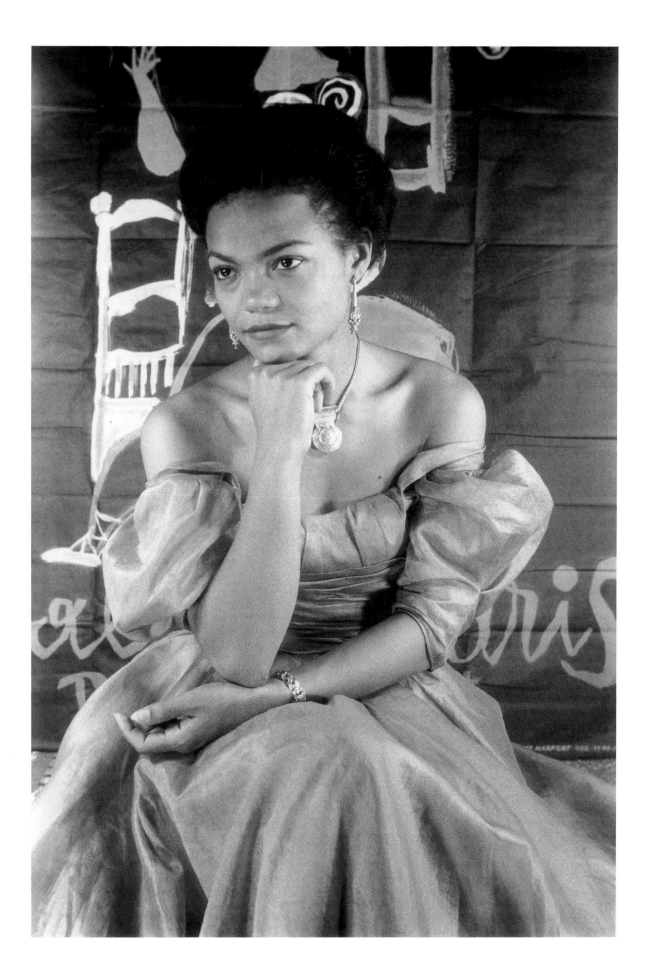

Geoffrey Holder

September 2, 1954

*Dancer, choreographer, costume designer,
director, and actor*

Geoffrey Holder (b. 1930) attended Queens Royal College in Trinidad, where he was born. His career as a professional dancer began in 1942, when he joined the Roscoe Holder Dance Company. Early successes with the Holder Dance Company were followed by performances with his spouse Carmen de Lavallade, the Harkness Ballet, Arthur Mitchell's Dance Theatre of Harlem, the Metropolitan Opera, and, in 1964, Josephine Baker and Her Company, which established Holder as a major figure in American dance. He has moved with ease from dance to choreography, and his many credits as a choreographer include *Mhil Daiim* (1964), with the Actors Studio Production. While Holder earned high praise as a dancer and choreographer, he broke new ground as a director and costume designer in *Timbuktu* (1978) and, more especially, in a Tony Award–winning production of *The Wiz* (1975). In his prize-winning television commercials as well as in his many films, the most recent of which is a performance alongside Eartha Kitt in *Boomerang* (1992) under the direction of Reginald and Warrington Hudlin, Holder emerges as an actor of tremendous talent and force. His own dance company has performed in the Caribbean and in the United States, and he has taught at the Katherine Dunham School in New York City and at Yale University. Holder has been honored with a Guggenheim Fellowship, two Clio Awards, two Tony Awards, and the Harold Jackman Memorial Award.

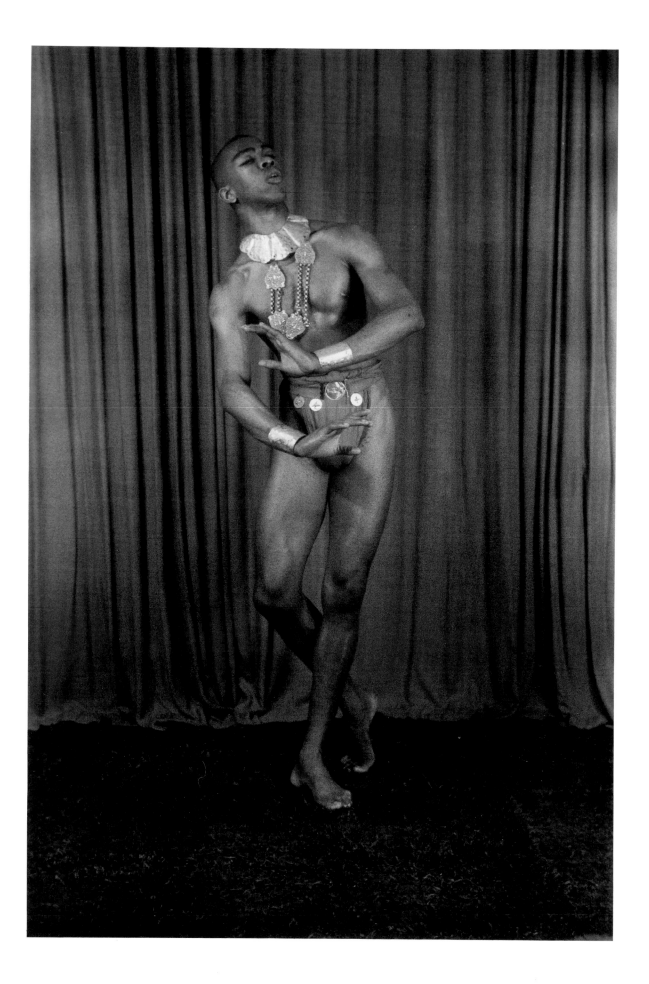

Alvin Ailey

March 22, 1955

Dancer and choreographer

Alvin Ailey (1931–89) was born in Rogers, Texas, but moved to Los Angeles at the age of twelve. In Los Angeles he was introduced to the world of dance by Lester Horton, a major figure in the arts community in black Los Angeles during the 1940s and founder of the Lester Horton Dance Company. Horton served as a teacher and mentor to Ailey, although Ailey himself was ambivalent about a career in dance. While attending the University of California at Los Angeles, Los Angeles City College, and San Francisco State University, Ailey continued to experiment with dance and to perform in productions staged and choreographed by Horton. In 1953 Horton suffered a fatal heart attack, and Ailey assumed responsibility for the completion of Horton's productions for the Massachusetts arts festival Jacob's Pillow. The critics were disdainful of Ailey's performance and choreography, but as a result of this shaping experience, Ailey made a lifetime commitment to dance. He made his New York City debut in Truman Capote's *House of Flowers* (1954), a production that also featured the dancer Carmen de Lavallade, another student of Lester Horton. While in New York City, Ailey studied modern dance with Martha Graham, ballet with Karel Shook, composition with Doris Humphrey, and acting with Stella Adler. In 1957 he danced in the musical *Jamaica,* starring Lena Horne, and two years later established his own dance company. With Judith Jamison as its principal dancer, the Alvin Ailey American Dance Theater rose to international prominence in the 1960s and 1970s. As a choreographer Ailey drew upon his training in classical ballet, folk dance, and modern dance to create such masterworks as *Blues Suite* (1958), *Revelations* (1960), *Cry* (1971), *Pas de "Duke"* (1976), and *The River* (1981). In addition to his successes as a choreographer and director of his own dance company, Ailey has staged operas at the Kennedy Center for the Performing Arts and at the Metropolitan Opera. Ailey's many honors include an honorary degree from Princeton University, the Spingarn Medal from the National Association for the Advancement of Colored People, the Capezio Award, and the Kennedy Center Honor for Lifetime Achievement in the Arts.

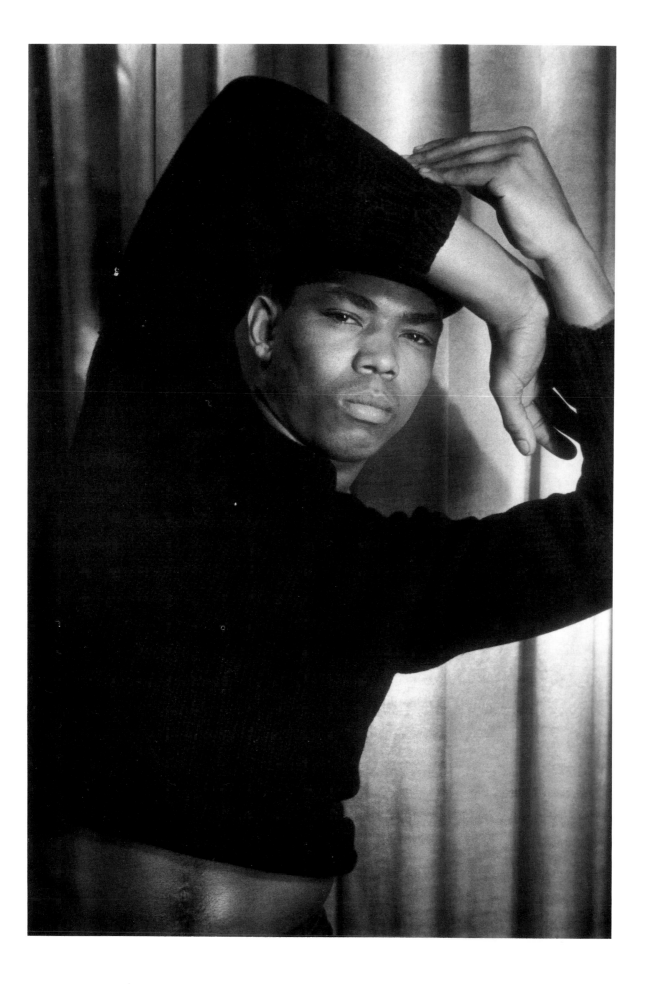

James Earl Jones

May 29, 1961

Actor

James Earl Jones (b. 1931), an actor who has earned international recognition for his prize-winning performances for the stage, television, and film, is a native of Arkabutla, Mississippi. He was introduced to the art and craft of acting by his father, Robert Earl Jones, a successful stage actor. After completing his baccalaureate at the University of Michigan in 1953, Jones pursued advanced study in acting at the American Theatre Wing in 1957, supplemented by acting lessons with Lee Strasberg. Jones's apprenticeship as an actor began with the New York Shakespeare Festival, where he appeared in productions of *Romeo and Juliet* (1955), *King Henry V* (1960), and *The Tempest* (1962). These critically acclaimed performances were followed by his 1968 Tony Award–winning performance in the Broadway production of *The Great White Hope*. Jones also starred in a Broadway production of the life of Paul Robeson, as well as in Athol Fugard's *Master Harold and the Boys* (1982) and in August Wilson's *Fences* (1987) under the direction of Lloyd Richards at the Yale Repertory Theatre. Jones has enjoyed considerable success not only on the stage but also in film and television. He made his film debut in *Dr. Strangelove* (1964), and since then he has appeared in such films as *The Great White Hope* (1970), for which he received an Oscar nomination, *Claudine* (1974), *Field of Dreams* (1989), and *The Patriot* (1992). In the *Star Wars* trilogy, he was heard as the voice of Darth Vader. His many television credits include *Roots: The Next Generation* (1979) and narration for the documentary *Katherine Dunham and Her People* (1980). Jones has received several Tony, Obie, and Emmy awards, as well as a medal for spoken language from the American Academy and Institute of Arts and Letters.

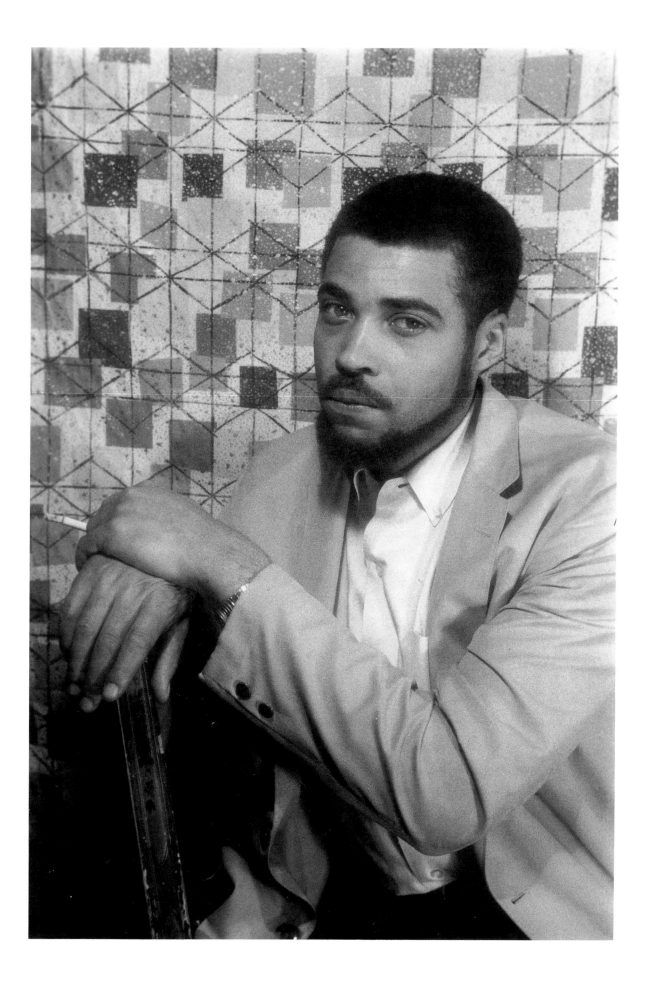

Carmen de Lavallade

March 3, 1955

Dancer and actress

Carmen de Lavallade was born in Los Angeles, California, in 1931. While attending Los Angeles City College from 1950 to 1952, de Lavallade was also a member of the Lester Horton Dance Company, the same company that provided the foundation in dance and choreography for Alvin Ailey. Like Ailey, de Lavallade made her New York City debut in Truman Capote's *House of Flowers* in 1954. Her critically acclaimed performance was followed by guest performances with the leading American dance companies, including those established by Alvin Ailey, Donald McKayle, Glenn Tetley, John Butler, Josephine Baker, and with her spouse, Geoffrey Holder. Moreover, de Lavallade has performed in productions of the Metropolitan Opera, the Boston Ballet, and the American Ballet Theatre. One of the most accomplished dancers of the post–World War II era, de Lavallade has also established a reputation for excellence as an actress. She has appeared in the movie classic *Carmen Jones* (1954) as well as four other films. Her many television credits include performances with the Bob Herridge Theatre in 1956, a production for public television entitled "The New Voice," and a guest appearance on "The Cosby Show." Fully committed to public service and teaching, de Lavallade has performed with the Countee Cullen Great Storytelling Services and was a professor of dance at Yale University's School of Drama. Honored for her achievements as a dancer and actress, de Lavallade is a recipient of the Dance Magazine Award and the Monarch Award and is a member of the Black Filmmakers Hall of Fame.

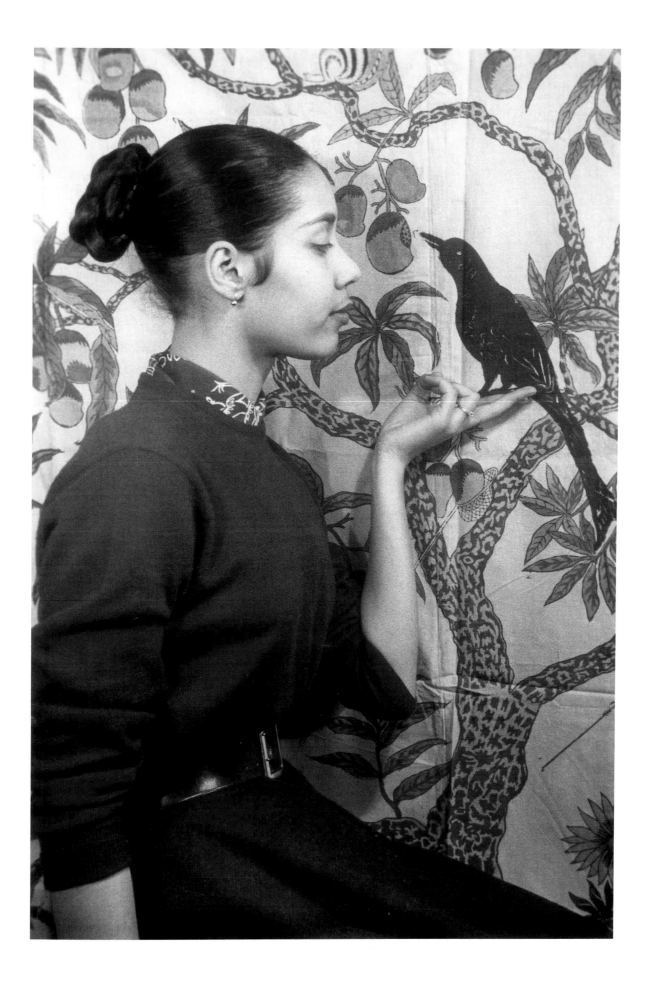

Arthur Mitchell

December 28, 1955

Dancer and choreographer

Founder and executive director of the Dance Theatre of Harlem, Arthur Mitchell was born in New York City in 1934. After graduating from that city's High School of Performing Arts in 1952 he studied dance on scholarship at the School of American Ballet. Like Alvin Ailey and Carmen de Lavallade, Mitchell danced in the Broadway adaptation of Truman Capote's *House of Flowers* in 1954. One year later his Broadway success was followed by a history-making invitation to join the New York City Ballet as the first African American to hold the position of principal dancer in one of the world's leading dance companies. The company's choreographer, George Balanchine, created a pas de deux in *Agon* especially for Mitchell, who was also featured as principal dancer in *A Midsummer Night's Dream,* among other Balanchine productions. Mitchell has performed as a guest artist for the Spoleto Festival of Two Worlds and the National Brazilian Ballet Company. Two of the many ballets choreographed by Mitchell are *Manifestations* (1975) and *Spiritual Suite* (1976). In 1969, he enriched the world of dance and created opportunities for generations of dancers by establishing the Dance Theatre of Harlem. Now recognized as one of the world's leading dance companies, the Dance Theatre of Harlem has performed in the United States, Europe, Africa, and the Caribbean. Mitchell's many honors include a Capezio Dance Award, the Changers Award, a medal from the New York State Board of Regents, and a certificate of recognition from the Harold Jackman Memorial Committee.

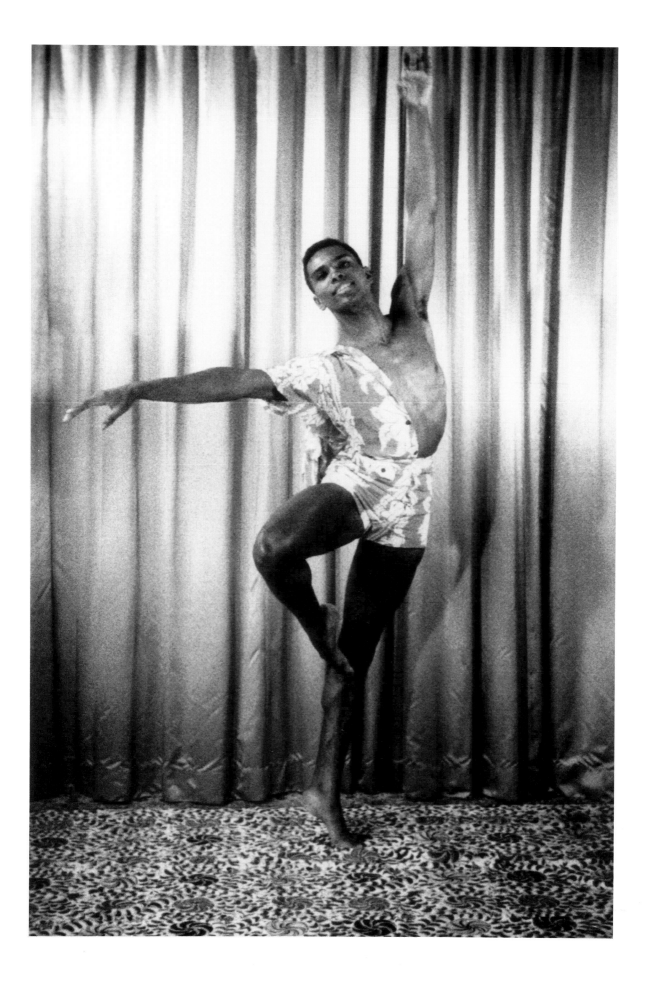

Imamu Amiri Baraka

(Everett LeRoi Jones)

January 3, 1962

Poet, dramatist, novelist, and essayist

Imamu Amiri Baraka (b. 1934) is a native of Newark, New Jersey, and there attended Central Avenue School and Barringer High School, from which he graduated in 1951. He was a scholarship student in science at Rutgers University, but after a year of study he transferred to Howard University, where he studied philosophy, literature, and sociology with the sociologist E. Franklin Frazier and the poet and critic Sterling A. Brown. After a period of service in the United States Air Force, Baraka settled in Greenwich Village, where he met Allen Ginsberg and other Beat poets. Baraka wrote for such magazines as *Naked Ear, Epos,* and *Evergreen Review* and established Totem Press, which published his first collection of poems, *Preface to a Twenty Volume Suicide Note . . .* (1961). During the 1960s Baraka emerged as the dominant figure in the Black Arts movement. In the Obie Award–winning play *Dutchman* (1964), in his examination of the dynamics of African American music, *Blues People* (1963), in his second collection of poems, *The Dead Lecturer* (1964), and in his collection of essays entitled *Home: Social Essays* (1966), Baraka established the terms of discourse and the objectives of black cultural production for many of the writers of his generation. As founder and director of the Black Arts Repertory Theatre and Spirit House Movers and Players in 1966, Baraka wedded the objectives of black art with the objectives of black revolution and in the process changed forever American theater and the relationship of the artist to society. One of the most prolific writers of this century, Baraka is the author of an autobiography, scores of books, plays, and anthologies, most notably *Black Fire: An Anthology of Afro-American Writing* (1968). As a professor of creative writing and English, Baraka has taught at the New School for Social Research, the State University of New York at Buffalo, Columbia University, and Yale University. He is currently a member of the faculty at the State University of New York at Stony Brook.

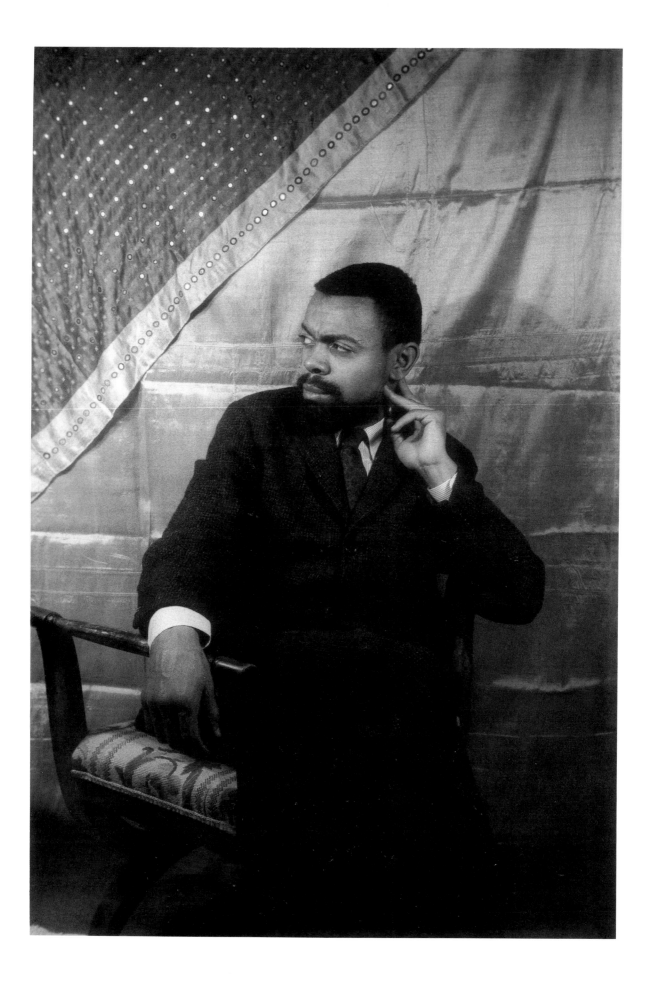

Diahann Carroll

(Carol Diahann Johnson)

March 14, 1955

Singer and actress

A native of the Bronx, New York, Diahann Carroll (b. 1935) attended public schools in New York City, including the High School of Music and Art. Yielding to the wishes and expectations of her parents, who had dreams that she would become a physician or a teacher, Carroll enrolled at New York University, but after a year of study she withdrew and made a lifetime commitment to singing and acting. She began her career as a singer by entering and winning first prizes in televised amateur talent contests, most notably "Arthur Godfrey's Talent Scouts" and "Chance of a Lifetime." Her winning performance on "Chance of a Lifetime" earned her a large monetary award and a one-week engagement at New York City's Latin Quarter. Success at the Latin Quarter was followed by a role, with Pearl Bailey, in *House of Flowers* (1954) for which Carroll earned her first Tony Award nomination. Almost thirty years later she returned to Broadway in *Agnes of God* (1983) and made theater history as the first African American actress to replace a European American actress in a leading role. Carroll had already made history as an actress when she accepted her contract to perform in "Julia" in 1968 and became the first African American actress to perform in her own weekly television series. In 1984, in the role of Dominique Devereaux on "Dynasty," Carroll was the first African American actress to star in a nighttime soap opera. Her many film credits include *Carmen Jones* (1954), *Claudine* (1974), with James Earl Jones, for which she received an Oscar nomination, *Paris Blues* (1961) and *Hurry Sundown* (1967). For achievements in theater, film, and television, Carroll has received, among other tributes, a Tony for her performance in *No Strings* (1962), a Cue Entertainer of the Year Award, an Image Award from the National Association for the Advancement of Colored People, and membership in the Black Filmmakers Hall of Fame.

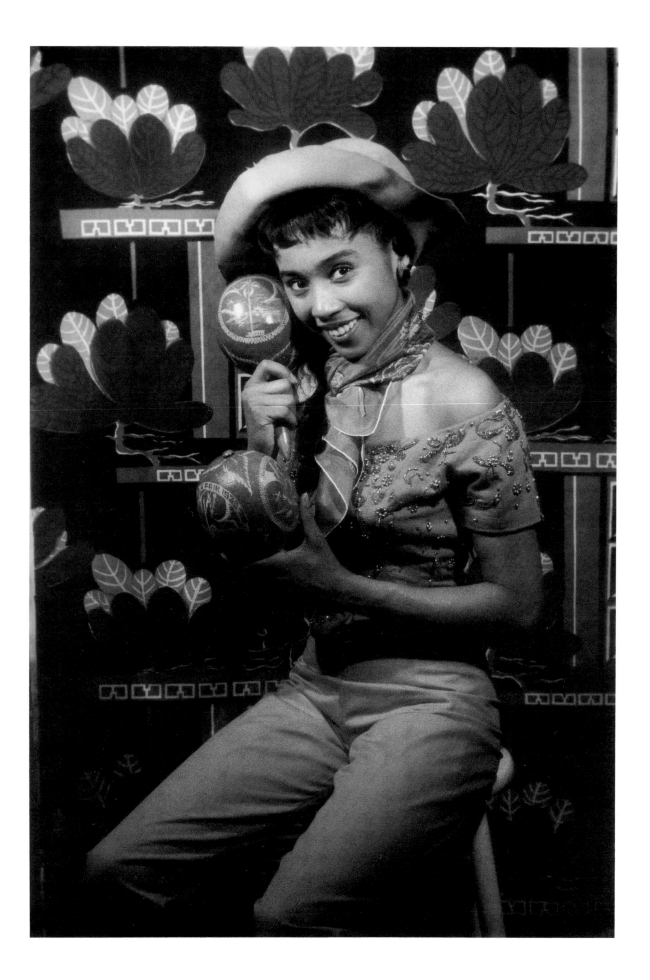

Billy Dee Williams

(William December Williams)

January 29, 1963

Actor

An actor who possesses all the charms of Hollywood's romantic leading men, Billy Dee Williams, a native of New York City, was born in 1937. Like Diahann Carroll, Williams attended New York's High School of Music and Art. He continued his training in acting at the National Academy of Fine Arts and Design and at the Actors Workshop in Harlem. He made his New York City stage debut at the age of ten in the Broadway production of *The Firebrand of Florence*. In 1960 Williams returned to Broadway in the critically praised *A Taste of Honey*. This success was followed by many others on Broadway, including his highly acclaimed performance in August Wilson's *Fences* (1988). Williams's portrayal of Gayle Sayers in *Brian's Song* (1971) was the first of many successful television performances, including guest appearances opposite Diahann Carroll in the nighttime soap opera *Dynasty*. Williams made his film debut in 1959 in *The Last Angry Man* and established himself as a romantic leading man in the 1970s in such films as *Lady Sings the Blues* (1972) and *Mahagony* (1975). In recent years, he has appeared in *The Empire Strikes Back* (1980), *Return of the Jedi* (1983), and *Batman* (1989). Williams's many honors include an Emmy nomination for *Brian's Song,* the Black American Cinema Society Phoenix Award, and membership in the Black Filmmakers Hall of Fame.

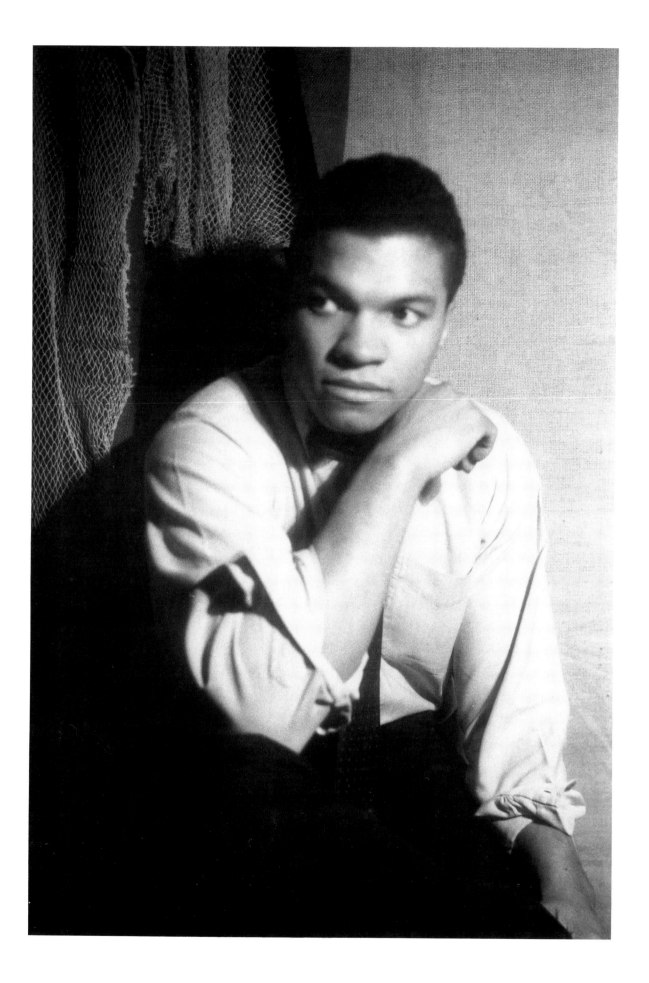

Song: *I Want a Witness*

Blacks in frame houses
call to the helicopters,
their antlered arms
spinning; jeeps pad
these glass-studded streets;
on this hill are tanks painted gold.

Our children sing
spirituals of *Motown,*
idioms these streets suckled
on a southern road.
This scene is about power,
terror, producing
love and pain and pathology;
in an army of white dust,
blacks here to *testify*
and *testify,* and *testify,*
and *redeem,* and *redeem,*
in black smoke coming,
as they wave their arms,
as they wave their tongues.

Michael S. Harper,
Song: I Want a Witness

Index